CATLIN'S LAMENT

CATLIN'S LAMENT

Indians, Manifest Destiny, and the Ethics of Nature

JOHN HAUSDOERFFER

UNIVERSITY PRESS OF KANSAS

Published by the
University Press of
Kansas (Lawrence,
Kansas 66045), which
was organized by the
Kansas Board of Regents
and is operated and
funded by Emporia State
University, Fort Hays
State University, Kansas
State University,
Pittsburg State
University, the
University of Kansas,
and Wichita State
University

© 2009 by the University Press of Kansas

Library of Congress Cataloging-in-Publication Data

Hausdoerffer, John.
Catlin's lament : Indians, Manifest Destiny, and the
ethics of nature / John Hausdoerffer.
p. cm.
Includes bibliographical references and index.
ISBN 978-0-7006-1631-2 (cloth : alk. paper)
1. Catlin, George, 1796–1872—Ethics. 2. Indians of North
America—Public opinion—History—19th century. 3.
Messianism, Political—United States. 4. Philosophy of
nature—United States—History—19th century. I. Title.
ND237.C35H38 2009
759.13--dc22
2008042552

British Library Cataloguing-in-Publication Data is
available.

Printed in the United States of America

10 9 8 7 6 5 4 3 2 1

FOR ATALAYA
and her world

Contents

Preface ix

INTRODUCTION
Catlin's Ethics and Ideology: The Age of Jackson 1

CHAPTER ONE
Catlin's Epiphany 21

CHAPTER TWO
Catlin's Gaze 50

CHAPTER THREE
Catlin's Lament 90

CHAPTER FOUR
Catlin's Tragedy: Catlin in Europe 130

CONCLUSION
Catlin's Fetish 150

Notes 161

Works Cited 169

Index 179

Preface

When the historian raises questions about the way nature was viewed in another era, she is also asking questions meaningful to her own epoch.
—Caroline Merchant

It was December 2004, and I was enjoying the mild Florida winter. I had just endured my first hurricane season. At its height, my wife Karen and I had to evacuate our new St. Petersburg home within an hour of arriving from Colorado. Even before the moving truck arrived, we found ourselves among thousands of cars, seeking shelter from the path of a hurricane that promised 16-foot ocean surges; our new house was 6 feet above sea level.

Ultimately, the hurricane changed course, shattering the homes of unknown people. In the following five weeks, another hurricane shut down my first week of teaching, a third hurricane shut down the second week of classes, and a fourth hurricane shut down the airport in Tampa—leaving me at a conference hotel in Tucson during yet another week of classes. Needless to say, 2,000 miles from the Continental Divide that had long framed my life and unsettled due to a barrage of Gulf storms, I felt displaced. But in the contemplative peace of this December day, a safe four months after the sky raged, I learned I knew nothing of displacement.

On *Democracy Now* that morning, Amy Goodman was interviewing Martin Wagner, an attorney for Earth Justice. Introducing him, she said, "Inuit leaders are seeking a ruling from an international court that the U.S. government's position on global warming is threatening their existence as a people" (*Democracy*). Arctic ice is the lifeblood of Inuit culture. Without ice, they lose the ability to travel from village to village and thus to maintain ancient social networks; without ice, they lose habitat for seals, essential to their diet and identity; without ice, they lose the buffer that traditionally protects their villages from storms. Melting has forced entire villages to move. A 2007 study from the Natural Resources Law Center of the University of Colorado reports that "the cost of relocating just one of the many Alaska Native

villages threatened by flooding and erosion exacerbated by climate change is estimated to be as much as $400 million" (Hanna 1). Given that the United States emits 25 percent of the world's carbon emissions while ignoring global agreements to curb the impacts of the climate crisis, Earth Justice joined with the Inuit Circumpolar Conference (chaired by 2007 Nobel Peace Prize nominee Sheila Watt-Cloutier) to file a petition of complaint with the Inter-American Commission on Human Rights (Revkin). Although quickly rejected, the petition attempted to bring international pressures on the United States to take the lead in climate solutions and to shift the dialogue of doubt on climate change to confront it as a human rights catastrophe.

This story struck me, not only because it humbled my brief, privileged feelings of displacement, and not only because the emergence of links between high-category hurricanes and climate change gave me an enhanced sense of empathy for people atop the world. The story also struck me because I was immersed in writing *Catlin's Lament: Indians, Manifest Destiny, and the Ethics of Nature*, a book that grapples with George Catlin's attempts to challenge nineteenth-century Indian removal and environmental exploitation.

I found myself, in the midst of a study that seemed innocuously couched in the 1830s, suddenly aware that global warming presents a new, twenty-first-century Indian removal. More than ever, I wanted to understand the historical foundation of well-meaning but failed efforts to stem injustices against native peoples. I wanted to learn from the limitations of Catlin's lament for displaced Indian cultures; I wanted to comprehend the limitations of his multidecade protest, rooted in regret for the "vanishing" rather than founded in a struggle for living cultures and the dynamic environments that sustained them.

I have since returned to Colorado. Teaching at my alma mater, Western State College in the Gunnison Valley, I certainly feel a firmer sense of place. But I feel no less affected by the prospects of climate displacement. Although I no longer live 6 feet above sea level (I now write from 8,000 feet, quite safe from rising sea levels), my home is in a mountain community that relies on consistent snowpack for its ranching economy, ski industry, ecological wealth, pine-beetle-free forests, and "Destination College." The 2006 State of the Rockies Report Card, from Colorado College, estimates that (if levels of carbon emissions

continue without significant reduction) the mountain range twenty minutes to the north stands to lose 50 percent of its average snowfall by 2085; the craggy San Juan Mountains 40 miles to the southwest stand to lose up to 80 percent of annual snowfall ("Global Warming"). Comprehending these threats to all aspects of my home—the economy, the ecology, and the culture shaped around certain seasonal patterns and expectations—I grasped the full meaning embedded in the now clichéd term *sustainability*. This climate crisis is first and foremost a crisis for specific ways of life in particular places, places intricately formed from the integration of nature and culture through time. Add sudden climatic shifts to that delicate dance between social and ecological systems, and the ability of places and peoples to *sustain* themselves culturally and economically weakens.

Just as on that December day in Florida, when I was humbled to learn of the Inuit's battle and how their struggle connects with my experience of global-warming-intensified hurricanes, so in Colorado I have learned that Indian nations face more extreme consequences if the waters that begin in the mountains outside my office window dry up. Climate-driven twenty-first-century Indian removal deeply threatens tribes along the Colorado River Basin, such as the Hopi and Navajo of the American Southwest. The Colorado River Basin faces (at least) a 20 percent loss in stream flows from global-warming-reduced snowpack (Hanna 19). As populations and industries demand more water across the West, one wonders how these native societies will sustain their agricultural and water-based tourist economies. One wonders if economic disparity, worsened by a warming climate and declining waters, will compel tribes to accept increased mining leases and waste disposal on their homelands—bringing profits to individuals far away while further depleting Indian resources and environments. How long can such societies remain on their homelands without compromising economic autonomy and cultural heritage? What ethical obligation does a globally privileged American public have to cultures that generate fewer carbon emissions yet bear a disproportionate brunt of the consequences?

Some climate solutions specifically empower native peoples facing disproportionate impacts, from supporting Indian-driven solar generation (NativeSUN) emerging on Hopi lands, where 10,000 people have

no electricity, to investing in the "Saudi Arabia of wind energy," envisioned by the Rosebud Sioux. These solutions emerge from a combination of Indian entrepreneurship and support from non-Indians who understand that the innovations of Indian nations reflect a people far from vanished and necessary to a future of global sustainability. Unfortunately, more dominant global-warming solutions further complicate the possibility of Indian sustainability. The supposedly carbon-neutral "nuclear cycle" has left more than 1,000 open uranium tailings piles on Diné land, while the Western Shoshone continue to struggle against nuclear waste on Yucca Mountain. Native peoples are often unheard in the growing global discourse on climate change, both in discussions of problems and of solutions (LaDuke 187, 192, 3).

As challenging and as necessary as it is to integrate Native American justice and ingenuity with climate solutions, on both technological and political levels, one finds even more complicated obstacles from an enduring historical narrative that describes Indian struggles as sad but unavoidable facts of a distant, resolved past. In other words, how might a commitment to Indian "climate refugees" and Native American solutions thrive 150 years after Anglo-Americans defined these diverse and vibrant people as "vanished"? We might begin by returning to that era in which vanishing was finally and inaccurately accepted as inevitable—the Jacksonian Era that shaped the 1830s and 1840s. In so doing, we must question nineteenth-century critics of Indian removal and environmental exploitation along with interrogating the usual suspects of removal, such as Andrew Jackson.

I chose George Catlin, both an inspiring and conflicted figure who epitomized a life devoted to raising public awareness of the plight of Indian cultures and lands. At the same time, Catlin accepted (albeit as a lament rather than as a celebration) the inevitability of vanishing as much as anyone. *Catlin's Lament* examines the intricate relationship between Catlin's resistance to and acceptance of the cultural and environmental tragedies of Indian removal. Although at its heart a scholarly analysis of a complex historical figure, this study implies a contemporary inquiry. How might we liberate our ethical and political concerns from unexamined cultural narratives that view catastrophes as "only natural"—whether what we call natural is Manifest Destiny in the 1830s or climate change and its consequences in 2009? How

might we build partnerships with cultures and ecosystems that reckon with the consequences of our comforts? How can we achieve Catlin's desire for native justice and an ethics of nature without reenacting Catlin's lament?

Just as no society is disconnected from the intricate places that support it, so every written work is produced within a community. I write in full agreement with Robert Berkhofer's statement that the friends and institutions that support a book "deserve to be thanked as much as the authors that I have cited in the footnotes" (xi). I owe a great debt to many friends, family members, colleagues, students, mentors, and institutions. Any weaknesses in this book come from my inability to fully listen to all of these teachers; all strengths originate with them.

I am grateful for the transformative introductions to historical and political thought that I received at Western State College from mentors Paul Lowdenslager, Jim Stewart, and Wally Lewis. I received equal mentoring in environmental studies from Steve Dunn. Josh Kates and Phil LeCuyer of St. John's College taught me how to explore a "compelling question of enduring significance" with intellectual urgency and humility. In Washington State University's Ph.D. program in American Studies, Leroy Ashby, David Coon, Noel Sturgeon, T. V. Reed, Paul Hirt, and Joan Burbick (my Ph.D. adviser and literary sage) nurtured, challenged, and elevated my discovery of George Catlin, and helped me untangle his web of work in environmental thought, Indian advocacy, travel writing, painting, popular culture, and public policy.

I would like to thank my colleagues, whose support and criticism grounded me in the stubborn facts of social justice and environmental health implied by my study, checking my tendencies toward intellectual reverie. Michael Egan and Jeffrey Crane deserve special recognition for the extensive criticism and nuance offered in preparation for an article on Catlin for their 2008 Routledge anthology *Natural Protest: Essays in the History of American Environmentalism*. The section on Black Hawk, in this volume, stands as a tribute to their editorial skills and scholarly rigor. Tony Zaragoza and Tyson Hausdoerffer made insightful comments on conference drafts of chapters, demanding clarity from complex, theoretical sections. Tony enlivened and complicated my political and ethical questions. Tyson's passion for inhabiting the spaces beyond the safe edges of an unexamined life sparked my love of

the West and interest in literature. Micho Gravis's support kept alive my confidence in the power of ideas, fueling my drive to complete this book. Sean Prentiss shared his writer's soul to transform the opening narrative, just one small yet essential offering from his decades of generous friendship.

Others offered general support, guest lecture opportunities, rich conversation, and comic relief as I navigated through this study for over half a decade: Azfar Hussein, Steve Shay, Anthony Miccoli, Eckerd College's Environmental Studies Program, Caroline Johnston, Erika Spohrer, Alison Ormsby, Heather Thiessen-Reiley, Western's Environmental Studies Council, Phil Crossley, Mark Lung, Chris Stadler, Paul Vaughn, Katie Desmond, Bill Niemi, Dave Plante, Adam Howard, Peter Lavigne, and George Sibley. Nancy Gauss and Patrick Muckleroy (and the staff of Western's Leslie J. Savage Library) allowed me to complete a major project from a small corner of the world. I also want to thank Jessica Young for years of mentoring and (along with John Sowell and Jay Helman) for ensuring the time needed to complete the final manuscript. Without question, I must recognize students of my courses at Washington State University, Eckerd College, and Western State College, who pushed me to translate the theoretical underpinnings of this and all of my work into more engaging language.

I also owe a special thanks to several conference and public audiences who provided invaluable feedback for this project. The 2002 American Studies Association meeting in Houston allowed me to present early versions of Chapter Two, on Catlin's journey west. The 2003 American Studies Association meeting in Hartford, Connecticut, provided a forum for testing ideas concerning Catlin and commodities found in the "Conclusion." The 2003 European Society for Environmental History meeting in Prague offered a highly critical yet productive forum for examining the connections between race and nature throughout this book, as well as the discussion of enlightenment science found in Chapter One. The 2005 Tamkang International Conference on Ecological Discourse in Taiwan and subsequent talks at Taiwanese literature departments at Kaoshuong and Ti'Tung universities helped me develop my literary analysis of Catlin's work. Jai-Yi Cheng Levine generously connected me with this outstanding group of Taiwanese scholars. The 2006 Association for the Study of Literature and

the Environment conference at Pondicherry University, India, challenged me to communicate the importance of Charles Willson Peale's scientific influence on both Catlin and continuing worldviews on nature. In particular, I must thank Murali Sivaramakrishnan for his kind hospitality and fruitful comments on this project throughout my stay in Pondicherry. I would also like to offer my thanks to Patricia Nelson Limerick; the great honor of speaking at the Center of the American West at the University of Colorado enriched my appreciation for the continuing significance of Catlin and for questioning how we imagine and thus live in the West.

I would like to thank the curators and archivists of the following galleries for their help in providing permissions to use Peale's and Catlin's artwork throughout: Pennsylvania Academy of the Fine Arts, Maryland Historical Society, New York City Hall, West Point Museum, New York Historical Society, National Portrait Gallery, and the Smithsonian's American Arts Museum and its National Gallery of Art. I would like to thank the Bancroft Library at the University of California, Berkeley, for their collection of Catlin family letters, and the National Museum of the American Indian display of Catlin's paintings in New York City in May 2005.

I owe a special note of gratitude to the editorial staff and board of the University Press of Kansas. Nancy Jackson first helped me see that this project was worthy of a book, Fred Woodward continued to welcome this project throughout changes in staff, and Kalyani Fernando has offered patience and wisdom in helping me negotiate the multiple identities of this book, merging many academic fields. George Miles and Tom Lynch provided insightful reviews that pushed this project, both as an academic study and as a book in general.

Finally, this book would have stayed in my computer as a personal memento were it not for the support and love of my family—from my late father (William Hausdoerffer), to the encouragement of integrity and lifelong learning by my grandparents (William and Rosemary Hausdoerffer; Ralph and Eleanor Fisher), to the limitless enthusiasm and pride for my work on the part of my mother (Judy Hausdoerffer). I will never forget visiting Catlin's painting of Black Hawk with my mother, telling her the story (see Chapter Three), and seeing her so deeply moved. The poem she wrote weeks later is a testament to the

living power of history and the timelessness of the human sense of justice. Sisters Laurie, Sarah, and Stephanie and their amazing families have encouraged my commitment to teaching and learning throughout my career. The Bergstrom family welcomed me into their fold with unconditional love and unquestioning support for the various life turns that underlie any intellectual work. Of course, my partner, wife, coparent, colleague, best friend, and sharpest editor, Karen Hausdoerffer, deserves more thanks than can be represented on this piece of paper. If I could write like her, this book would be in its fifth edition by now. Without her love, motivation, empathy, eloquence, and honesty, it would not have seen this first printing. She is my coauthor in every sense of the word, in every aspect of my life.

John Hausdoerffer
Gunnison, Colorado
March 2008

Catlin's Ethics and Ideology:
The Age of Jackson

Is it better to work out consciously and critically one's own conception of the
world and thus, in connection with the labours of one's own brain, choose one's
sphere of activity, take an active part in the creation of the history of the world,
be one's own guide, refusing to accept passively and supinely from outside the
moulding of one's personality?
—Antonio Gramsci

"I would prefer not to." This is my favorite line in American literature. On the surface an innocuous expression of polite noncompliance, in the context of Herman Melville's novella "Bartleby, the Scrivener" the statement at once reveals the potential despair and possible freedom of the human condition. Melville's fictional character Bartleby notoriously repeats these words throughout the 1853 story, a repetition that transforms this simple statement into a meditation on passive resistance. The story is set in the wake of the industrial revolutions of nineteenth-century New York City, a rapidly urbanizing city whose population surged from 100,000 to nearly 4 million people in the 1800s (Garraty 273; McKelvey 60). Bartleby spends every waking hour copying legal documents at a mechanized pace, in a cramped, dim building on Wall Street. The reader finds Bartleby performing a single function in life, capable only of cataloging the official interactions of people he will never meet and prosperity he will never experience. Alienated from the fruits of both his labor and his place in the world, diminished to what Karl Marx, in the same decade, called "an appendage of the machine," Bartleby has reduced his choices in life to this mere act of refusal (Marx and Engels 16). "I would prefer not to," he proclaims, whenever asked to complete any other duties for his employer. He no longer sees himself as free to imagine or create a fulfilling life, yet he still conveys a deep independence in his ability to refuse.

Although perhaps unfelt by the numbed Bartleby, "I would prefer not to" is a declaration that reflects both the hopelessness of limited choices and the faith that one still possesses absolute autonomy, despite how fleeting one's choices have become. He reserves the auton-

omy to choose *not* to consent. Even in the end, when Bartleby's stubbornness leads him to prison, where he "prefers not" to accept food until he starves to death, he maintains his "unaccountably eccentric" agency (Melville 2425–2427).

Far more than the crux of a fictional, dark comedy, "I would prefer not to" serves as an anthem of dissent for an age of domination. Written as America industrialized its economy, communities, and daily life and in turn intensified the slavery, Indian removal, and environmental exploitation that enabled such explosive industrial growth, "Bartleby" suggests that freedom lies at the core of even the bleakest situations. Bartleby shows that the essence of dissent begins and ends with the basic decision to withhold consent. As Bartleby's employer exclaims in frustration, "nothing so aggravates an earnest person as a passive resistance" (2410).

But how often does the refusal to consent emerge in a series of defiant decisions, executed as consistently as the fictional Bartleby? Outside the mind of Melville, in the complicated world of nineteenth-century life, how might someone refuse consent in less deliberate situations? How might someone intentionally decline to participate in the collective, unexamined ideologies that quietly define and subtly justify the injustices underlying one's epoch? How might someone ethically decline ideologies imprinted by society onto one's consciousness, as if by nature itself?

These are a challenging series of questions, particularly with reference to the mid-1800s, a time in which an increasing number of American leaders both benefited from and were increasingly troubled by institutions of slavery, Indian removal, patriarchy, and the loss of forests, prairies, and species. George Catlin (1796–1872) was among these leaders. He devoted his life to achieving success and a position of ethical influence specifically through his public attempt to withhold consent from and envision change for what he saw as unjust—the devastation of Indian cultures and environments.

The life of George Catlin intersects so many elements of nineteenth-century American culture that it is impossible to characterize him under a single historical identity. Typically, American collective memory champions his six-year, five-part journey West in the 1830s to visit as many Indian tribes as possible and to record their customs, land-

scapes, and leaders in hopes of educating Americans on the genuine character of a "truly lofty and noble race" (Catlin, *Letters and Notes* 3).[1] He has influenced American society with historic reach and with an astonishing array of formative work. In landscape painting, Catlin's artistic rendering of the West created a lens for viewing the West as a place of unique, intrinsic beauty. As a portrait artist, Catlin popularized a style of representing Native American leaders that in his time challenged stereotypes of Indian savagery. As an early ethnographer, eager to document and catalog what he considered to be "vanishing" peoples and cultures, he cataloged not only portraits of leaders but also studied and depicted cultural ceremonies and sacred sites. As a lecturer, museum curator, educator, and entertainer, Catlin is considered the founder of the "Wild West Show," precursor even for today's Western genre of filmmaking. His Gallery Unique of art, artifacts, and narratives depicting Indian life and landscapes from his western expeditions (from 1830 to 1836) opened in major U.S. cities such as New York, Boston, Philadelphia, and Washington, D.C., as well as European cities such as London and Paris (from 1833 into the 1850s). He performed his work before crowds sometimes comprising over 1,000 people, with audience members including Daniel Webster, P. T. Barnum, Charles Baudelaire, Queen Victoria, King Louis-Philippe, and Charles Dickens.

Undeniably, Catlin's multifaceted life invites an interdisciplinary study of his forms of expression and levels of historical influence. Most impressive, however, is not the diversity of expression for which Catlin won fame, but the extent to which he saw each of these media as yet another venue for recording and exhibiting icons of Indian cultures and western environments, in hopes of preserving knowledge of these lifeways in the face of "iniquities." As a young man in the 1820s, ten years before his trip West, Catlin pledged his energies to studying and artistically rendering the West. He promised "nothing short of the loss of my life, shall prevent me from visiting their [Plains Indians'] country, and of becoming their historian" (2). His ethnography, manifested in paintings, essays, and performances, endeavored to oppose and redefine destructive stereotypes of what he called the "vanishing" cultures and spaces of the West. Catlin hoped that a well-publicized and well-distributed blend of science, literature, art, and entertainment would convince audiences worldwide of the need to establish "a *na-*

tion's Park!, containing man and beast, in all the wild and freshness of their beauty" (*Letters and Notes* 2: 261–262). Of this park he said, "I would ask no other monument to my memory, nor any other enrolment of my name among the famous dead, than the reputation of having been the founder of such an institution" (2: 262).

However, while George Catlin sincerely intended to challenge what he called the iniquities of mid-nineteenth-century America (260), he ironically based his challenge on ideologies that underlay those iniquities. As much as he sought ethnographically to extract and artistically to preserve the "Nature"[2] of Indian traditions to influence public sympathy for Indians and their lands, on a deeper level he consented to dominant assumptions about the "inevitable vanishing" of Native American cultures and western environments. These unexamined assumptions paradoxically caused him to consent to the very ethos of "Manifest Destiny" he earnestly sought to challenge—inevitability. George Catlin's work presents a uniquely complex example of how unexamined ideologies undermine the most genuinely expressed ethical intentions. Catlin's historically celebrated intentions to "save" the "Nature" of Indian cultures and "preserve" western environments offer an ideal case study for investigating the elaborate ability of ideology to blur the ethical difference between refusing and offering consent.

AN AGE OF DEMOCRACY?

George Catlin faced a subtle blend of oppressive forces interwoven into the daily fabric of American life. The Jacksonian Era that Catlin criticized—the period between the 1828 election of Andrew Jackson and the beginning of the antebellum period in 1848—relied on sophisticated ideologies that perpetuated inequalities. The mid-nineteenth-century United States reveals a complex interplay of cultural and social conditions, important phenomena for understanding fully the intricacies of what Catlin both challenged and consented to.

On one hand, it was an "Age of Democracy," with non-property-owning Anglo-American males earning the right to vote, and with economic opportunities arising for Anglo-Americans as settlers expanded across the continent. A quarter million settlers crossed the trans–

Mississippi West in the 1840s in search of economic prosperity. The country's population surged from 3 million to 30 million between the American Revolution and the 1850s. Factories, now powered by networks of dams and assembly-line labor, intensified the production of commodities; between 1820 and 1840 investment in industry rose from $50 million to $250 million, transforming the United States into a significant, global economic force (Kline 25). A simultaneous belief in two previously oxymoronic realities defined the spirit of the age: many Anglo-Americans believed in and pursued, at once, both individualistic social mobility *and* tremendous national power. Individual liberty would emerge from national potency, and vice versa, creating an "Age of Democracy," at least rhetorically.

But democracy for whom? Under what environmental and cultural conditions would the continent provide both seemingly limitless individual liberty and infinite national power? Of course, this unprecedented age of political and economic potential for Anglo-Americans emerged during a destitute time for Indians, blacks, workers, women, and ecological systems. More than a historical irony or coincidence, cultural and environmental injustices collectively served as prerequisites for Anglo-American opportunity.

For example, the opportunity to settle the West and the economic promises of timber, cotton, wheat, cattle, and minerals required the availability of deeply inhabited Indian homelands. Leaders of the day failed to see how a society, with surging immigrant and urban populations, could maintain the promises of democratic opportunity for whites without "empty" land to settle or "unlocked" raw materials to transform into wealth. This ideology fueled Andrew Jackson's controversial 1830 Indian Removal Act, resulting in the removal of cultures from their homelands—from the Seminole of Florida to the Sauk of Illinois (Wilentz 205; Heidler and Heidler 41, 175, 221). Jackson's view and the country's belief in Anglo-democratic opportunity resulted in the removal of 70,000 native peoples in the 1830s. Most infamously, this decade of mass removal led to the "Trail of Tears," during which 4,000 Cherokee died on the forced journey from Georgia to Oklahoma. Leaders such as Andrew Jackson, John Calhoun, and Lewis Cass saw removal (perhaps sincerely) as a humanitarian act for the good of Indians, revealing the dangerous power of ideology—the danger of a

society explaining itself to itself without questioning its basic assumptions. Jackson claimed that removal "will prove in the end an act of enlarged philanthropy. These untutored sons of the Forest, cannot exist in a state of Independence, in the vicinity of the white man. If they will persist in remaining where they are, they may begin to dig their graves and prepare to die" (qtd. in Dippie, *Vanishing* 60). Without prevailing cultural assumptions about the fate of "untutored" races and uncultivated "Forests," Jackson could not have uttered such a statement as legitimate truth and thus could not have made such a pseudohumanitarian claim on human displacement.

With Indians removed, their cultural and environmental practices were replaced with the exhaustive, early capitalist extraction of raw materials fueling a global market revolution. Slave labor intensified as a central tool for extracting raw materials rapidly and cheaply in these "new" western lands. In these territories, slavery expanded with such intensity that in many sections of Georgia, Louisiana, and Texas, slaves constituted well over 50 percent of the population (McPherson 32). As with Jackson's justification of Indian removal, slavery was described as a "positive good" for the slaves themselves. The paternalistic plantation owner was viewed as protecting "inferior" beings from the confusing poverty of cities or the uncivilized darkness of Africa. As John Calhoun said in 1850, "We see [slavery] now in its true light, and regard it as the most safe and stable basis of free institutions in the world" (qtd. in McPherson 50).

In addition to "available" land and resources, and in addition to the economic utility of a dehumanized labor force, new methods of transporting and producing materials provided the basis for the new wealth and opportunity of this "democratic" age. Canals, steamboats, and railroads opened the once distant timber, wheat, minerals, and cotton of the continent's interior to urban centers and ports such as New York, as if they were next door (Cronon 33, 70; Sellers, *Market* 41–44). Places once the distant homes of native cultures and ecosystems could now be moved fluidly, without old limitations imposed by changing seasons or geography. The places of the West could be seen from eastern cities as commodities, as simplified economic parts of whole, complex cultural and ecological systems (Steinberg, *Down to Earth* 70). Materials and labor could be moved with ease to the emerging factories of the

Northeast. These factories, powered by dammed rivers and over-worked laborers, functioned in tandem with the "free" labor of Southern slavery and the "free" resources of previous Indian lands to generate an economic explosion for American cities.

A new middle class developed rapidly. Merchants, factory managers, financiers, and lawyers were in high demand to maintain this new market economy. Again, development and opportunity rested on the shoulders of exploitation. The factories that enabled these opportunities particularly employed young, lower-class, female workers unable to marry into this emerging middle class. Patriarchal ideologies supported the emerging urban middle classes just as white supremacist ideologies (through slavery and Indian removal) founded the cheap production that allowed the factories to thrive. Women could not vote, own property, seek equal education, or even testify in court in many cases of abuse. The few opportunities for social mobility were found in middle-class marriage or lower-class factory work (Sellers, *The Market Revolution*, 242, 405–407). Ideologically, during this age of democracy many believed that in order for individual liberty to work effectively in the context of national power, the very men who sought those liberties would need virtuous homes to return to. Thus, it was believed, through the influence of feminine "republican virtue," men of this democratic nation would not be morally corrupted by their search for power. The historian Jan Lewis expands on the ideologies of female virtue in the early republic, stating that "to the extent that the success of the republican endeavor rested upon the character of citizens, republicanism demanded virtue of women, not because it numbered them as citizens but because it recognized how intimately women, in consensual unions, were connected to men. A virtuous man required a virtuous mate. Moreover, republicanism called upon every means at its disposal to assure male virtue" (699).

Women who could not marry into this class had few options beyond factory work, leaving them without institutional support for their rights against the labor and sexual exploitation found throughout the factory system. Just as with Indian removal and slavery, however, the very limitations of rights and opportunities for women supported the levels of production necessary for white males to pursue the socioeconomic liberties promised by this "democratic" age. Without a cheap

labor force that could be compelled to endure long and dangerous working conditions, the rapid expansion of industrial wealth from $50 million to $250 million in twenty years would have been unimaginable. Further, without the ideology that these hierarchies were natural, the achievement of liberty through power might have emerged as the oxymoron it likely, in reality, was.

The collective human tragedies of Indian removal, slavery, factory exploitation, and patriarchy produced tremendous wealth and opportunity for the culturally privileged, but also resulted in dramatic environmental devastation. During a single person's lifetime in this period, the passenger pigeon went extinct owing to habitat loss, the buffalo dwindled in numbers from 30 million in 1830 to a few thousand (with 5 million slaughtered in just three years), and forests the size of Europe were mowed down (Opie 38–39; Kline 26; Gordon 37). The economic and political prosperity of male Anglo-Americans rested upon what contemporary ecofeminist scholars Greta Gaard and Lori Gruen call (with reference to interlinking injustices in our own era) "the mutually reinforcing oppression of humans and the natural world" (157). *These are not separate or coincidental human and environmental tragedies.* They "mutually reinforced" one another, both materially and ideologically. Materially, "free" land and labor from Indians, blacks, working-class immigrants, and women collectively enabled the feverish pace at which environments were depleted. Ideologically, the view that "naturally" inferior blacks, "naturally" savage Indians, and "naturally" nurturing women were all better off under the paternal, watchful eye of white males allowed for these material injustices to be named something other than unjust. What Catlin called iniquities, desolating, extermination, hostility, avarice, and destruction (to name just a few specific terms that he employed) were rhetorically configured into the "natural" blessings of liberty, progress, democracy, freedom, civilization, and opportunity.

This view of racial and gender hierarchy as "natural," after all, is the essence of "ideology." "Ideology" refers to the unexamined assumptions that provide the foundation for cultural belief systems and socioeconomic practices. Cultural theorist Carla Freccero defines ideology as "the way a society explains itself to itself; a certain way of presenting the world that passes itself off as the truth of the world, that

seems so self-evident that we take it as the truth" (158). Ideology, then, is *not a conscious justification* of particular social practices like slavery or environmental devastation. Ideology is *the tacit base of assumptions* regarding what is "natural" about society that enables a society to accept its own practices, institutions, and beliefs as just—such as the view of the time that the plantation owner can best care for the "naturally inferior" black slave or that nonhuman living systems instrumentally serve human social systems as merely a store of commodities. As historian Philip Deloria states, "Ideologies, in other words, are not, in fact, true, but, as things that structure real belief and action in a real world, they might as well be" (*Indians* 9). Thus, the ideology of "naturalness" that fueled true belief in Indian removal, slavery, industrialization, patriarchy, and environmental degradation was not seen as a set of subjective opinions or beliefs. It was seen as the product of observation, as natural as the setting of the sun. Nineteenth-century ideologies of "Nature" provide the glue holding together these "mutually reinforcing" modes of domination.

Of course, no society or time period can be reduced to the caricature of a single ideology for the sake of judging it from the present, no matter how extensive the injustices and the ideologies that justified them might have been. Even in the context described above, extensive and intricate public disagreements emerged. One need look no further than the 1830 Indian Removal Act (which passed by a single vote following bitter congressional debate) to grasp and respect the fact that even infamous historical moments are shaped by nuanced disagreement across the cultural and political spectrum. However, despite disagreement from the likes of Henry Clay, Daniel Webster, and Davy Crockett, President Andrew Jackson's push for Indian removal benefited from a dominant series of cultural assumptions regarding the "inevitability" of Indian and environmental vanishing and the prosperity that would emerge for the new republic once vanishing occurred. Jackson had an intuitive sense of these assumptions when he questioned his citizens: "What good man would prefer a country covered with forests and ranged by a few thousand savages to our extensive Republic, studded with cities, towns, and prosperous farms . . . and filled with the blessings of liberty, civilization, and religion?" (28). Despite the sophistication of soon-to-be-removed societies like the Cherokee

(they developed their own press and participated actively in the American economy—including the ownership of slaves), Jackson's dominant ideology rendered this narrative of "savageness" true (Taylor 62). Similarly, despite intense arguments about the legal rights of Indian societies, Jackson's dominant ideology legitimated the view that "savageness" must not continue in areas of removal and "forests" could not persist in areas of future settlement without threatening the promised "blessings of . . . civilization." Though rigorous debate occurred, a dominant series of deeply set cultural assumptions about Indian identity, the instrumental value of forests, the fate of both, and how delaying these vanishing things would delay liberty itself made removal the political path of least resistance. Thus, Jackson had more than just one extra congressional vote on his side; he shared and advanced the dominant story of the continent's destiny.

Even the Catlins and Websters of the world concluded that it would inevitably be, at some point, a "settled" continent. Consider, for example, when Catlin quoted Webster's 1849 Senate speech asking the Congress to purchase Catlin's collection of Indian paintings and artifacts. Webster claims that Indian tribes are "all passing away to the world of forgetfulness . . . I go for [Catlin's Gallery] as an *American* subject—as a thing belonging to us—to our history—to the history of a race whose lands we till, and over whose obscure graves and bones we tread, every day" (qtd. in Catlin, *Life among the Indians* 8). Here Webster shows both his resistance and consent to Jacksonian politics. He calls for sympathy for "obscure graves" as a challenge to how policies in his era were sanitized. But he promotes his era's default ideology when he allows that Indians are "passing [to] forgetfulness." Jackson's removal proposal enacted his culture's (even his political opponents') dominant narrative. Although alternative political choices were possible and discussed, Jackson made them appear to run against the grain of the American story of achieving liberty. He successfully made his opponent's view seem antithetical to the ideologies of the age, and his opponents challenged Jackson's policies without challenging the basic cultural narrative of inevitable disappearance.

Given such deeply set and "mutually reinforcing" dominant ideologies of race, gender, nature, and destiny, how does an individual living in such a time even begin to question this web of ideological and ma-

terial injustice? How does a person disturbed by the consequences of these ideas for living peoples and systems inspire an alternate view? How does one, like the character Bartleby, "prefer not to" consent? How does one go beyond Bartleby, beyond resistance to enact solutions, not just through voting differently or expressing a contrary opinion, but through living out an alternate set of assumptions about the future of a continent's cultures and environments, and one's own place in it? In other words, if ethics is the process of negotiating one's self-interests with the rights of humanity and the needs of the world, and if ethics is the endeavor to determine and enact choices that benefit both the self and the world, how does one live an ethical life in the context of the deeply rooted practices and ideologies of this era? George Catlin tried.

GEORGE CATLIN'S ETHICAL INTENTIONS

Given that Catlin attempted to preserve images and artifacts of Indians and their environments, as well as parks to safekeep some of these peoples and their environments, while accepting their disappearance as inevitable, is it accurate to consider Catlin's career as devoted to social change? Since he was also an entrepreneur seeking profit and fame from recording a vanishing people, is it fair to see him as an advocate for Indian causes, especially if he saw them as "lost to the world" and "doomed [to] perish" (Catlin 15–16)? Is it erroneous to see him as anything more than an ethnographic artist? Is he nothing more than a cultural eulogist?

Among Catlin scholars, one finds a spectrum of views on these questions. As far back as 1948, Lloyd Haberly wrote melodramatically that "destiny had really elected [Catlin] to make known the truth about the American Indians" (12), suggesting that Catlin sought specifically to expose lies that fueled expansionist realities. In 1959 Harold Mc-Cracken stated, "The whole history of the struggle of our race to make this [continent] our own . . . has usually been written from our viewpoint or even as a salve to our conscience. What George Catlin wrote in his day was an extremely unpopular viewpoint—truthful though it was" (14). In 1970 Roderick Nash credited Catlin with establishing "the

National Park as an American contribution to world culture" (734). William Truettner in 1979 claimed that "Congress, like the public, no longer considered Indians a desirable complement to the western wilderness. . . . The concept Catlin had preached in the 1830s, the preservation of a naturally ordered sphere of savage life, had become anathema to white men in the course of western expansion" (59). In the 1990s Benjamin Kline echoed Nash in claiming that Catlin "deplored the rapid vanishing of the wilderness" and that his "arguments for preserving wilderness in the United States initiated the idea for national parks" (35). Paul Reddin in 1999 explains that "it was a practical and energetic age, a time of land clearing, canal and road building, steamships, staple crop production in the South, textile milling in the industrial Northeast, and the emergence of railroads. . . . Catlin failed to attune himself to his age" (8). W. Richard West in the 2002 Smithsonian publication *George Catlin and His Indian Gallery* states, "Catlin placed great value on Indians and their cultures, revealing genuine concern at how they were being systematically stressed and destroyed by non-Indians" (21). Steven Conn in 2004 summarizes this view of Catlin as a resistant voice in the mid-nineteenth century: "Catlin's sojourn among the Indians of the Great Plains did prompt him to speak out . . . against the treatment they suffered at the hands of encroaching America" (63).

What evidence has led these historians to recall Catlin as a sympathetic and resistant voice in the Jacksonian Age? Catlin challenged the practices of his times in five ways: he subverted Indian stereotypes, he redefined the value of western landscapes, he criticized the consumptive practices and general apathy of the American populace, he asked for changes in government frontier policy, and he sought to ethically detach his own endeavors in the West from exploitive institutions of expansion.[3]

First, Catlin challenged negative stereotypes not only of Indians in general but even of Indian opponents in American wars, such as Black Hawk and Osceola from the Black Hawk and Seminole wars, respectively. As he said in his classic, two-volume work on his travels to Indian lands, *Letters and Notes of the Manners, Customs, and Conditions of North American Indians*, "The Indian's misfortune has consisted chiefly in our ignorance of their true native character and disposition . . . in-

ducing us to look upon them in no other light than that of a hostile foe" (8). Later in the same chapter he asserts that Americans have "too often recorded them but a dark and unintelligible mass of cruelty and barbarity" (9). As already stated, given the closeness of Removal Act votes, Jackson relied heavily on society's view that Indians were "savages." Catlin, through the basic act of painting humanizing portraits of demonized societies, undercuts the very logic of Jackson's removal claims and military policies. Even decades after *Letters and Notes,* in his carefully crafted introduction to his 1861 *Episodes from Life among the Indians,* he displays his unique ability to expose this logic. In remembering why Jefferson Davis voted against a congressional purchase of Catlin's Gallery, Catlin questions the "principle" that Davis claimed underlay his negative vote: "This unexplained *'principle'* I construed to be clearly the principle adopted and proclaimed by President Jackson many years before, of removing all the southern tribes of Indians west of the Mississippi River, that their 250,000,000 acres of rich cotton lands might be covered with slave laborers; which principle, with an accompanying hostility to everything Indian, had been and was being carried out by the successive administrations" (9). Catlin understands and criticizes the link between rich land, slave economies, and Indian removal. Even further, he understands the link between Indian removal and the "accompanying hostility" that emerges from negative, inaccurate stereotypes. Yes, he assembled his artistic and ethnographic record for fame and success, but he hoped to assemble it in such a way as to specifically resist this interlinking nature of "hostility" and "removing."

Second, Catlin's western portraits challenged the prevailing ideology that the spaces of the West were "savage forests" awaiting "the blessings . . . of civilization." His paintings show the pre-"settled" West as open yet fulfilled without awaiting transformation from American culture. Unlike works of popular painters late in Catlin's life, such as those of John Gast and Frances Palmer, Catlin's paintings do not show incomplete landscapes, awaiting the arrival of miners, loggers, farmers, wagons, trains, steamboats, and cities. In showing these spaces as complete, Catlin challenges the combined ideology that the spaces are untamed wilderness and that the people inhabiting those "forests" are in turn savage and in need of removal to allow for settled lands and

thus civilized people. He challenged the view that "Nature" is improved once American expansion transforms it.

Third, beyond contradicting the imagery of Indians and nature that enabled displacement policies, Catlin questions the daily practices of his readers and audiences. He asks the reader to "divest himself, as far as possible[,] of the deadly prejudices which he has carried from his childhood, against this most unfortunate and most abused part of the race of his fellow men" (7). In the conclusion of volume 1 of *Letters and Notes*, while depicting a time he witnessed Indians killing buffalo for alcohol, Catlin again directly challenges the reader: "Reader! . . . The buffaloes (the quadrupeds from whose backs your beautiful robes were taken, and whose myriads were once spread over the whole country, from the Rocky Mountains to the Atlantic Ocean) have recently fled before the appalling appearance of civilized man" (261). He not only challenges media stereotypes or the way his viewers think about Indians; he also directly confronts the individual consumer behavior of his audience, showing the link between their clothing preferences and devastated lands far away.

Fourth, Catlin directly questions the structural policies of fur trade companies and the government. He extends the critique of his audience to a criticism of how fur companies traded alcohol for hides with impoverished, desperate Indian societies plagued with disease, alcoholism, and few economic alternatives. "Oh insatiable man, is thy avarice such! Wouldst thou tear the skin from the back of the last animal of this noble race, *and rob thy fellow-man of his meat, and for it give him poison!"* (260). Even further, he demands policy change within the government, particularly toward those tribes that have yet to confront frontier conditions of greed, poverty, alcohol, guns, and buffalo slaughter. Although Catlin maintains his belief that current, traditional, and autonomous tribal lifeways are "doomed and must perish" (except on his canvas, in his shows, and perhaps in his park), he does believe that those tribes can meet a kinder, gentler frontier society if certain shifts in western policy occur. In *Letters and Notes* he states:

It is for these inoffensive and unoffending people, yet unvisited by the vices of civilized society, that I would proclaim to the world, that it is time, for the honor of our country—for the honor of every cit-

izen of the republic—and for the sake of humanity, that our government should raise her strong arm to save the remainder of them from the pestilence which is rapidly advancing upon them. We have gotten from them territory enough, and the country which they now inhabit is most of it too barren of timber for the use of civilized man; it affords, however, the means and luxuries of savage life, and it is to be hoped that our government will not acquiesce in the continued willful destruction of these happy people. (61)

He thus hopes behaviors on the frontier can change, through challenging dehumanizing stereotypes, consumer behavior, and government policy. He holds out hope that a combination of artwork and policy will preserve knowledge of "original" Indian lifeways and introduce a more humane frontier, respectively. His goal is a humane frontier that allows some Indians a park to continue living traditionally and still others the chance to adopt western virtues without being corrupted by its vices (greed, alcohol, disease). Although revealing a particularly paternalistic brand of humanitarianism, he conveys his hope for policy change in volume 2 of *Letters and Notes:* "If the strong arm of the Government could be extended out to protect them, I believe that with the example of good and pious men, teaching them at the same time, agriculture and the useful arts, much could be done with these interesting and talented people, for the successful improvement of their moral and physical condition" (244–245).

In addition to *Letters and Notes,* paintings that humanize, and his literary call for a more humane frontier that includes both a park and more ethical frontier policies, Catlin also made his views clear in his life as a public intellectual. According to historian Brian Dippie, Catlin did not "hide his ideological agenda. His assumptions about the Indians he painted required no teasing out. He made them the overt rationale for his entire enterprise. He believed that America's native peoples, once proud 'noble savages,' were being destroyed by advancing civilization" (*Green Fields* 28). Although enterprising in his goals, Catlin periodically risked his financial success in speaking his mind. His 1832 travel accounts published in the *New York Commercial Advertiser* disputed the economic view that the West was "empty land" (qtd. in Reddin 8). Eventually, Catlin's opinions in lectures and published letters

about trade practices alienated the American Fur Company, which had provided him with transport in his early trips, causing him to take his next trip with the U.S. military (Reddin 15–16; Dippie, *Green Fields* 41). Catlin's hopes of selling his Gallery to Congress were thwarted by the political content of his words—at times blatant criticisms of policy, more often subtle celebrations of cultures that were still actively resisting expansion.

Contemporary ethnographers like Henry Schoolcraft, who competed with Catlin for public money, "rankled to see Catlin praised and the United States condemned" (Dippie, *Contemporaries* 72), and exploited Catlin's condemnations to lobby against efforts to showcase Catlin's work (and thus Catlin's values and critiques) in Congress. This perception negatively affected Catlin's reputation, resulting in, for example, his losing votes in Congress to his early unfavorable legacy among historians. Writing shortly after Catlin's death, Thomas Donaldson said: "Mr. Catlin took the sentimental side of the Indian question in the matter of state policy. . . . Mr. Catlin permitted his sympathy for the Indian to warp his judgment" (qtd. in Conn 63). Nevertheless, Catlin continued to engage public audiences in ethical dialogue. A decade after facing failure in America and eight years after presenting his Gallery and lectures to Europe, he humanized Indian societies by criticizing the consequences of expansion:

The march of civilization is everywhere, as it is in America, a war of extermination, and that of our own species. For the occupation of a new country, the first enemy that must fall is *man,* and his like cannot be transplanted from any other quarter of the globe. . . . But to complete a title, man, our fellow-man, the noblest work of God, with thoughts, sentiments and sympathies like our own, must be extinguished; and he dies on his own soil, unchronicled and unknown. (*Eight Years' Travels* 62–63)

However, recent historians have questioned the extent to which Catlin set out to inspire change, arguing instead that he sought to record the images of a dying people for the sake of posterity, knowledge, money, and fame. This view holds that either Catlin was an entrepreneur who tapped into white curiosity and guilt—finding new

ways to fill theaters and sell paintings—or he was an early ethnographer who believed deeply in preserving a record of native peoples and lands, but not the cultures and places themselves. As Dippie states, although "Catlin was essentially at odds with the spirit of a burgeoning West" (*Contemporaries* 57), he "had always been frank about his motives in going West to paint Indians. He was, he said, after fame and fortune" (434).

So how does one understand Catlin's role in this era? Is it careless to call him a devoted dissident, on the level of Henry David Thoreau or Frederick Douglass or Elizabeth Cady Stanton? Conversely, is it cynical to suggest he was merely an artist and entrepreneur, devoted to tapping a unique and lucrative market of ethnographic curiosity? When one looks at Catlin's writings, one learns that he thought he could do both. Indeed, he thought that he found a new path to fame and wealth. But he also felt that this enterprising path represented a new way to ethically refuse consent and recommend change within a new capitalist society.

This is the fifth way in which Catlin challenged his age—he thought he modeled an economic endeavor and inhabited a philosophical position ethically innocent of perpetuating Indian "extermination." As he adamantly declares in *Letters and Notes,* "I travel not to *trade,* but to *herald* the Indian and his dying customs to posterity" (103). One might read this and conclude that in "heralding," Catlin did not seek to address injustice but, rather, to record cultures and lands before those injustices fully obliterated them. But in stating this, Catlin clearly shows a deliberate ethical intent to prosper in his society without participating in its injustices. He sought a financially profitable brand of sincere political theater, immune to the problematic trappings of "trade," a term he chooses to contrast with his own endeavors. As he says, "The humble biographer or historian, who goes amongst them from a different motive, *may* come out of their country with his hands and conscience clean, and himself an anomaly, a white man dealing with Indians, and meting out justice to them; which I hope it may be my good province to do with my pen and my brush . . . having done them no harm" (*Letters and Notes* 2: 225).

Catlin seeks to withhold consent, to do "no harm." "If in my zeal to render a service and benefit to the Indian, I should have fallen short

of it, I will, at least, be acquitted of having done him an injury" (2: 255). He "prefers not to" participate in the injustices of his society, and instead he hopes to offer another vision for the West and to redefine the value of its peoples and places—vanishing though they may be. While it is true that he does not refuse consent to the underlying capitalist structures of profit that began to drive art and entertainment in his time, he does hope that, as an enterprising and successful artist and entertainer, he can oppose the negative by-products of those structures. Catlin hoped that if he could make change, he could at least model for his society how to thrive from American wealth and fame without participating in the injustices that underlie that very prosperity. He hoped for a moral perfect storm in this exploitive era—to criticize unethical behavior, to exonerate himself, and to achieve fame and wealth through establishing his critical innocence from Jacksonian injustice while perhaps inspiring it in others. George Catlin was deeply engaged in the ethical dilemmas of his time and made thoughtful decisions to publish works that pushed those ethical dilemmas into the politically charged realms of environment and culture.

Catlin never could create his park in "the wild and freshness" of the West, but he did attempt to create it in popular culture—in his "Gallery Unique." If his idealized conception of the relationship between civilization and nature, science and advocacy, could not be preserved within an expanding West, he thought it could be reconstructed on canvas, in writing, and on the American and European stage. That is, he hoped that emerging media of popular culture offered ideal sites for his ethnography, cultural preservation, and early naturalism. He also saw it as a site of ethical discourse. As late as his European struggles in the 1840s, he claimed that his purpose in presenting Indian paintings, artifacts, and "real Indians" to European audiences was to "inform the English people of the true character and condition of the North American Indians, and to awaken a proper sympathy for them" (*Eight Years' Travels* vi). Even with reference to using "real Indians" on stage for his own profit, Catlin says, "in justice to *me* . . . I considered my countenance and aid as calculated to promote their views; and I therefore justified myself in the undertaking, as some return to them for the hospitality and kindness I had received at the hands of the var-

ious tribes of Indians I had visited in the wilderness of America" (vii). If nothing else, Catlin could model ethical immunity while memorializing lost, natural values (embodied in romanticized Indian cultures and landscapes) as lessons and warnings for an American culture that from his point of view had become corrupt. George Catlin, from his dissatisfaction with urban life as a Philadelphia portrait artist in the 1820s, to his optimistic journeys through the West in the early 1830s, to his search for fame and fortune on the American and European stage in the 1830s and 1840s, "preferred not to." He preferred not to consent to the cultural and environmental domination he saw and resented around him.

But what we prefer and what we practice when submerged in the ideological abyss of a historical moment are often quite different things. *Catlin's Lament: Indians, Manifest Destiny, and the Ethics of Nature* seeks to understand the tenuous relationship between conscious ethical intentions and the unexamined cultural ideologies of George Catlin. Catlin, without question, should be included in our collective historical memory of nineteenth-century objectors. Nevertheless, we must include him in a way that carefully and explicitly asks hard questions about how his own ideologies surrounding "Nature" undermined his ethical intentions. Problematic constructions of "Nature" ironically underlay both the injustices of the Jacksonian Era and the most ethical intentions of George Catlin. When even an era's top critic submits to its problematic ideologies, historians must carefully examine that ideology to understand both the era and the critic in new, intricate ways.

I look at five main "snapshots" from Catlin's career to explore how his work consistently teeters between resistance and consent to nineteenth-century ideologies concerning Nature. Each snapshot will provide the foundation for each of the following five chapters, showing the continuous interference of Catlin's unexamined assumptions throughout his career. Chapter One examines his initial epiphany in the 1820s leading him to devote his artistic and literary talents to Native American environments and cultures. In particular, I inspect the impact of Charles Willson Peale's Museum on Catlin's years in Philadelphia and Catlin's early career in the field of portraiture.

Chapter Two looks at his journey west to document "vanishing" life-

ways. This chapter, emphasizing Catlin's classic *Letters and Notes,* examines the way in which Catlin studied and preserved the environmental and cultural "Nature" of the West.

Chapter Three analyzes Catlin's presentation of his western findings to American audiences. The chapter takes seriously Catlin's genuine compassion for the decline of Indian cultures and focuses on the implications of his "lament" for this decline.

Chapter Four explores Catlin's presentation of his work in European cities. I base this exploration on a close reading of his lesser known work, *Eight Years' Travels and Residence in Europe.* Historians consider this time period Catlin's downfall, since he sensationalized "real Indians" until a group died of smallpox and ended his public educational performances. In this chapter the claim is made that Catlin's actions in Europe represent the pinnacle of, not a downfall from, the assumptions underlying his intentions.

The "Conclusion" revisits Catlin's death in 1872, the same year Yellowstone National Park was founded. Yellowstone is significant to understanding George Catlin, not only because historians credit him with having first conceived of the park idea in 1832 but also because Yellowstone's founding represents the epitome of Catlin's assumption that consuming a commodified construction of "Nature" will preserve what is most essential about environments and cultures.

Many thorough and engaging biographies of George Catlin's life have been written. I do not seek to supplant those works, nor to praise or blame Catlin as an individual human being, trying to "do well by doing good" in this world. He is credited with many "firsts" in history, from first ethnographic artist of the West, to first Wild West showman, to first national park advocate. These innovations must be respected to grasp both his opposition and consent to the practices of his times. Included among these firsts, however, is his being one of the first to hope that consumption of and profit from Nature would sufficiently preserve the essential values regarded as inherent in an environment. Thus, Catlin's ideologies of Nature must be questioned to understand the nuances of his ethics, the complexity of his times, and the problematic influence of Nature on environmental thought—past and present.

Catlin's Epiphany

> *If "nature" is what makes it possible to recapitulate the hierarchy of beings in a single ordered series, political ecology is always manifested, in practice, by the destruction of the idea of nature.*
> —Bruno Latour

In the mid-1820s, while in Philadelphia as an overworked portrait artist, George Catlin had a much-needed epiphany: "My mind was continually reaching for some branch or enterprise of the art, on which to devote a whole life-time of enthusiasm; when a delegation of some ten or fifteen noble and dignified-looking Indians, from the wilds of the 'Far West,' suddenly arrived in the city, arrayed and equipped in all their classic beauty . . . exactly for the painter's palette" (*Letters and Notes* 2). In these Indian delegates, Catlin sees "the grace and beauty . . . of nature, unrestrained and unfettered by the disguises of art" (2). They offer him "the most beautiful model for the painter" (2). Catlin also imagines that the landscapes from which these delegates arrive represent "unquestionably the best study or school of the arts in the world: . . . the wilderness of North America" (2). According to Catlin, this moment forever transformed his life and career—indeed an epiphany. He shifted his artistic goals from portraying men of power to memorializing what he deemed to be an idea of "Nature" embodied in the "vanishing" persons and landscapes of American Indians.

Undoubtedly, Catlin perceived these delegates as a natural alternative to the Philadelphia art world in which he had been working, and as a subject that would help him establish a unique place in that world. Philadelphia was the heart of postrevolutionary American art. Yet with this early view of an Indian delegation, Catlin swears that the "wilderness," not Philadelphia society, represents the best "study or school" of art. He professes that the art of civilization "disguises" the art of Nature. By contrast, he hopes his work, if published widely, will reveal the art of Nature. Like other romantics of his age, Catlin laments that "civilized" art leaves untapped the resources of Nature's art, embedded in the bodies and lands of Indians. Even worse, from Catlin's critical

perspective in this aggressively expansionist age, American civilization would inevitably usurp these landscapes, overwhelm these "lords of the forest," and "obliterate the grace and beauty of Nature" (2).

Catlin decides in this epiphany that if he ever hoped to learn true art, beyond the corrupt "disguises" of civilization and high culture, he would have to visit this school of "Nature" and paint its models before they vanished entirely. Thus began his celebrated, six-year western journey in the 1830s. Catlin proclaims: "The history and customs of such a people, *preserved* by pictorial illustrations, are themes worthy [of] the life-time of one man, and nothing short of the loss of my life, shall prevent me from visiting their country, and of becoming their historian" [emphasis added] (2). He suggests that his artwork, if properly learned in this "wilderness" school, would in turn *save* these endangered species of natural art—or at least the "grace and beauty" of their images—from obliteration. Catlin's undisguised artwork would then offer future generations access to the "Nature" his work preserved, even after Indians vanished in the way he feared. Hence, visiting and painting the West became the central ambition of his epiphany—for the sake of art itself, for the potential of future "unfettered" artists, and for the preservation of "natural" customs and landscapes.

This moment, this epiphany, is loaded with hopeful and well-intentioned assumptions about what can be known, experienced, expressed, and preserved of Nature and culture through art. Catlin attributes tremendous epistemological and ethical powers to art. He assumes that art can do far more than capture a likeness—a two-dimensional resemblance of a people or culture. He believes that "pictorial illustrations" can preserve the "history and customs" of a people, and through them the very Nature that their physical bodies reflect. The concrete, complex individuals, cultures, and landscapes of the western "wilderness" are merely emblematic of his true study: the abstract Nature that they echo.

Where does this confidence in art's ability to preserve come from? Where does this epiphany come from? Pivotal moments in history infrequently disclose the weave of seemingly mundane events and ideologies behind them. Even more, epiphanies are often portrayed as if erupting spontaneously, as flash moments of inspiration. Rarely are they represented as the product of intricate contexts and unexamined

assumptions, long held by the person experiencing the epiphany. The contexts and assumptions underlying Catlin's epiphany need to be explored for an understanding of his ambition and ideology, including especially the formative influences (on Catlin's epiphany to go west) of Charles Willson Peale's Museum and of the practices of nineteenth-century portraiture. These underpinnings influence Catlin's belief that Indian bodies and wilderness represented an essential Nature whose essence both inspired and could be sufficiently preserved in "unrestrained art." Catlin, and the scientific-artistic community in which he was embedded, constructed an idealized Nature that is best known and preserved when separated from the dynamic environmental, cultural, political, historical, and economic conditions producing it. This mentality allows him to accept imminent Indian displacement while inhabiting a critical and ethical distance from its unjust sources.

Three contexts behind Catlin's epiphany beg close attention: the scientific-artistic principles manifested in Peale's Philadelphia Museum, the general field of early-nineteenth-century portraiture, and a paragon example from Catlin's early career as portraitist—his 1828 portrait of Governor DeWitt Clinton. Without understanding these contexts and assumptions, one runs the reductive risk of either praising or blaming Catlin *as an individual* throughout his career, rather than trying to understand how his *work* (regardless of his intentions) both subtly resisted and consented to the ideological world that surrounded him.

PEALE'S MUSEUM: ENLIGHTENMENT KNOWLEDGE
AND REPUBLICAN NATURE

Catlin arrived in Philadelphia in 1823 to work as a miniaturist painter and portraitist. Philadelphia in the 1820s was the cultural center of the new republic. In addition to Peale's Museum (1784–1843) and the Pennsylvania Academy of Fine Arts (founded by Peale in 1805), Philadelphia housed the American Philosophical Society (founded by Benjamin Franklin in 1743) and the Academy of Natural Sciences (founded in 1812). Catlin took full advantage of these institutions, particularly Peale's Museum (Reddin 5). He encountered Peale's Museum

on the dwindling end of a brief and dissatisfying career as a lawyer. Catlin claims, "I very deliberately sold my law library and all (save my rifle and fishing tackle), and converting their proceeds into brushes and paint pots; I commenced the art of painting in Philadelphia" (*Letters and Notes* 2). This is not just a career change for him but also a metamorphosis of his self and physical belongings. Philadelphia offered a climate for such a transformation from lawyer to painter, leaving Catlin to await only the West to complete his conversion from advocate of civil law to ambassador of natural law.

Nature as Enlightenment

Catlin's formative visits to Peale's Museum immersed him in an intellectual atmosphere dependent on the assumption that Nature must be studied apart from environmental relations—apart from those geographical, ecological, and cultural conditions that shape the disposition of "natural" objects. What definition of *Nature* emerged from this environmentally isolated atmosphere? The historical context of the late European Enlightenment, which extensively influenced Peale's work, in turn shaped Catlin's definition of *Nature*. As Peale stated in an 1816 address, he founded his museum in 1784 in order to "diffuse knowledge of the wonderful works of creation, not only of this country but of the whole world. Also to show the progress of the arts and sciences, from the savage state to the civilized man; displaying the habits and customs of all nations" (Peale 3: Part 3, 414–415). This address mimics the European Enlightenment promise that scientific knowledge of Nature ensured continual progress for humanity, from the "savage state to the civilized man." To Enlightenment thinkers of the late eighteenth and the early nineteenth centuries (Diderot, Voltaire, Jefferson), progress relied on knowledge, and knowledge relied on rational, scientific access to Nature, rather than on religious tradition, faith, or superstition (Outram 3). Since the work of Copernicus, Galileo, Descartes, and Bacon, scientists had conceptualized the universe as sun centered rather than earth centered; agriculture had yielded more crops and higher human populations than ever imagined; industry had begun producing goods on more efficient levels; and medicine had dramatically reduced the previously high incidence

of infant mortality (Hampson 43–48). Enlightenment thinkers believed that if the human mind could so thoroughly read Nature to understand the universe, create an anthropocentric boon from the land, and prolong life, then such knowledge of Nature could result in social and political structures that continually progressed toward perfection.

Accessing and understanding Nature became the central goal of virtually all scientific and political thought in the Enlightenment era. Several thinkers, including Voltaire, Jefferson, Rousseau, and Peale, went so far as to replace God with Nature. This Deist religion argued that God (Nature) was a sort of clockmaker at the origins of time, who structured the universe to run on natural laws, without further personal or divine intervention—not unlike the way a clockmaker designs a clock and then lets in run on its own. If humans could know those laws of Nature's clock, they could know the clockmaker—God. Over a century before the Enlightenment, during the scientific revolution, thinkers such as Johannes Kepler and Tycho Brahe felt they could "read the mind of God" through the geometric study of the universe (Wilson 3). The Enlightenment era extended this view to see the mind of God as the rational order behind physical objects. Nature as the mind of God behind the material world became synonymous with that rational order. Nature was not the products of the universe; *Nature was the process behind the universe*. According to Peale historian Lillian Miller, "a Deist, [Peale] believed that the natural universe was created by an omnipotent and benevolent Creator; thus, all of man's needs could be met through the manipulation of nature once man had learned nature's way or encompassed nature's meaning" (91–92). Nature in this deist view signifies the essential "meaning" behind all entities in the universe. A rational mind, then, could access the meaning of a rational universe only if it divined Nature (the rational agent behind things) from the physical entities of the wild world. As Peale states, "He who knows [divine wisdom] not from observation on nature, can scarcely learn it from another source" (Peale 2: Part 1, 263). If humans could use and manipulate this wisdom of Nature to rationalize and improve human relations, they could become the creators of the ideal society. Peale inserts himself snugly into this Enlightenment age when he declares, "Every one who really delights in the contemplation of nature *must* be virtuous" (Peale 2: Part 1, 263).

Environmental historian Carolyn Merchant illustrates how scientific and Enlightenment revolutions between 1500 and 1800 fundamentally altered western views of "Nature." Merchant claims that, before Copernicus concluded in the 1540s that the earth was not the center of the universe, the earth was seen as "the ancient center of the organic cosmos" (*Death of Nature* xxii). Following this shift, the earth became merely one element of a systematic universe, where the earth, moon, stars, and all other planets followed identical natural laws that could be understood rationally. What had been a view of a "disorderly, active nature" was transformed into something more like a machine (Merchant 164). According to Merchant, this "organic cosmology . . . was undermined by the Scientific Revolution and the rise of market-oriented culture" (xx). For industry to thrive and rapidly extract resources for new industries, Merchant argues, it required a *view* of Nature that ethically sanctioned this mechanized *use* of the earth. If Nature could be defined as mechanical, as not living or organic, then it could legitimately be exploited rapidly for resources. Influential scientific and industrial thinkers such as Francis Bacon, excited to apply the new science and "read the book of nature" (Merchant 164), were equally excited to economically implement this new science of reading rational order. Bacon stated that the new scientific methods of observation "do not, like the old [organic, disordered interpretation of nature], merely exert a gentle guidance over nature's course; they have the power to conquer and subdue her" (qtd. in Midgley 42).

By the time that Enlightenment thinkers extended this mechanistic philosophy of the earth to a rational relationship with God as Nature, "Nature" was something conceptually distinct from the tangible processes of life, death, and interaction found within the organic world. "Nature" signified the rational source, the mechanical logic ordering life and the universe, and the set of laws that all things material and moral follow. It is no accident that Thomas Jefferson, writing during the same Enlightenment period that saw the opening of Peale's Museum (of which Jefferson was a founding board president), immediately evokes "the laws of nature and nature's God" in his Declaration of Independence. "Nature" was a concept abstracted from environments, divorced from relations among species within specific communities. Nature, to Enlightenment thinkers, was the universal process

enabling environments to exist. Enlightenment thinkers could grasp this concept only when the enlightened mind could abstract and isolate the rational structure behind tangible social, political, cosmological, and environmental phenomena. Nature was best known apart from living environmental systems; it was best known within and for the sake of "civilization," far from "wilderness."

Peale's Museum offered such access to Nature through a display of the "works of creation," detached from their origins. In other words, Peale created an Enlightenment temple. By 1820, entering its fourth decade under Peale and his sons, and during the years Catlin visited, the Philadelphia Museum presented a collection of 100,000 items. Set up in historical Independence Hall, the museum combined history paintings and portraits from the Peale family, the first reassembled "mastodon," eight wax figures representing "the races of mankind," a vast assemblage of preserved flora and fauna, and (anticipating Catlin's Gallery Unique of the 1830s and 1840s) anthropological and geological evidence from both the Lewis and Clark and Long expeditions across the continent (Sellers, *Mr. Peale's Museum* 92). As historian Charles Coleman Sellers reports, "One of [Peale's] handbills issued from 1818 to 1820 cites 212 animals in the Quadruped Room . . . , 1,240 birds, together with 180 portraits overhead, 121 fishes, 148 snakes, 112 lizards, 40 tortoises and turtles, 1,044 shells, corals, and so on, and the mineral collection rounded out as 8,000" (246). Peale aimed "to bring into view a world in miniature" (20).

When Catlin entered Peale's Museum in the early 1820s, the following welcome was sketched above the doors:

> The Book of Nature open,
> . . . Explore the wondrous work,
> . . . an Institute
> Of Laws eternal, whose unadulterated page
> No time can change, no copier corrupt. (*Mr. Peale's Museum* 15)

One is unlikely to find a verse that better summarizes the Enlightenment construction of "Nature." Recalling Bacon's view of Nature, Peale proudly saw his museum as the "Book of Nature," which he had opened to the public. It was not the complicated, chaotic, fabled, and

misunderstood "nature" of the pre-Enlightenment world. In fact, in a 1799 lecture on natural history, Peale said that the ancient mind, interpretation of nature, and therefore pre-Enlightenment nature itself were "in a Mass; jumbled together" (qtd. in Stein 184). But Peale professes in this same lecture that the modern mind, especially when instructed by a museum of "Laws eternal," gains "possession of the master key of a grand Pallace by which we can step into each of the apartments, and open any of the cabinets, to become acquainted with their contents" (qtd. in Stein 184).

Peale follows Enlightenment scientists, such as the Swedish botanist Carl Linnaeus, in promoting hierarchical classification systems that order the chaos of nature, so the "Book of Nature" can be read by rational minds (Pratt 25). In a second 1799 lecture on natural history, Peale claims, "The world is a museum in which all men are destined to be employed and amused[,] . . . but it is only by order and system . . . that the great book of nature may be opened and studied, leaf by leaf, and a knowledge gained of the character which the great Creator has stamped on each being—without this, our desire would very soon be arrested by confusion and perplexity" (2: Part 1, 268).

It is important to note the distinction Peale draws between "the world" and "the great Book of Nature," since it highlights the extent to which Peale constructed Nature as the rational truth embedded in living environments, but only known when separated from them— "only by order and system." Peale's Museum claims to turn an "amusing" but "confusing" world into this ordered "Book of Nature." According to Peale's Enlightenment point of view, without scientists and artists like himself, without such a "Pallace" provided to the public, Nature's "Creator" and Nature's "contents" could not be known. Further, without the classificatory cabinets provided by "an Institute" of the Enlightenment such as Peale's, "the world" would be too chaotic and "jumbled" to achieve its full potential as "Nature" (the intelligible, rational order behind all things to be read for human enlightenment).

Nature as Social Harmony

In addition to a site of epistemological order, Peale saw his museum as one of social order through Nature (rational order divined from the

messy world). In the late fall of 1796, during a time of heightened tensions, rival Indian societies of the Northwest and Southeast met at Peale's Museum. Those from the Northwest were former British allies who recently surrendered their resistance to American encroachment onto their lands, including the Delaware, Kickapoo, Ottawa, Shawnee, and Chippewa. Those of the Southeast had recently served in U.S. military efforts against tribal resistance in the Northwest, including the Choctaw, Chickasaw, Cherokee, and Creek. Peale describes the scene as one of great animosity between these groups, due to a history of colonial wars and shared ignorance "of the intention of the other" (qtd. in Sellers, *Good Chiefs* 10). The museum, far more than their respective homelands, offered them "for the first time . . . a scene calculated to inspire the most perfect harmony" (qtd. in Sellers 10). Peale continues: "After leaving the Museum they formed a treaty so far as their powers extended, and wishing the white people to be witnesses of the sincerity of their . . . intentions I supplied them with a room. . . . they heard a speech sent by General WASHINGTON, recommending peace.—Their orators spoke; and they departed Friends" (qtd. in Sellers 10).

In Peale's mind, his "Institute," more than the savage wilderness of the tribes' homes, offered a harmony conducive to peace. Just as fauna is better understood outside environments, so "harmony" is more possible in this Enlightenment institution. However, Peale's hope for peace through enlightened Nature excused him from asking hard ethical questions about aggressive levels of U.S. expansion, land theft, and forced Indian alliances leading to the tensions in the first place. In his mind, it is better if the "chaotic" environments of Indians become managed under the harmonizing, enlightened, natural gaze of American society, both through settlement on their lands and rational organization in Peale's Museum.

Peale's fellow Philadelphians shared his views, as expressed in a December 6, 1796, recollection of the event in the *Philadelphia Gazette*. Centering the event in "Peale's Museum," the paper reports that

the obstacles to a friendly intercourse were gradually removed, and the chiefs of the different tribes cautiously approached each other. . . . This uncommon, if not unprecedented, measure will afford un-

equivocal evidence of the advantages of a frequent intercourse of the Indian chiefs with the agents of the government and such other citizens as have the power as well as the inclination to promote the happiness of the savage state, by depriving it of some portion of its natural ferocity, and inspiring it with confidence in the purity of our motives. (Peale 2: Part 1, 163)

Peale's Museum, filled with the taxidermy of an entire continent and devoted to Nature, represents the antithesis of "the savage state"—which from an Enlightenment point of view is embedded in too much "natural ferocity" to be Nature. The above article reflects a compassionate desire for peace among the various tribes. During this time, several years before the Louisiana Purchase and several decades before the 1830 Indian Removal Act, Indian assimilation was fervently hoped for (in response to tensions among American land speculators, postrevolutionary settlers, and resistant Indian tribes). The article ends with a suggestion that "the only true art of civilization" is to "extinguish the sparks of animosity, and strengthen the cement of friendship" (163).

Despite being a fervent member of the American revolutionary generation and a supporter of American expansion (an inherent cause of Indian wars), Peale was generally an adamant opponent of war. Even without this example of Indian peace in his museum, he saw the organization of Nature in his museum as inherently promoting peace. Peale hoped he "might live long enough to see mankind more wise and not disgrace themselves [sic] below the brute Creation, even the most voracious of which did not kill their [sic] own species" (124). He felt his museum represented Nature saved from its savage state. He hoped to have summoned a "Nature" that would save all humans, not only tribes, from the "natural ferocity" of the *state of nature*. Just as, epistemologically, "Nature" needed to be separated from environments in order to be known, so, socially, "savage" humans needed to be separated from the wilderness in order to be saved from mutual destruction. Peale's Museum facilitated this separation, although he was perhaps unaware of the fact that this very separation of "Nature" from the "savage state" was wrapped up in justifying Indian displacement and war.

Further, Peale saw his museum as preserving more than (Enlightenment) Nature. He argued his museum was necessary to preserving the republic, just as his colleague Thomas Jefferson argued that freedom is deficient without an expansive physical environment, since Jefferson saw abundant nature as required for thousands of generations to cultivate his vision for agrarian independence. In Jefferson's *Notes on the State of Virginia*, for example, Britain is useful to Jefferson only as a past example to be improved upon. America is the future, both because of its uniquely "natural" conception of rights and its exceptionally "natural" continent on which those rights were to be cultivated. In terms of natural environment, Americans could leave their livestock to "the hands of nature," while in Europe animals suffered from "the poverty of the soil" (52). He celebrates America as "but a child of yesterday," contrasting it with a Britain whose "sun of . . . glory is fast descending to the horizon" (65–66). Jefferson implies that the War for Independence must go in the direction of American culture, lest history, culture, and philosophy should regress in the direction of a "descending" British sun—lest the generous gifts of philosophical Nature and geographical nature go ignored. Nature renders freedom from Britain possible, desirable, and obligatory.

Just as Jefferson employs "Nature" in the service of illustrating American exceptionalism over, and independence from, Britain, so Peale sees his museum as a temple to American independence—politically, scientifically, and culturally. In a December 1786 letter to John Beale Bordley, Peale states, "It is to be lamented that too many rare & valuable [scientific phenomena] have already been sent & [are] still (*daily*) sending (*to the old world*) to the other side of the Atlantic" (1: 461). Peale worried about a continuing colonial relationship with Britain, in an intellectual sense, wherein American scientists might end up mere collectors of materials for the civilized, enlightened minds of British scientists to interpret. Peale's Museum, then, represented an anticolonial act vis-à-vis Britain. He hoped the American mind would become the subject studying and inscribing meaning on chaotic environments, rendering American sites of civilization as the "Book of Nature." Otherwise, in comparison with Britain, America would be regarded as the savage state of nature, needing to be systematized and

divined in Europe. Thus, Peale saw the success of his museum as among the criteria determining whether or not the new republic would indeed become an enlightened civilization—as among the criteria for the completion of the American Revolution.

He sought funding based on the argument that his museum would cultivate civic virtue necessary in a vibrant republic (Ward and Hart 222). It seems that the white, male, upper-class leadership of the new republic understood this as well. When Peale formed his Board of Visitors in 1792 to guide the museum's success and further "to create a great national resource covering every aspect of natural history" (Sellers, *Good Chiefs* 58), Jefferson was elected the board's first president. Subscribers to the museum included James Madison, Alexander Hamilton, George Washington, eighteen senators, and nine congressional representatives (Sellers 71). Just as the "harmony" of Peale's Museum would four years later bring together warring Indian tribes, so in 1792 Jefferson and Hamilton found a rare common interest in Peale's Museum. Peale proudly saw this political harmony as a direct result of his ability to harness the deep harmony of Nature (on which he saw the republic based) within the walls of his museum.

Beyond the fact that this elite membership reflected a general political hope that access to Nature would ensure the health of the republic, Peale aggressively hoped to extend this access to all classes. He stressed that his goal was "to form such a school of useful knowledge, to diffuse its usefulness to every class of our country, to amuse and in the same moment to instruct the adult, as well as the youth of each sex and age" (Peale 3: 415). He charged twenty-five cents as an entrance fee, a price that he hoped would attract a broad audience without putting himself out of business (Sellers, *Mr. Peale's Museum* 146). Peale talks of "combining instruction with amusement, and harmonizing with every profession: for here, men of every religion or political sentiment, may meet and converse on the interesting objects that surround them, without jarring in their opinions; and where it will be often found that those, when viewed more closely, could harmonize much better, if known to each other" (3: 415). In this effort to balance "instruction with amusement," he insisted on the display of Nature for the sake of the moral uplift of an expanding democratic citizenry.

Nature Preserved

Peale's 1822 self-portrait *The Artist in His Museum* encompasses the core definitions of Nature active in his museum, including his epistemology of "Nature" as the rational source of the universe separate from environments, his belief in this constructed Nature as the paragon of social harmony, his hope for a naturally educated citizenry, and his goal of presenting (Enlightenment) Nature in order to promote republican virtues. In preparing this painting in 1821, Peale writes to his son Rembrandt (also a renowned portraitist): "I think it important that I should not only make it a lasting monument of my art as a Painter, but also that the design should be expressive[,] that I bring into view the beauties of Nature and art, the rise & progress of the Museum" (Stein 169).

In the painting, Peale appears as the kind, gentle, Enlightenment intellectual revealing the museum's "Book of Nature" by simply lifting the curtain. His position in the painting centers him as the creator of the museum and as a public servant welcoming the viewer into his creation. Peale's actual body touches nothing but the curtain, lifted in an inviting gesture. His other hand, nonthreatening and nonforceful, welcomes the viewer into a scene that he or she ultimately need not touch in order for it to enlighten and amaze. Into the very building in which Jefferson, Franklin, and Adams presented the "Declaration of Independence" to the Continental Congress for signing, Peale paints himself as deist minister of the early republic. After all, in that very building, he organized the physical and abundant nature necessary for manifesting the philosophical vision of the Declaration of Independence and the expansion of the new republic.

The materials illuminated behind Peale display the levels of enlightened progress that the republic had introduced to the "savage state." The viewer's right side of the painting represents a messier, less organized "nature" (Stein 184). Its tone is shadier than the left side. Some disorganized and random animal bones are strewn on the ground, awaiting context and meaning from Peale's hand. They sit in front of the curtain, not yet deserving of the Enlightenment stage. One glimpses the skeletal legs and ribcage of Peale's beloved mastodon, salvaged from the scattered darkness of a farmer's land in the early 1800s.

As in *The Exhumation* (in which Peale is on the right, directing the project), in *The Artist* Peale positions himself as the agent of knowledge. Nature is devoid of meaning until Peale adds intelligence and human labor to the chaos of wilderness. In *The Exhumation,* he and his project provide bright light in the midst of a dark storm. He *exhumes* "Nature" (the rational system behind material phenomena) from nature (wilderness, "jumbled" chaos, the premodern "savage state"). This act, like his museum, places the workers, the machines, and the soon-to-be-compartmentalized bones of the mastodon into the machine of his museum, and into a kind of harmony unknown to the continent prior to the republic. The product of that natural republican harmony can sit safely, where it can be known, in his museum.

The left side of *The Artist in His Museum* represents the exact opposite end of this process of cultivating wilderness into ordered, republican knowledge. Even though the light comes from behind Peale, from the direction of the mastodon, Peale's face is illuminated as he angles his welcoming body toward ordered Nature. The cabinets, glowing as much as Peale's face, reflect the success of his project to "bring into view a world in miniature." In the back one sees a well-dressed man explaining the cabinets of birds and mammals to his son, a future citizen. The man does not need Peale's help, as Peale has set a miniature world in motion that can now be understood by any rational mind.

Another man stands back from the cabinets, absorbing enlightenment from Nature. Above him one finds several framed Peale portraits, which circle the upper perimeter of the room. Peale, in his career, painted revolutionaries such as Samuel Adams and William Pitt, presidents such as Thomas Jefferson and George Washington, and leading scientists such as William Bartram and Benjamin Franklin (Miller and Ward, *New Perspectives* Figures 1–103). One cannot tell who is specifically featured in each of these paintings, but Peale's long-standing reputation as portraitist implies to his audience the metaphorical, political, and financial presence of these republican idols. He places them in his ordered Nature. They represent the end goal of his natural trajectory, which was to depict "the progress of the arts and sciences, from the savage state to the civilized man" (Peale 3: Part 3, 414). Placing these men in this room of natural law not only naturalizes the republic; it shows that the republic ensured the exhumation of "Nature" from

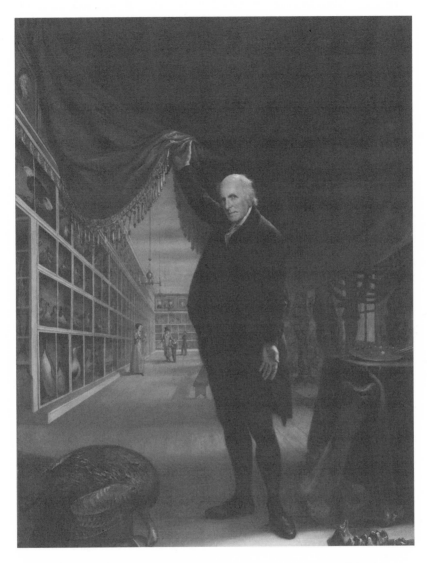

Charles Willson Peale, The Artist in His Museum, *1822. Courtesy of the Pennsylvania Academy of the Fine Arts, Philadelphia. Gift of Sarah Harrison (The Joseph Harrison, Jr., Collection).*

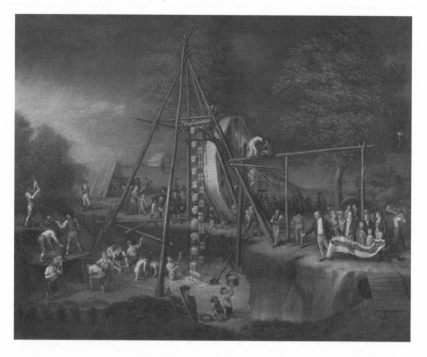

Charles Willson Peale, The Exhumation of the Mastodon, *1805–1808. The Maryland Historical Society, Baltimore.*

"natural ferocity." Of course, standing at the center of the transition from the mastodon on the right to the enlightening cabinets on the left, Peale positions himself as the scientific agent of this change and therefore as an agent of the success of the republic (Stein 203).[1]

In the bottom left corner of *The Artist in His Museum* sits a dead turkey, a symbolically American bird awaiting Peale's expert hand in taxidermy. It is removed from the "savage" chaos of its original habitat. It is removed from the wilderness and is about to become a window into Nature. The turkey is a work in progress toward illuminated classification. It therefore represents the continuing role of Peale and his museum in *preserving* the virtues of Nature. Everything in the museum is preserved, collected away from the chaos of "the world" that distracts the mind from knowledge of Nature.

Peale's Museum gives rich insight into the worldview, intellectual culture, and construction of "Nature" that influenced Catlin's forma-

tive years as artist and ethnographer. When Catlin walked into Peale's Museum in the early 1820s and joined the Philadelphia Academy of Art in 1824, when he learned from exhibits and mentors and thus began to associate with this prestigious community of artists and scientists, he walked into the assumption that Nature could be known, Nature could generate social harmony, and Nature could serve the republic most effectively when separated physically and abstracted intellectually from the organic conditions of wilderness environments and "savage" cultures. Catlin launched his ethnographic and artistic career in the midst of an epistemology claiming natural entities themselves could not be preserved in their original environments, where they decay and face chaos; natural entities become preserved as Nature only when rendered intelligible in systematized places such as Peale's Philadelphia Museum, in cabinets and on carefully delineated canvases—organized only by the most scientifically "enlightened" minds and artistically "unfettered" (to reincorporate Catlin's language) hands.

NINETEENTH-CENTURY PORTRAITURE

Portraiture: Depicting Status and Self

Peale's choice to call himself "The Artist" in his 1822 self-portrait, a painting depicting his role in scientific endeavors, illustrates the extent to which art was intertwined with scientific pursuits in the late-Enlightenment age. He set a professional mold of artist-scientist-curator-educator-entertainer for Catlin eventually to follow. Just as in the case of Peale's Museum, though, one can trace in portrait art the assumptions about art, knowledge, and Nature that led to Catlin's epiphany.

Many American portraitists of this time period viewed the interaction between artist and sitter quite studiously. The sitter-as-patron demanded that his or her subjectivity and inner, most natural self be captured on the two-dimensional canvas. Conversely, during the seventeenth and eighteenth centuries in aristocratic Europe, portraiture sought to depict the noble status of the sitter. As art historian, Joanna Woodall states, "Subordinate figures such as dogs, dwarfs, ser-

vants, jesters, and black attendants were strategically placed to render the sitter's elevated status and natural authority clearly apparent" (2). Moreover, recognizable emblems defined the sitter's place in the social order. The portrait was a thought-out organization of icons to present the imagery of authority to appear as if nonproduced—as if "only natural." Prior to the nineteenth century, the subjectivity of the sitter was far less essential in establishing the person's status.

Conversely, in the nineteenth-century United States, in a society perpetuating the ideology of an "Aristocracy of Virtue," many believed that merit and character more naturally justified social status than inheritance or bloodline. Woodall illustrates that this shift is equally reflective in portraiture: "Issues of realism and truth were central to nineteenth-century portraiture. In portraits of men, overt role-playing was abandoned in favor of attempts to reconcile a convincing characterization of the sitter's socio-political position with depiction of the essential inner quality which was considered to justify his privileged place" (5). Elite status became available to scientists, elected statesmen, and explorers, men who had (in theory) earned it through merit alone. Portraitists in this context believed that to convey the status of the sitter, one must no longer look to the arbitrary emblems of aristocracy. One must access and portray the "inner quality," the naturally meritorious and naturally aristocratic character that, nurtured through hard work, justly earned them fame and social status. Through painting them and capturing their inner essence, the painter might justly earn, in turn, naturally aristocratic status.

Although the portrait itself became an emblem of status indicating the sitter's wealth, the artist believed that the portrait could transcend arbitrary aristocratic status by showing a meritorious self behind the likeness. That is, unlike old portraiture's reliance on aristocratic emblems, this new portraiture perpetuated the belief that status had to be earned in a natural republic, based on natural talents and work ethic. In science as in art, in Peale's Museum as well as in the methods of new republican portraiture, one sees examples of early-nineteenth-century American assumptions that Nature is deeply known through its corresponding image—an image necessarily separate from conditions of production, be they environmental, cultural, economic, or social.

Portraiture: A Market within a Market Revolution

Portraiture placed many artists in a bind. On the one hand, it was a way to make a living as an artist during an age when an expanding middle class demanded to be immortalized and to have its new position declared on canvas. It was also a way of attaining status by painting members of the elite class. The ability to see the inner quality of great persons reflected something of the inner quality of the artist capable of seeing it. On the other hand, artists saw portraiture, in comparison with the more prestigious and inspiring "history painting," as grunt work. Many artists, such as Thomas Sulley (Groseclose 47) and Peale, along with Peale's sons Rembrandt and Raphaelle, found themselves looking to commissions from portraits as funding for greater projects in history painting. They envied painters like Benjamin West and John Trumbull for their ability to sell great history paintings (in addition to portraits) that preserved significant revolutionary moments.

By the 1820s, portraiture had begun to wear on many artists. The necessity of it in a republic with many sitters, but scant commissions for history paintings, generated an artistic world of many portraitists and miniaturists, yet few who could call themselves "artists" in the ideal sense of the word. Gilbert Stuart, a portraitist of the era, remarked cynically, "By-and-by, you will not by chance kick your foot against a dog kennel, but out will start a portrait painter" (qtd. in Groseclose 35). Many portraitists were "journeyman painters," who were forced to live an itinerant lifestyle of continually seeking new and modest commissions to make a living (Groseclose 37). Even Rembrandt Peale, a sought-out painter of elites such as Jefferson and Washington, worked at his father's museum in order to pursue history painting. He saw such work as "freeing an artist from total bondage to portraiture" (Sellers, *Mr. Peale's Museum* 221). Miniature painting, which paid less and often required more meticulous and monotonous work, was seen as the lowest a portraitist could go—where even the relationship to the sitter's "inner quality" found in portraiture was subsumed under the demand to create a flattering likeness quickly (Ward 109).

Despite portraiture's lack of prestige and opportunity—from the point of view of many artists—it nevertheless played an integral part

in justifying the social positions of an emerging middle class. Portraiture, itself a market, helped sanitize the material relations underlying the market revolution of the early 1800s, through elevating the status and public dignity of industrialists, expansionists, and planters (Groseclose 35).

In the years surrounding 1820, a surge in industry occurred as the republic intensified its exploitation of western resources, Indian lands, and slave labor. As the U.S. population exploded tenfold, particularly in urban centers such as New York, Boston, and Philadelphia, the economy shifted from household manufacturing to an industrial and factory-based system of production. According to economic historian Stuart Bruchey, the cotton textile industry expanded from 8,000 total spindles in 1807 to 80,000 spindles in 1811 to 191,000 spindles in 1820 to over a million spindles in 1831 (149). Bruchey also points out that "factory consumption of wool rose from 400,000 pounds in 1810 to 15 million in 1830" (149). Steam-powered factories and steamboats, the opening of the Erie Canal, along with the opening up of territories due to the increasing removal of Indian tribes from their homelands, introduced a level of production never before seen on this or perhaps any other continent (Sellers, *Market Revolution* 41–43; Steinberg, *Down to Earth* 55–59). According to environmental historian Benjamin Kline, "forests could be cut, fields cleared, dams built, mines worked with unprecedented speed. As a result, in less than a single lifetime an area of eastern North America larger than all Europe was deforested" (26). In addition to these resources, heightened demands on human labor were required to sustain these levels of production in the factories. As the lower classes, both men and women, faced brutal working conditions in physically dangerous and mentally dehumanizing factory conditions, new middle-class jobs for managers, clerks, and merchants opened up. Meanwhile, factory owners began to enter the elite classes.

Portraiture participated in this market revolution in three ways. First, as has been said, the expanding middle class both could afford a portrait and desired to memorialize their class transformation as a reflection of their natural talents, captured on canvas. A portrait, within an artistic profession that assumed the artist could access the "inner values" rather than the mere affectations of aristocracy, naturalized the middle-class sitter's social status as egalitarian and just. After all, status

coming from an assumed field of equal opportunity appeared as a status based on the individual's character, not on a system that privileged birthright, race, or gender.

Second, portraits became more like commodities—parts of a whole market system that helped to privilege sitters, many of whom drove and managed market production. What was aesthetically constructed as a qualitative work depicting the "inner quality" of an individual subject was also in this context a quantitative act. The portrait became one of many parts that elevated the status of a planter or merchant being painted. In concert with a sitter's exploitation of resources and workers (often including slaves), the portrait legitimated the sitter's position in society as both obtained through merit and as natural to that person's inner quality emerging from the canvas. The portrait, within the complex, interconnected economic system that enabled its commissioning and purpose, was as much a commodity as it was an aesthetic expression.

Finally, the portrait did far more than elevate the sitter. It more importantly offered a view of status and virtue that distracted the viewer's attention from the relations of production necessary for that status position. According to Peale historian David Ward, "Just as Peale's portraits of American patriots subsumed the Revolution and independence into a mythic construction of patriotic nationalism, his portraits of planters and merchants signified their attainment of status and class rather than the process of their social and economic mobility" (93). Were that "process" evident in the portraits, it might have revealed the realities behind egalitarian fantasies. It might have revealed the material injustices of extracting resources and exploiting labor underlying the falsely constructed "merit" of the sitters. What the artist or observer could see and make visually seen as "natural" about a sitter perpetuated (probably inadvertently) a political and economic regime at the expense of cultures, environments, and workers.

CATLIN AS PORTRAITIST

How does George Catlin, in his prewestern career, inherit these epistemological assumptions claiming that art enables access to Na-

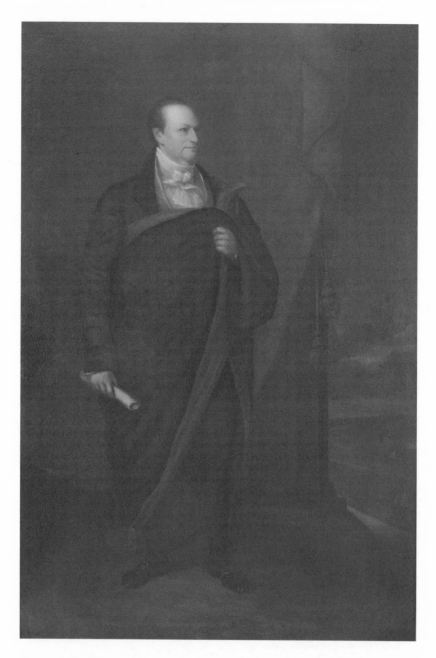

George Catlin, DeWitt Clinton, *1828. Photograph by Glenn Castellano. Courtesy of the Art Commission of the City of New York.*

ture? As a young Philadelphia artist in the early 1820s, he immersed himself in a cohort of artists, including Charles Willson Peale, Rembrandt Peale, and Thomas Sully, all whom influenced him (Hassrick 15). To what extent did Catlin's early career, in the midst of which he had his epiphany to preserve the "Nature" of Indian cultures and wilderness, reflect the ideological assumptions regarding scientific knowledge, artistic rendering, and preserved "Nature" of his time? To what extent did his early work adopt Peale's view that Nature must be separated from environments in order to be known and preserved? To what extent did his early work legitimate the industrial exploitation of labor, cultures, and environments validated in nineteenth-century portraiture?

In Philadelphia, Catlin displayed a particular talent with watercolor miniatures, but the pay was poor and the work tedious (Catlin, *Letters of George Catlin* 29). Catlin sought opportunities to escape this work. In 1824, within three short years of his arrival on the scene, he was admitted into the Pennsylvania Academy of Fine Arts. Based on his work as a miniaturist, this prestigious membership led him far beyond the limited profession (Dippie, *Contemporaries* 8). Although Peale's Academy of Fine Arts identified specifically with the state of Pennsylvania, it held a national and (Peale would argue) international reputation that attracted the country's leading artists and connoisseurs. Catlin's contact with Peale immersed him in a community of artists, a market for his portraits, and a belief in the ability of art to access and preserve Nature.

By 1826, Catlin's reputation extended to Boston, New York, and Baltimore (*Letters of George Catlin* 29). This reputation encouraged him to move to New York and try his hand in the highly regarded community of portraitists. In the same year, he became a member of New York's National Academy of Design. Institutionalized now as a prominent artist in the two most prestigious cities of American art, Catlin earned coveted commissions painting significant figures of the early republic.

Chief among these was Catlin's 1828 portrait of DeWitt Clinton, governor of New York, for whom he had previously painted multiple miniatures in 1824. In his portrayal of Clinton's face and expression, Catlin met the expectations of the age dictating that artists must con-

vey the subjective excellence of the sitter. Unlike Peale's self-portrait, where he kindly looks at the viewer as an invitation into his museum, Catlin's Governor Clinton thoughtfully looks away. Scrolled-up paper in hand, Clinton appears to have taken a break for the briefest of moments from serving the people of New York. He stands at a heightened position, from which he can physically as well as intellectually separate himself from his constituency. He is objective, not caught up in the storm below. The paper illustrates that he has a legal mind; he respects the laws that he must execute. Not merely an enforcer, he is a scholar of the responsibility with which he is charged.

But he is also a man of action in this picture, far more than some bookworm legalist. In the field of portraiture during this time, sitting versus standing represented a significant difference. The sitter's stance could often balance out his profession's reputation. Only in special cases would a portrait show the individual beyond head and shoulders (Jordanova 105). Illustrating Governor Clinton as standing rather than sitting, above the fray yet expressing deep involvement and care for it in his countenance, and in the middle of working on a document, renders him the ideal statesman, combining objective thought and compassionate action.

Donning a robe, and holding it in a stance reminiscent of Roman statues, Clinton evokes the analogy often made at the time between the Roman and U.S. republics. The emblems and stances alone do not inscribe this Romanesque statesmanship on the body of Clinton. Catlin manages to paint his face successfully enough to portray a "naturally" dignified individual, whose character "naturally" matches his position and authority. Moreover, the middle and upper classes of this time had well-honed rules of etiquette, including posture, speech, laughter, coughing, entering a room, even sighing (Ewers 48). Living in a time of such thoroughly defined codes of social order placed the portraitist in the position of needing to capture all of these elements, and make them appear as natural, uncontrived products of the sitter's subjectivity, in order to succeed. Catlin, a success during these years in highly competitive markets, clearly knew how to evoke social position and to make it seem perfectly natural to the sitter.

Catlin also knew how to dignify the specific accomplishments of a sitter. Staying with the Clinton portrait, one notices a curtain drawn

between the civilized, rational space of Clinton's room and the gathering storm featured outside. One sees a low sun over a waterway—quite likely the Erie Canal, given that Governor Clinton inaugurated the canal. The Erie Canal connected Albany and Lake Erie, and in turn Albany and New York City. This link connected the interior west of the Great Lakes, the Atlantic Ocean, and global markets beyond. With the steamboat already emerging as a revolution in transportation and with expanding global markets for American industry, the Erie Canal intensified the capacity to extract resources from western territories. In many ways the canal accelerated the "civilizing" of the West, which in turn threatened the cultural autonomy and ecological health of Indian lands across the continent. In the Clinton portrait, a single ship navigates the scene, as the governor looks out approvingly and contemplatively, thinking perhaps that the fruits of his labor have only begun to be harvested.

Clinton was aboard the first steamboat to travel on the canal from Buffalo to Albany, accompanied by none other than George Catlin (Haverstock 37). The portrait not only elevates and immortalizes the status of this man who opened the old Northwest; it naturalizes the relationships among republican government, capitalist expansion, and nature itself. This portrait exalts the ability of these relationships to civilize wilderness. More important, Catlin's painting skillfully shows Clinton and his achievements in colonizing the West as separate from their cultural and environmental consequences. Clinton comes across as a man empowered by and in power over nature, but in a sanitized way that liberates the future rather than oppresses the past or present.

Catlin knew his audience, his times, and the power of art to elevate. He was influenced by contemporary discourses regarding the ability of art to access the natural and to naturalize the institutional, while hiding the consequences of spreading such republican institutions across the continent. Although the respected artist William Dunlap called Catlin's portrait of Clinton "utterly incompetent . . . the worst full-length which the city of New York possesses (Truettner 14)," Catlin and Clinton understood that its value reached far beyond the aesthetic. Clinton displayed it in City Hall.

The two years following the Clinton portrait and leading up to Catlin's famous departure for St. Louis and points beyond have been

characterized as something of a love-hate relationship between Catlin and portraiture. After completion of his portrait, Clinton himself plugged Catlin into a network of military, political, and industrial leaders. These connections would eventually lead Catlin to William Clark and the military-economic ventures that carried him west. Dippie notes that "an officer at West Point that same year ordered a portrait at $40 and a group at $60, putting Catlin however modestly in the company of his friend Thomas Sully, who between 1815 and 1839 executed a series of portraits for the West Point Library at fees ranging from $300 to $600" (*Contemporaries* 8). But in 1828, Catlin became so frustrated with reactions to his work within the New York artist community that he resigned as member of the National Academy of Design.

Based on elite aesthetic criteria alone, Catlin's work could not succeed for long in New York. He needed something apart from aesthetic criteria for compelling a mass of patrons to notice. He needed an epiphany. Judging from the letters of Catlin's father, Putnam, George Catlin struggled in markets ranging from New York, Washington, and Richmond (Virginia), to Philadelphia in the years between 1828 and 1830. Putnam worries to his son, "I am so sorry to hear there are so many Artists before you in Washington but I imagine you have work in Richmond still. I am as anxious as ever to hear of your fame and success as an artist" (Catlin, *Letters of George Catlin* 46). Having abandoned his father's beloved profession of law to take a chance as a painter, Catlin might have felt significant pressure to succeed. After he moved to painting Indian cultures and landscapes, his old critic Dunlap commented further: "He has had an opportunity of studying the sons of the forest, and I doubt not that he has improved both as colorist and a draughtsman. He has no competitor among the Black Hawks and the White Eagles, and nothing to ruffle his mind in the shape of criticism" (qtd. in Truettner 14). Such scathing commentary must have fueled Catlin's belief that his contemporaries offered only the "disguises of art." Dippie declares, "Catlin's mixed reception in New York played a part in his decision to paint Indians, placing him beyond academic criticism, literally a non pareil" (*Contemporaries* 10).

Rejecting his critics and much of the market as phonies allowed Catlin to rethink the bases for what constituted great art—it must reach beyond "unnatural" disguises to access and, more important,

preserve an authentic Nature. Preservation would trump aesthetics; in fact it would define it. Moreover, preservation would define both his new approach to fame outside of overly harsh art critics and his approach to living an ethical life, having "flown to their rescue" and "having done them no harm" (Catlin, *Letters and Notes* 16; 2: 225).

CONCLUSION

Literary epiphanies often render an event or individual as inspired spontaneously, rather than as the product of complex relations, assumptions, and practices over time. Catlin's epiphany, when read in context, is in line with culturally rooted contemporary assumptions of the relationship between knowledge, art, and nature. His epiphany is enabled by, and in turn enables, early republican cultural and economic institutions; and it is a direct, personal response to frustrations with concrete experiences in the field of portraiture and a paternally ingrained desire for fame and fortune.

Like Peale's Enlightenment scientist, Catlin believed that the artist could access and communicate "Nature." Like Peale in his purpose behind the cabinets of dead, isolated, but preserved fauna in his museum, Catlin believed that the intrinsic character of Nature could best be preserved on the two-dimensional canvas. Nature, even beyond all "disguises" for Catlin, could be known visually. Its essential value lay not in organic relationships, but in "the production of a literal and graphic delineation of the living manners, customs, and character of an interesting race of people, who are rapidly passing away from the face of the earth[,] . . . thus snatching from a hasty oblivion what could be saved for the benefit of posterity, and perpetuating it, as a fair and just monument, to the memory of a truly lofty and noble race" (Catlin, *Letters and Notes* 3).

Catlin hoped to fight for "a literal and graphic delineation" of an actuality he saw as destined for "oblivion." He believed fervently that image preserves essence, or at least preserves the artistic and intellectual resources of "Nature" inscribed on these people's bodies and lands. Moreover, like Peale in his combined artistic, scientific, political, and financial ambitions for his museum, Catlin hoped he could be-

come both an ethical and entrepreneurial artist through recording a "race" facing "oblivion." He hoped this record would preserve an underlying concept of Nature that could not "vanish" once preserved.

Ethics in this context is limited to recording images for posterity, rather than resisting structures of exploitation in hopes of denying the supposed destiny of vanishing. This ideological background helps us understand, without judgment, the limitations of Catlin's ethical enterprise and the problematic essence of his epiphany—why would he do anything other than "record" if he felt that all that could be "rescued" was enlightened knowledge of "doomed" lifeways? Even further, why would he experience a deep sense of environmental loss if he felt, along with his contemporaries, that what was most valuable in these "obliterated" environments and cultures was a Nature that could be known only when rationally examined and preserved away from those environments?

Catlin could not have believed that painting could preserve nature for posterity without a preexisting epistemological tradition that defined Nature as something outside of environmental relations. He could not have had his epiphany without a view that Nature could be preserved through art. This epiphany stands on the shoulders of Peale's Enlightenment "Nature," of portraiture's confidence in conveying natural, "inner," subjective quality through image, and is influenced by an expanding republic whose officials saw value in painting's ability to naturalize social position and the civilizing of wilderness.

Still, one could convincingly argue that Catlin breaks free from the Enlightenment discourses of Peale and academic art, the epistemologies of art and nature, and the socioeconomic institutions of the 1820s when he swears off "civilization" and its "disguises" in his epiphany. One could argue that his epiphany is a break from rather than an extension of all of these ideologies. However, Catlin's epiphany questions only contemporary failures of art and science. It does not question the ability of science and art to preserve Nature in cabinets, paintings, and galleries. He does not question the underlying ability of civilized people to know Nature through extracted and iconographic parts of whole, complex environmental and cultural relations. If anything, his epiphany further entrenches him in the epistemology of Peale and the

ideologies of nineteenth-century portraiture. He feels that a lack of en-
lightened contact with the "character" of wilderness (a character that
the right artist can mine from wilderness itself) is solely responsible
for a lack of access to Nature. Catlin's critique of civilization reaffirms
and gives new life to the American nation's deepest beliefs in why Na-
ture is separate, how it can be known, and what is at stake in its preser-
vation—a visual record for the sake of enlightened knowledge, but not
necessarily for the sake of sustaining "uncivilized" cultural and envi-
ronmental relations.

Perhaps our presumed alienation from nature cannot be alleviated by scenery,
perhaps it requires a more profound engagement with the natural world as a
system in which we are enmeshed, which feeds us and takes our waste.
—Rebecca Solnit

In the years between 1830 and 1836, George Catlin traveled thousands
of miles beyond the frontier (that contact point, in his mind, between
wilderness and civilization) of the American West. Although he had
painted Indian leaders such as Red Jacket since 1826, and although he
had journeyed to northeastern Indian reservations to paint Seneca,
Mohegan, Oneida, and Tuscarora tribal leaders as early as 1828, it was
his five trips west of the St. Louis frontier that most defined his Indian
relations, portraits, and ethical concerns.

In 1830, Catlin traveled with General William Clark as far as Ft.
Leavenworth, just west of present-day Kansas City. This was the most
isolated post on the Missouri River, and here Catlin painted Delaware,
Iowa, Kickapoo, and Shawnee. Returning to St. Louis, he worked on
his canvases throughout 1831. In 1832, Catlin traversed 2,000 miles on
the steamboat *Yellow Stone*, going as far as Ft. Union, a newly con-
structed American Fur Company trading post near the current Mon-
tana–North Dakota border. From Ft. Union he trekked farther into the
interior to study and record the Blackfoot, Crow, Cree, Sioux, and
Mandan. In 1833, Catlin returned east to complete and display his
paintings in Cincinnati, Louisville (Kentucky), Pittsburgh, and New
Orleans. The next year he embarked west again. He traveled to Ft. Gib-
son (near present-day Tulsa, Oklahoma), this time with the U.S. Army
rather than the American Fur Company. Here he painted Comanche,
Kiowa, and Wichita. After witnessing 151 troops dying of a harsh fever,
Catlin negotiated the 540 miles back to St. Louis alone on a horse. Ar-
riving in Minnesota in 1835, he painted recently displaced Ojibwa,
Sauk, and Fox. He journeyed the following year to the Pipestone
Quarry in Minnesota, a ground so sacred that the Sauk begged him not
to visit. After this 1836 visit, Catlin returned to show his work, sell his

Gallery, and promote his ideas in eastern cities (Virginia Museum of Fine Arts).

The particular trip he took in 1832 stands out the most for him, since it brought him into intimate contact with lands as far west as the mouth of the Yellowstone River and with cultures less affected by frontier life, such as his beloved Mandan. Although his 1841 *Letters and Notes on the Manners, Customs, and Conditions of North American Indians* recalls and blends several different trips, it is this 2,000-mile journey that defines the ethos of the work.

> I started out in the year 1832, and penetrated the vast and pathless wilds which are familiarly denominated the great "Far West" of the North American Continent, with a light heart, inspired with an enthusiastic hope and reliance that I could meet and overcome all the hazards and privations of a life devoted to the production of a literal and graphic delineation of the living manners, customs, and character of an interesting race of people, who are rapidly passing away from the face of the earth. (3)

It is this trip that most fulfills Catlin's Philadelphia ambition to preserve Nature through a "literal and graphic delineation" of the West. In his book, Catlin describes visits to "forty-eight different tribes . . . containing in all 400,000 souls. I have brought home safe, and in good order, 310 portraits in oil, all painted in their native dress, and in their own wigwams; and also 200 other paintings in oil" plus various landscapes "containing in all over 3000" (4). This journey, eloquently depicted in his seminal text, most reflects the hope and labor of a "life devoted" to the preservation of nature and culture. Although dedicated mainly to a "literal and graphic delineation" rather than to the peoples and places themselves, Catlin sought to produce far more than a new, more dignifying kind of Indian imagery (3). He sought a social change in consciousness through recording and conveying those images.

Catlin himself claims to have experienced this change in consciousness while overlooking the mouth of the Teton River, along the Missouri River in 1832. He describes this place as "the very heart or nucleus of buffalo country" (249). Catlin begins depicting buffalo country, as one might expect, from his ethnographic desire to record vanishing

buffalo for posterity. He describes the migratory patterns of buffalo and how they "blacken the prairies" with their abundant numbers during running season (249). Dispelling myths about the origin of black circles found throughout the prairies, he confirms that they come from buffalo wallowing in the soil. He describes Indian hunting methods. Supplementing his descriptions are his ethnographic artwork—paintings of an Indian hunting in winter, wolves attacking a buffalo, and a buffalo bull in his wallow. At first, it seems that Catlin is well settled in his role as artist-observer, hoping simply to record nature before it disappears rather than advocating for its survival. He claims to have "had abundant opportunities of seeing this noble animal in all its phases—its habits of life, and every mode of its death" (249).

However, Catlin quickly moves from ethnography to ethics when he reports that buffalo death comes from a combination of "desperate" Sioux, who in his mind have come to do anything to support their need for whiskey, and the "indefatigable men" of the United States, from white fur traders to white consumers—including his readers. He points out that Americans are "always calling for every robe that can be stripped from these animals' backs" resulting in a "wild and shorn country" (249). He concludes: "It seems hard and cruel . . . that we civilized people with all the luxuries and comforts of the world about us, should be drawing from the backs of these useful animals the skins for our luxury[,] . . . the greater part of which are taken from animals that are killed expressly for the robe . . . and for each of which skins that Indians have received but a pint of whiskey!" (263).

As he complains about Indian poverty and buffalo loss, and as he questions the ethical complicity of fur companies and his readers, Catlin begins to imagine alternatives. He suggests that if Americans really need robes, they should invest "in machines for the manufacture of *woolen robes,* of equal and superior value and beauty; thereby encouraging the growers of wool, and the industrious manufacturer, rather than [consuming] . . . the last of the animals producing [buffalo robes]" (263). This is also the moment in which he imagines his famed "nation's Park," expanding from Mexico to Canada in "almost one entire plain of grass." (261). From individual consumer responsibility to industrial change to policy solutions, Catlin steps outside of his ethnographic role of recording and mourning the vanishing to hope that his

country can implement this plan. He sees it as a plan that can preserve buffalo and the lands on which they thrive, but even further, he hopes it can protect native peoples from dependence on corrupt frontier practices such as buffalo slaughter for whiskey. Not only does he cry out against the destruction of "this animal in all its pride and glory," but he extends this concern to "the peace and happiness (if not the actual existence) of the tribes of Indians who are joint tenants with them, in the occupancy of these vast and idle plains" (261).

Catlin continues the intellectual progression of this moment, moving not only from art to ethnography to ethics to politics but also to a new way of seeing the West. Not only does he define this space as the legitimate home of the buffalo and Indian "tenants"; not only does he call for new economic and political policy; he calls, as well, for a new vision of the West in the mind's eye of the American public. Further, he challenges the justifications for rejecting that vision.

While sitting in "the shade of a plum tree," in the "grass on a favorite bluff," Catlin imagines that he is suddenly transported above the earth. "I was lifted up upon an imaginary pair of wings, which easily raised and held me floating in the open air, from whence I could behold beneath me the Pacific and the Atlantic Oceans—the great cities of the East, and the mighty rivers" (258). In this reverie, he imagines that "the world turned gently around" (258). He sees the whole rotating earth from a fresh perspective, not caught up in the desperation of the Sioux or the greed of fur companies. He imagines himself above the fray and claims a moment of transcendent clarity. As he looks down from space at global regions across the round earth, far from the American West, he misses "the vast and vivid green, that is spread like a carpet over the Western wilds" (259). He realizes that the vast green home of the buffalo is unique only to this relatively small place in the world, to less than a 1,000-mile-long, continentwide space of his "nation's Park." This uniqueness, this rarity, saddens him. Focusing his gaze back on the western plains, his reverie includes buffalo being slaughtered and Indian cultures vanishing along with the buffalo, the species on which their economy relies (Krech 123–150; LaDuke 140–148). This vision of loss is somewhat to be expected, since Catlin made a habit of joining his contemporaries in predicting Indian disappearance.

But this moment is also exceptional. He rises not only above the ge-

ographic fray in this reverie; he manages an instant above the ideolog-
ical fray. "It may be that *power* is *right,* and voracity a *virtue;* and that
these people, and these noble animals, are *righteously* doomed to an
issue that *will* not be averted. It can be easily proved—we have a civi-
lized science that can easily do it, or anything else that may be required
to cover the iniquities of civilized man in catering for his unholy ap-
petites" (*Letters and Notes* 260). Catlin usually agrees with the conclusion
that Indians and buffalo and their rights to their lands are destined to
vanish. He frequently helps spread this "civilized science." But in this
moment he reveals this "civilized" science as merely a justification of
civilized "iniquities." Catlin expresses frustration that the iniquities of
cultural removal and environmental devastation are deemed *civil,* and
institutionalized into daily life to the point that no one challenges it.

From the point of view of his culture's mainstream ideologies, it
would be wrongheaded to question a scientifically predicted vanish-
ing, but Catlin questions "unholy appetites" and the "proofs" that le-
gitimate them anyway. He continues, with more than a light hint of
saddened sarcasm: "We have a mode of reasoning (I forget what it is
called) by which all this can be proved; and even more. The *word* and
the *system* are entirely of *civilized* origin: and latitude is admirably given
to them in proportion to the increase of the civilized wants" (260).
Catlin understands that the ideologies of his time ("the *word*") func-
tion to justify and maintain an economy that requires cultural and en-
vironmental exploitation ("the *system*"). So when he says above that
"*power* is *right,*" he says it ironically, showing that his society with all
of its civilized science and complex prosperity is really at its base a
"might makes right" society, where reason is twisted to explain away
the "iniquities" of "power." He sees that knowledge (science) is intrin-
sically tied to power, and in this moment he suggests that perhaps it
should not be.

> I say that *we* can prove such things [such as the proof that "*power*
> is *right*"], but an *Indian* cannot. It is a mode of reasoning unknown
> to him in his nature's simplicity, but admirably adapted to subserve
> the interests of the enlightened world, who are always their own
> judges, when dealing with the savage: and who, in the present re-

fined age, have many appetites that can only be lawfully indulged, by proving God's laws defective. (260)

While some readers (and this writer) might interpret as insulting the term "nature's simplicity" with reference to other human beings, what Catlin means in this context is that he has not found societies such as the Mandan guilty of such manipulations of truth to justify power. Catlin questions the logic of domination of his times, suggesting that it is fundamentally unfair that the people who will benefit from Indian vanishing also get to be the ones to determine that vanishing is naturally inevitable. He would like to discover a perspective for a future West, but not from the point of view of those exploiting it. He seeks a universal perspective from above, as he looks down imaginatively upon the earth and questions its ideologies. He seeks "the laws of nature" and "God's laws" in revealing to him some other way to live in the West, and some other way to let Indian societies and species flourish in the West.

Alas, Catlin's reverie comes to an end. He returns to earth both geographically and ideologically. After wondering if some new system could provide for buffalo health, "whose numbers would increase and supply [Indians] with food for ages and centuries to come" (262–263), he stops imagining. "But such is not to be the case—the buffalo's doom is sealed, and with their extinction must assuredly sink into real despair and starvation, the inhabitants of these vast plains, which afford for the Indians, no other possible means of subsistence; and they must at last fall a prey to wolves and buzzards, who will have no other bones to pick" (263). Although revealing an understanding of how social systems rely on intricate connections within ecological systems in this passage, Catlin returns to accepting his period's root ideology—it is carved into the plan of nature that these systems will vanish. He is left with ethnography as the closest thing to an ethical enterprise in this context of "extinction." But when he returns to ethnography and to artistically recording the vanishing, he returns to it with a hope that it might reveal the true nature of a place and summon the humane spirit of those who view the record. Perhaps this will lead to a market for woolen robes, perhaps to his massive park, but at least, in the worst-

case scenario, he can excuse himself as one who set out to herald rather than to trade. No matter what, from Catlin's perspective, he will leave his reader with a record of images. But he will also leave a record of what might be preserved beyond just his canvas, if everyone could inhabit his extraterrestrial and extra-ideological literary space. Despite this hope, his return to ideologies of vanishing makes it very difficult for him to realize these ethical dreams for himself and his society.

So how does one come to grasp this transcendent passage in the larger context of *Letters and Notes?* Even further, how does one come to understand the ideologies accepted in *Letters and Notes* in the larger, complicated context of George Catlin, justice for native peoples, and the ethics of Nature? Again, Catlin's Enlightenment roots inclined him to frame preservation as a process of classifying and portraying nature as separate from the environmental and cultural conditions of "savage wilderness." Moreover, as a competitive portraitist, Catlin's success at capturing the natural talents of his sitters further legitimized the social status of these elite Americans who dominated the continent. Thus, where previously I discuss the scientific and artistic assumptions driving Catlin's ambition to know and preserve the West, here I consider the implications that emerge when Catlin transports these assumptions to the West itself—as far west as the mouth of the Yellowstone. I consider the impact of these assumptions through three central questions: how do Catlin's artistic contributions to interlinking economic, political, and military institutions sanction his journey west? How does Catlin's intellectual confidence in preserving Nature through art cause him to gaze the West? How do these positions (both institutional and intellectual) implicate Catlin in the relations of power that dominated the West in his era, despite his sincerely held ethical intentions to the contrary?

SANCTIONS OF POWER

Catlin views himself as something of a loner on this venture. Just as he earlier asserted that he learned to paint in Philadelphia "without teacher or advisor," so in discussing his move west, he claims: "I opened my views to my friends and relations, but got not one advocate

or abettor. . . . I broke from them all,—from my wife and my aged parents,—myself my only advisor and protector" (3). Just as Catlin oversimplified his isolation from communities of art and science in Philadelphia, so his western journey (despite his expressed claims) benefits from the extensive support of key nineteenth-century military, political, and economic leaders and institutions.

Following Catlin's 1828 portrait of Governor DeWitt Clinton, Clinton introduced Catlin to a network of leaders in westward expansion. Clinton arranged for Catlin to paint several officers at West Point. Catlin even at one point discussed (with secretary of war General Peter B. Porter) the possibility of a professorship at West Point in order to escape portraiture and focus more on history painting (Truettner 13).

The painter's support from prominent men like Clinton and Porter was predicated, as evidenced in his portrait of Clinton, on his ability to exalt the expansion of the republic in portrait. Consider, for example, his 1828 portrait *West Point Parade*. This painting reveals no evidence of Catlin's heartfelt concern that Indians were "lost to the world . . . sunk into the earth;" we find no worries about "ploughshare turning the sod over their graves" here (16). Instead, Catlin portrays a budding and idyllic civilization blending gently and naturally into an undisturbed landscape. The landscape itself provides an empty canvas for his celebration of the ordered lines of civilization (on the left of the painting). Inscribed on this natural canvas is a pleasing parallel line of soldiers that would make the geometer Euclid jealous. The soldiers face down a storm sternly, and the space between neatly cut, colonial-style barracks and at-attention soldiers creates a barrier of light that diagonally bisects the painting through land, American flag, water, and sky—forming a boundary over which the storm shall not pass. Judging from the shadows, the sun is behind them, as are signs of gentle settlement. The colonial-style buildings also stand at attention. Loyal to the same Euclidean parallel, the buildings mark a distinct border or frontier between civilization and the wilderness beyond. The sun begins to hit the hills behind the perfectly lined buildings, as civilization, via West Point's protection, will soon continue its safe, sanitized march. In full dress and regalia, these soldiers perform a drill to the calm enjoyment of the well-dressed, upper-class male and female onlookers. Watching the wild storm retreat, these viewers take in the mechanized

George Catlin, West Point Parade, *ca. 1828. West Point Museum Art Collection. United States Military Academy, West Point, New York.*

military order with the same calmness with which they absorb the view of rolling hills, peaceful sailboats, and landscapes awaiting civilization beyond. The buildings, men, women, military prowess, and front lines of civilization represented in this depiction of West Point belong in and tame, rather than disturb, the natural setting. In fact, they properly order the setting, as did Peale's Museum and machinery in *The Exhumation of the Mastodon.* Catlin's connections through West Point, then, result from a visionary talent he had in portraying military-industrial expansion as a harmonizing force. Catlin was far from a solitary traveler when he set out in 1832; his West Point connections helped connect him to General William Clark and thus into his beloved West.

The West Point painting was not Catlin's final work before moving west. Between 1829 and 1830, he was commissioned to paint *Virginia Constitutional Convention.* Excited at the chance to produce a history painting reminiscent of John Trumbull's *Declaration of Independence,* Catlin eventually found the painting a laborious task, not unlike painting over 100 miniatures into one piece. The expectations of 101 delegate-

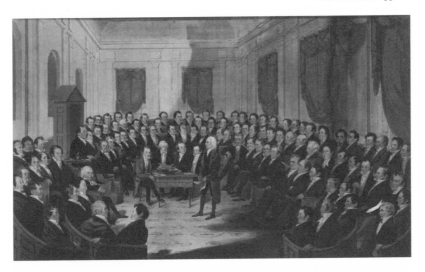

George Catlin, Virginia Constitutional Convention, *1830. Collection of the New-York Historical Society. Accession #1947.414.*

sitters—hopeful historical figures—coupled with Catlin's own distaste for meticulously detailing so many figures' faces, have caused historians to speculate that this painting was the "last straw" in Catlin's rejection of east-coast portraiture (Truettner 15; Dippie, *Contemporaries* 21–22).

He much preferred the work he found in St. Louis; even the portraits had a more romantic pull for him. His 1830 portrait of General William Clark perhaps best exemplifies the company in which Catlin found himself upon entering St. Louis. When he arrived there in 1830, something quite distinct from "vast and pathless wilds" lay ahead. Steamboats, traders, Indian delegations, French trappers, British companies, and American military expeditions had explored, extracted from, and settled the region for decades. To move far west enough to access "savage wilds" would require money, support, and guidance. Catlin historian and descendant Marjorie Catlin Roehm reports that "George was not idle a moment. He needed money, and to acquire it he was dependent on his paint brush and his pen. It is said that in whatever town he happened to be, regardless of the length of his stay, he would hang out his shingle: 'Portraits Painted.' He painted a por-

trait of General Clark, and received commissions from other impor-
tant personages in St. Louis" (Catlin, *Letters of George Catlin* 49).

In many ways, then, one could agree with Catlin's assessment that his
trip west was self-made, based on his ability to find his own work.
Nonetheless, his ability to portray and naturalize DeWitt Clinton as a
wise leader and paternal pioneer of westward expansion led to Catlin's
connections with West Point and beyond, including with Clark in St.
Louis (Truettner 16). In other words, Catlin needed to position himself
as beneficial to institutional power in order to become individually "self-
made" in this context. Even in *Letters and Notes*, Catlin discloses that "I
have been kindly supplied by the Commander-in-Chief of the Army and
the Secretary of War [presumably Porter], with letters to the com-
mander of every military post, and every Indian agent on the Western
Frontier, with instructions to render me all the facilities in their power,
which will be of great service to me in so arduous an undertaking" (16).

Catlin's ability to exalt the expansion of civilization in his West
Point and Clinton portraits allows him to paint Clark in the summer
of 1830, and in turn financially and logistically to initiate his mission
west. His illustration of Clark shares several characteristics with his
Clinton portrait. In both cases the sitter stands, with right arm
dropped in contact with an important document. In both cases the left
arm angles into a posture of authority and confidence. Both look seri-
ous and caring, though Clark has more of a businesslike expression
than the compassionate almost-smiling Clinton.

The relationship depicted with the world outside, however, is re-
versed in the two paintings. For Clinton, his specific indoor work is
hidden in the rolled-up scroll as he looks out at a landscape that he
made available to expanding civilization, in the form of the Erie Canal.
By contrast, Clark sits in a simple, unadorned room, shut off from the
outdoors with which he is so well associated. Also reciprocal to Clin-
ton, the painting reveals Clark's text. Below and to Clark's right, a book
of "Indian Treaties" rests against a globe (which Clark's explorations
have helped map for enlightened knowledge). As governor of the Mis-
souri Territory and superintendent of Indian Affairs, General Clark
likely drafted and negotiated these treaties. Moreover, the portrait
shows Clark, his pen resting momentarily in the ink, working on a
treaty from his 1830 diplomatic trip to Prairie du Chien—to negotiate

with Iowa (also known as Ioway) lands. This trip was a significant success for United States expansion, resulting in Sauk loss of territories in Illinois and their removal west (Catlin, *Letters of George Catlin* 47). Clark invited Catlin along to paint these councils. He took Catlin on yet another trip in 1830 to Cantonment Leavenworth, on the lower Missouri River, where the ethnographic artist painted Shawnee, Iowa, Sauk, Fox, and Kickapoo subjects. The context of Indian removal treaties was the political canvas on which he painted these portraits.

Thinking back on the Clinton portrait, Catlin worked to show the governor as more than a bookworm legalist by associating him with the landscape. In the Clark portrait, Catlin did the opposite. That is, he deemphasized Clark's association with exploration, showing him as an architect of diplomatic expansion. Catlin understood how to establish an individual's authority and how to balance that authority with meritorious action and thought. He paints his subjects, whether Clinton, West Point, or Clark, as entities who have earned their status.

Catlin looked to Clark as his mentor while in St. Louis. Catlin visited Clark's Indian Museum, as explorers hoping to travel into Indian Territory had to visit Clark's museum and obtain a pass from Clark. Catlin, of course, received far more than a pass; he received Clark's friendship, his guidance into the Indian territories, and an opportunity to paint Clark for posterity. The Clark portrait was perhaps Catlin's deepest offering of gratitude to Clark for opening the West to him (Dippie, *Contemporaries* 16). Clark introduced Catlin to Pierre Chouteau and leaders of the American Fur Company, who agreed to transport Catlin aboard the *Yellow Stone* in 1832—the source of his observations in *Letters and Notes*. Thus, Catlin's first efforts in 1832 toward the mouth of the Yellowstone River were predicated on a political network reaching far back into his career as a portraitist. Most important, this political network was predicated on Catlin's ability to legitimate status and expansion through portrait.

CATLIN'S GAZE

The position of power that Catlin enjoyed in voyaging west is also enabled by the "gaze" through which he viewed the cultures and en-

George Catlin, General William Clark, *1830. National Portrait Gallery, Smithsonian Institution, Washington, D.C.*

vironments of the West. From the day Catlin decided to paint, and certainly from the day he decided to paint Indians of the West, he sought a model of beauty on which to base his career. From his first epiphany, he assumed to know Indians from the position of the objective observer, innocently gazing upon pure nature and beauty. Recalling the

opening pages of *Letters and Notes,* "My mind was continually reaching for some branch or enterprise of the art, on which to devote a whole life-time of enthusiasm; when a delegation of some ten or fifteen noble and dignified-looking Indians, from the wilds of the 'Far West,' suddenly arrived in the city [Philadelphia], arrayed and equipped in all their classic beauty . . . exactly for the painter's palette!" (2). He sees them as objects of classic beauty, as noble, as wild, and therefore perfectly suited for his "palette." Perhaps, even more, his palette was perfectly suited for them. That is, he superimposes his expectations of beauty, nobility, and wildness on them. Immediately, his way of knowing them was limited to an aesthetic epistemology. They are a branch of art, a two-dimensional image waiting to jump onto his canvas. Catlin offers vivid descriptions of outer appearance, but no depiction of their ideas. "In silent and stoic dignity, these lords of the forest strutted about the city for a few days . . . attracting the gaze and admiration of all who beheld them" (2).

Before Catlin even stepped on the *Yellow Stone* that took him far west of St. Louis (and even farther from Philadelphia), he positions himself as the civilized artist-historian, knowing and appreciating Indian objects of exotic beauty. This position allows him, the urban admirer, to "gaze" at his subjects and know them without knowing how they gaze in return. This gaze permits his knowing them based on sight, because their intelligibility and value are from the outset defined in terms of visual essence—not unlike the cabinets and paintings of Peale's Museum.[1] Catlin wants to study Indians in order to study art in natural purity. "The country from which [the Indian] hails is unquestionably the best study or school for the arts in the world; such I am sure, from the models I have seen, is the wilderness of North America" (2). These men are first and foremost "models"; they are icons of Catlin's constructed ideal of wilderness. He does not need to talk with them, or interact with them subjectively, to know that he wants to devote his life to them; his gaze knows them through the look of them.

Cultural historian Mary Louise Pratt, in her book *Imperial Eyes,* claims that travel writing in the eighteenth and nineteenth centuries inadvertently claimed not-yet-colonized spaces as objects of imperial societies by first making them objects of knowledge. That is, travel writing by natural historians transformed the homelands of non-

European peoples into the "natural" *phenomena* of undiscovered enlightened knowledge, rather than recognizing those spaces as, in themselves, long-standing sites of complex knowledge *production* (i.e., the homes of "other" cultures). The natural historian of this age, in Pratt's view, occupied "a seat of power behind the invisible, innocent speaking 'I'" (61). Pratt argues that this seemingly innocent "I" (a self of scientific curiosity seemingly formed through the innocuous pursuit of knowledge, not empire) is, ironically, an "imperial eye." She says the natural historian's "imperial eyes passively look out and possess" (7).

Does Catlin's gaze participate in colonial power? Does he "possess" the West through "imperial eyes"? These are complex questions, especially given Catlin's strong and sincere critiques of the treatment of Indians: "Their rights invaded, their morals corrupted, their lands wrested from them, their customs changed, and therefore lost to the world; and they at last sunk into the earth, and the ploughshare turning the sod over their graves, and I have flown to their rescue" (16).

How could someone like Catlin represent colonial interests when he so intentionally sets out to "rescue" peoples losing their lands and customs? Pratt claims that natural historians, on a global level and not unlike Catlin, frequently saw themselves as members of an "anti-conquest." She discusses how, from the point of view of these scientists combing the globe for knowledge, "natural history is not transformation in the least. That is, as it understands itself, it undertakes to do nothing in or to the world" (33). Unlike war, slavery, and the extraction of resources, natural historians felt that their work transformed and extracted nothing, and therefore represented a contrast, and even an act of resistance to nonscientific colonial ventures. Catlin's words reflect this hope to resist. Pratt, however, sees the ultimate aftermaths of this position of anticonquest differently. She suggests that these anticonquerors are "advance scouts for capitalist 'improvement' to encode what they encounter as 'unimproved' and, in keeping with the terms of the anti-conquest, as *disponible*, available for improvement" (61).

In analyzing the knowledge produced by Catlin's gaze, we must ask if Catlin (with his dominant social position, his scientifically empowered gaze, *and* his sincerely ethical intentions to "rescue") exemplifies Pratt's claim. Namely, does Catlin perpetuate the anticonquest of Pratt's scientific travel writers? Does he study non-colonized spaces

as unknown "natural" objects rather than engaging with them as cultural and environmental relations? Does he "encode" precolonized environments for conquest by rendering them "available for improvement"?

In 1832, Catlin arrived at Fort Union, at the mouth of the Yellowstone River. Transported as a guest of the American Fur Company, aboard the *Yellow Stone* for its maiden voyage, Catlin found himself in the midst of a clear effort to weaken Indian claims to the land and to settle the area for trade. Although this was the first steamboat into this region, Catlin was not alone in moving west. Euro-Americans had already populated much of the West by the early 1830s. As recently as 1790, in the decade of Catlin's birth, most of the 3,900,000 (total) Americans lived within 50 miles of the Atlantic Ocean. By 1840, shortly after Catlin's journey, 4,500,000 Americans had crossed far beyond the Mississippi (Zinn 125). With such massive settlement, Euro-Americans claimed that Indian "extinction was inevitable" and that existing Indian cultures stood in the way of white settlement and progress (Zinn 132). Indians, it was concluded, needed to be removed—preferably through treaty, ultimately through force. Yet Catlin both disagreed with the brutality of Indian removal and criticized weaknesses in the very notion of "civilized community" that fueled the brutality (Dippie, *Green Fields* 46).

Indeed, Catlin dearly wished he could halt the violent treatment of Indians. He deliberately separated his intentions from those of this expansionist and imperialist regime. As briefly mentioned in the "Introduction" to *Catlin's Lament,* he positioned himself as the artist and as "the humble biographer or historian, who goes amongst them from a different motive, [who] *may* come out of their country with his hands and his conscience clean, and himself an anomaly, a white man dealing with Indians, and meting out justice to them; which I hope it may be my good province to do with my pen and my brush . . . having done them no harm" (*Letters and Notes* 2: 225). Catlin's position and gaze allow him to construct himself as a rational individual innocently observing Indians from the rarified regions of the future—as Pratt would say, an anticonquestor. As their "historian," he dearly hopes to separate his intentions from the political and economic exploits that place him in their midst.

Nonetheless, Catlin's institutional and intellectual position, the way in which his gaze earns the confidence of "civilized man" to include him on this steamboat, reveals an unexamined assumption that contradicts his intentions. According to Patricia Nelson Limerick's *Legacy of Conquest,* "Catlin traveled as the guest of the American Fur Company; in contemporary terms, the company would have been the corporate sponsor of Catlin's arts project" (182–183). Limerick also points out that the American Fur Company led the global trade for buffalo robes, which in many ways pushed the extensive slaughter of buffalo (the basis of Plains Indian economies and environments) that Catlin so lamented. The steamboat, Catlin's beloved *Yellow Stone,* was in fact "the steamboat that would make possible the increased export of the buffalo trade" (183). As his ship arrives at Ft. Leavenworth in 1832, Catlin remembers, "Our approach . . . under the continued roar of cannon for half an hour, and the shrill yells of the half-affrighted savages who lined the shores, presented a scene of the most thrilling and picturesque appearance" (*Letters and Notes* 14). The "savages" are again understood from the basis of the assumption that they must first be known visually, as objects denied subjectivity and abstracted as wild contrasts to the cutting edge of civilized technology that carries him to this place. From Catlin's description, one pictures the Indians partly afraid of, partly in awe of, his entrance into their territory. Catlin is on the front lines of Manifest Destiny in this scene, bringing with the newfangled steamboat a rapidly expanding American civilization. Although he approaches aboard a steamboat with cannons, he assumes that he can reject the position of political power that places him there, and simply know things.

Catlin assumes that the pursuit of "natural" knowledge and "natural" beauty places him in an ethically innocent relationship with the West. For example, shortly after arriving on shore, he remarks that he is so "surrounded by living models of such elegance and beauty, that [he feels] an unceasing excitement of a much higher order—the certainty that I am drawing knowledge from the true source" (15). First, *he* is surrounded in this picture; he centers himself as the nucleus of the interaction—as the gazing agent of knowledge. Second, he characterizes the Indians (here and elsewhere) as "models of elegance and beauty" in a way that connects their physical being to nature, and in

turn nature to truth. They are not subjects, in the way that Catlin certainly is as first-person narrator; they are objects that allow the civilized gaze contact with "knowledge from the true source." Of course, as we know from Peale's methodology, the truest of "true sources" is the "Nature" that Catlin hopes to preserve on canvas for enlightenment knowledge—a Nature based on the abstracted images of these peoples and landscapes.

Letters and Notes is ambitious. Catlin sets out to catalog every western tribe with intimate detail, to share this catalog with American audiences, and to argue for a more humane treatment of Indians. This endeavor requires a reputation of trust within Indian cultures, as well as a reputation for authenticity among his Euro-American readers. Without trust among the Indians, he would not be able to penetrate the depths of their ceremonies, their hunting practices, or their tepees, nor could he convince tribal leaders to sit patiently through meticulous portraits. Without trust among Euro-Americans, he would not be able to establish legitimate access to the "true source" of life among Indians west of the frontier. Therefore, for Catlin to succeed in his goals, both American and Indian audiences (as well as Catlin himself) cannot regard his "eyes" as "imperial."

But Catlin employs "imperial eyes" when he takes full advantage of his artistic, epistemological, political, economic, and military privilege in order to pursue knowledge. For example, in 1832 when his portraits gain him currency as a medicine man among the Mandan, he recorded:

> They looked upon me as some strange and unaccountable being. They pronounced me the greatest *medicine-man* in the world; for they said I had made living beings—they said they could see their chiefs alive, in two places—those that I had made were a *little* alive— they could see their eyes move—could see them smile and laugh, and that if they could laugh they could certainly speak, if they should try, and they must therefore have *some life* in them. (107)

Medicine, according to Catlin, meant mystery, or that which was unaccountable in daily reality to the Mandan. He held that the Mandan felt his painting had the power to perpetuate life. Shortly after drawing

his first portraits in this village, Catlin reports that "they commenst a mournful and doleful chaunt," claiming that he was a "most dangerous man . . . that I was to take a part of the existence of those whom I painted, and carry it home with me amongst the white people, and that when they died they would never sleep quiet in their graves" (108). Although it may not be "true" that the figures of Catlin's paintings live, Catlin neglected to respect the power that he exerted when he set out to know, to paint, and to make visible and preserve "for centuries yet to come, the living monuments of a noble race" (16). Given the unexamined ideologies that he inherited, why would he see this Indian ontology as true? After all, the "truth" that Catlin's privileged position empowers him to pursue ethically sanctions him to neglect the wishes of his hosts. Their concern that "they would never sleep quiet in their graves" comes from a less legitimate truth, a less legitimate form of knowledge concerning the aftermaths of a painting. In an age of vanishing, Catlin felt he owed it to them to portray them more than to listen to them.

One finds a stronger instance of imperial eyes when Catlin, in viewing a series of Mandan religious ceremonies, wanted to obtain some essential religious artifacts to add to his collection. The Mandan refused his wish. "I abandoned all thoughts of obtaining anything, except what I have done by the *medicine* operation of my pencil, which was applied to everything, and even upon that they looked with decided distrust and apprehension, as a sort of theft or sacrilege" (164). Not only does he ignore the wishes of his hosts, not only does he fail to respect their beliefs when they say a painting takes life away from the model, but, more important, he does not consider the dangerous connections that exist when one attempts to know and to make visible an "other" culture—to possess it within one's gaze.

One notices the power of his gaze and the contradictions of his anticonquest in a more vivid example, later on the same 1832 trip but this time among the Upper Missouri Sioux. Catlin insists on visiting the source of the sacred "red pipe stone," despite pleadings from the Sioux that he not violate their sacred place. The "red pipe stone" provided the materials out of which tribes across the region made their peace pipes. It was the central site of a central event for many Indian lifeways. Catlin felt it necessary to study the quarry, to extract some stone for

study and display, and to preserve the quarry through scientific collection and artistic portrayal. In *Letters and Notes* a group of Sioux confronts Catlin and his party, as Catlin travels to the quarry. He quotes the Sioux council member Te-o-kun-hko: "We know that no white man has ever been to the Pipe Stone Quarry, and our chiefs have often decided in council that no white man shall ever go to it" (Catlin 2: 172). Catlin puts his foot down: "We have heard that the Red Pipe Quarry was a great curiosity, we have started to go to it, and we will not be stopped" (2: 173).

Curiosity, in Catlin's mind and in mid-nineteenth-century America, is the central determinant of value in this situation. Protocols for cultural respect are defined in this moment by Catlin rather than the Sioux, in the name of discovery, art, and satisfying "curiosity" (perhaps the heart of the human sciences)—in the name of Catlin's gaze. The dangers of his passionate ethical hope to record the humanity and sophistication of a people before they disappear become clear. Does this make him *only* an enterprising ethnographer, not interested in improving the lives of real Indians? No, he felt he could temper the full brutality of imminent conquest if he could keep at least the visual reality of Indian life from vanishing. Moreover, as said, he sincerely hoped this record would inspire a more ethical consciousness among Americans benefiting from conquest. He hoped inspired readers might lobby for a combination of civil white/Indian settlement ("Christian" settlement, not greedy alcohol/fur trading) and a park for those Indians who did not want to participate in settlement. Among the Mandan, for example, Catlin "laments that the light of civilization, of agriculture and religion cannot be extended to them" (183). He wishes this "light of civilization" could be extended without his despised darkness of civilization, such as alcohol and fur trade, disease and war.

Returning to the Red Pipestone Quarry of the Sioux, one finds that Catlin's wish to facilitate a kinder "vanishing" of Indian lifeways *without* brutal conquest turns out to be a dangerous hope. The Indians, in a rare instance of dialogue and subjectivity within this text, command, "No white man has been to the red pipe and none shall go" (2: 173). To be the first seems only to contribute to Catlin's curiosity, adding further importance to his need to see, to paint, to know, and hence to preserve that which no other white man and no one else with his scientific

George Catlin, Pipestone Quarry, on the Coteau des Prairies, *1836–1837.*
Smithsonian American Art Museum, Washington, D.C., Gift of Mrs. Joseph
Harrison, Jr.

gaze has witnessed. Another Sioux, "a grim and black-visaged fellow,"
exclaims, "You see (holding a red pipe to the side of his naked arm)
that this pipe is a part of our flesh . . . if the white man take away a
piece of the red pipe stone, it is a hole made in our flesh, and the blood
will always run" (*Letters and Notes* 2: 173–174).

The pleading of the Indian is not heeded, because it comes from a
nonscientific worldview. It comes from the other side of imperial eyes
and therefore does not express legitimate knowledge. Within Catlin's
ideology, so long as he paints Indians against their will for the sake of
art and posterity, and so long as he takes the red pipestone for the sake
of ethnography and geology, these acts remain ethical choices in a
larger climate that accepts vanishing. Just as earlier he did not feel
compelled to cease painting in response to Indian concerns that his
paintings would take part of their lives, would render them immortal,
and would cause them to be restless in their graves, so in this case he
seems uncompelled by Indian beliefs that his theft of their stone would
cause their "blood" to "always run."

Moreover, his "eyes" possess, preserve, and make available to imperial eyes the most sacred of Indian lands. He lays the groundwork for the country to inherit parts of the continent still "unsettled." When one views Catlin's painting of the quarry, one notices his rendering of a precivilized landscape of Indians, with half-naked bodies blending into the rocks in terms of color and importance. Yes, Catlin shows them making use of the land, but in a way that does not truly transform the land from natural entities to "natural history." From Catlin's point of view, they need his "rescue" as their historian more than they need him to respect their view of the sacred. From a Pealean-Enlightenment point of view, they never transform the land into "Nature." Catlin serves his society's need for him to capture what is disappearing more than he serves the Indians' need to survive. Unintentionally, he sets up a relation where the most sacred piece of land (from a Sioux perspective) primarily serves enlightened knowledge (from the perspective of Catlin's gaze). It is hard to imagine how Catlin's work does not, then, lay the groundwork for economic and political quests in less sacred places once he legitimates this most sacred Sioux place as an instrument of civilization. Today, the rock is geologically termed catlinite.

Indeed, Catlin hopes that his gaze will have power, but only in a most positive way. He feels that observing deeply, painting meticulously, and studying scientifically each face, each ceremony, each hunt or battle, and each landscape will influence his society to settle more humanely. Catlin sincerely hopes and feels that he is "a white man dealing with Indians, and meting out justice to them; which I hope it to be my good province to do with my pen and my brush" (2: 225). He not only wishes that his brush sees, knows, and communicates but also that his brush ensures justice in its ability to show the Nature of Indian lands and cultures to Americans living east of the frontier. He further hopes that his paintings will grant visual immortality to what he considered a dying race.

Catlin considers the gaze of scientific curiosity to be a universal portal into clear perception and, eventually, knowledge. Yet, even though he understands that his paintings have power within Indian culture, and even though he hopes that his paintings will have power against American prejudices and "iniquities" toward Indians, he still sees his paintings as an innocent pursuit of art and knowledge without realiz-

ing that an objectifying position of power enables this production of knowledge. The way in which Catlin gazes at the West, then, fits Pratt's generalization that "only through a guilty act of conquest (invasion) can the innocent act of the anti-conquest (seeing) be carried out" (66).

"NATURE" AND ITS AFTERMATHS

In order to understand more completely how Catlin's role in anti-conquest inadvertently fueled conquest, we must look further into not just *how* he gazed but also *what* he saw through his gaze. In other words, it is important to understand the "Nature" that Catlin constructed in order to apprehend more completely the unintentional promotion of unjust power that resulted from it.

First and foremost, he saw natural, pristine scenes of Indians and landscapes. Before entering the frontier, Catlin expected beauty and wildness from both humanity and nature. Upon arrival on the frontier in 1832, he fulfills his expectations: "the upper part of the [Missouri] river, was, to my eye, like fairy-land . . . where the astonished herds of buffalos, of elks, and antelopes, and sneaking wolves, and mountain goats, were to be seen bounding up and down over the green fields" (18). The "bounding" animals and the "green fields" have obviously been left to themselves; otherwise, they would not be "astonished" upon his arrival. He sees the land as wilderness because it has existed apart from the control and manipulation of civilization.

Catlin's view of the land outside of civilization as "fairy-land," as animal abundance and "green fields," which industrialized society can only disrupt, conveys an affinity for romantic philosophies of nature. Catlin followed the tradition of the explorer-scientist-artist-naturalist-ethnographer set fifty years earlier by Peale's Philadelphia colleague William Bartram. Like Catlin, Bartram traveled deep into the frontier of his era to study, paint, and write about native peoples and wild nature. Bartram was not a museum scientist in the Peale tradition, nor was he devoted to ordering nature for enlightened knowledge of its essence like his father John Bartram. As Bartram biographer Thomas Slaughter puts it, William Bartram had "less confidence in sci-

ence, commerce, and man, and a greater love for unspoiled nature than John had" (185).

William Bartram, throughout the 1770s, sought a messier, more chaotic, more emotionally challenging relationship with a "wilder" nature that would at once reveal the frightening power and transcendent beauty of the natural world. His most famous trip was his 1776–1777 trek through the woods and swamps of the South, during which he painted groundbreaking images of natural phenomena engaged in dynamic interactions. His paintings challenged the view of his father and of Peale that flora and fauna are best known when isolated and organized in cabinets or in a managed garden. He argued that an emotional truth of nature could be felt through sublime experience—through blending the fear and awe of a powerful, beautiful world into one's scientific analysis of nature.

In 1791, Bartram published his accounts of these journeys, entitled *Travels through North & South Carolina, Georgia, East & West Florida, the Cherokee Country, the Extensive Territories of the Muscogulges or Creek Confederacy, and the Country of the Chactaws.* In this account, one finds both sides of the romantic sublime (fear-driven and beauty-driven awe). In one classic example, Bartram spends an evening in a lagoon (what his contemporaries would describe as mere swamp) watching millions of insects finish their short-lived existence (hours or days), an event he calls the "Ephemera." Of these dying insects in a lagoon, he says:

> The importance of the existence of these beautiful and delicately formed little creatures, whose frame and organization are equally wonderful, more delicate, and perhaps more complicated as those of the most perfect human being, is well worth a few moments of contemplation; I mean particularly when they appear in the fly state. And if we consider the very short period of that stage of existence, which we may reasonably suppose to be the only space of their life that admits of pleasure and enjoyment, what a lesson doth not it afford us of the vanity of our own pursuits! (88)

Bartram finds in nature a reminder of the "awful," fleeting essence of existence, humbling even to a human seeking to grasp all of nature

(87). This moment of witnessing millions of living beings go from pleasure to death gives him a "transient view of the glory of the Creator's works" (87). God is in the wilderness, a revolutionary idea when compared with Peale's view of wild nature as "jumbled." That is, nature, rightly understood for Bartram, is "more complicated" than what humans make of it from scientific study and thus needs to be experienced face-to-face with its power to determine life and death. To know nature requires one to live out the death and life of its inhabitants. On another night, Bartram sleeps among alligators, wood rats, and bears, suddenly aware of his own fleeting nature but also inspired by a primal knowledge of nature's potency (114–120). Bartram's *Travels,* written before Lewis and Clark's or Catlin's journals, established an icon for a new kind of scientist, a new kind of artist, a new kind of writer, and a new relationship with nature—what Catlin called "unrestrained and unfettered" (2). Catlin negotiates Bartram's romantic view with the Enlightenment view of Peale's Museum—seeking unfettered experience in wilderness to find its essence while extracting that essence for the sake of enlightening civilization in museums and galleries before the wilderness disappears.

John James Audubon, more of a contemporary of Catlin's than was Bartram, traced Catlin's journey to the mouth of the Yellowstone River a decade later, in 1843. In his *Missouri River Journals,* he accused Catlin of having embellished the cultural richness and natural beauty of the West. Of the Indian inhabitants, without taking into account what a decade of oppression can do to a people, Audubon states, "They appear to be very poor, and with much greater appetite than friend Catlin describes them to have," claiming that the Indians he encountered were "stupid, and very superstitious" (585). Upon meeting Mandan leaders whom Catlin praised, Audubon complains of their dirty appearance and says when "we shook hands with each of them, I felt a clamminess that rendered the ceremony most repulsive" (615). A month later in his journal, he repeats this criticism: "when and where Mr. Catlin saw these Indians as he has represented them, dressed in magnificent attire, with all sorts of extravagant accoutrements, is more than I can divine" (693). Of Catlin's "poetical" depictions of Mandan huts and villages, Audubon says, "Mr. Catlin has tried to render them so by placing them in regular rows, and all of the same size and form, which is by no

means the case" (615). Of Catlin's inspired representation of the green fields of the West, Audubon declares, "We have seen such remarkably handsome scenery, but nothing at all comparing with Catlin's descriptions; his book must, after all, be altogether a humbug. Poor devil! I pity him from the bottom of my soul" (628).

Despite Audubon's dislike for Catlin's romantic embellishments, he (perhaps inadvertently) shares with Catlin a romantic affinity for redefining the value of nature in the face of rapid economic growth. In his 1831 book *Ornithological Biography*, Audubon speaks of the passenger pigeon's beauty and abundance as enthusiastically as Catlin rendered his view of the plains. From his study of passenger pigeons, Audubon estimates that "we have One billion, one hundred and fifteen millions, one hundred and thirty-six thousand pigeons in one flock," exclaiming that "the air was literally filled with Pigeons; the light of noon-day was obscured as by an eclipse" (263–264). Beyond his enthusiasm for sheer abundance, he praises the beauty of their motion in a way that recalls Bartram and anticipates Catlin's western depictions: "during their evolutions, on such occasions, the dense mass which they form exhibits a beautiful appearance, as it changes its direction, now displaying a glistening sheet of azure, when the backs of the birds come simultaneously into view, and anon, suddenly presenting a mass of deep purple" (264).

Audubon's romantic view is most clearly expressed in his paintings of birds. Like William Bartram's descriptions, Audubon's paintings suggest that nature must be known in a manner that reaches beyond Enlightenment rationality to sublime levels of beauty and awe. Unlike the samples in Peale's cabinets, Audubon's depictions of birds show them vividly in motion, engaged (sometimes violently) with their surrounding environs and other species. As his historian William Souder states, Audubon "was as interested in how birds lived as he was in their appearance. . . . Audubon's paintings had begun to merge the beauty of the birds with their wildness in a way no previous naturalist had managed" (5). Audubon attempted to become a member of the Philadelphia Academy of Natural Sciences, of the Philadelphia tradition established by the likes of Charles Willson Peale, Thomas Jefferson, Benjamin Franklin, and John Bartram, but was told "ornithology . . . was about 'truth' and 'correct lines'" (15). Even Audubon's ap-

proach to taxidermy relied on the inventive use of wires to show stuffed animals as alive and active in their environment. He eventually returned to exploring the interior, in hopes of painting and recording every bird species in existence.

Audubon shared with Catlin not only a romantic sentiment and the desire to record vanishing species but also a critical perspective of the destruction of environments in the face of Euro-American settlement expansion. In discussing the abundance of passenger pigeons, he laments, "Here again, the tyrant of the creation, man, interferes, disrupting the harmony of this peaceful scene. As the young birds grow up, their enemies, armed with axes, reach the spot, to seize and destroy all they can. The trees are felled, and made to fall in such a way that the cutting of one causes the overthrow of another" (268). Even with the fabled evil wolf, in *Ornithological Biography*, Audubon regrets that "there seems to be a universal feeling of hostility among men against the Wolf" while pointing out that "few instances have occurred among us of any attack made by Wolves on man" (543–544). So, like Catlin, he hoped artistic renderings of scientific truth could challenge negative stereotypes, driving "hostility" toward the world outside of "civilized" America.

Also like Catlin, though, Audubon believes that his subjects of concern are vanishing and that they must be urgently known and preserved. For Audubon's subjects, this two-part belief leads him to justify killing countless numbers of passenger pigeons and other endangered species in order to know and share them for enlightened knowledge—even if his reasons for and representation of natural science challenged old Enlightenment views of separation. As Audubon scholar Duff Hart-Davis claims, "The rarer the bird, the more eagerly he pursued it, never apparently worrying that by killing it he might hasten the extinction of its kind" (40).

In addition to artist-scientist-explorers, Catlin's romantic view of nature was shared by contemporary writers such as Henry David Thoreau, Ralph Waldo Emerson, and James Fenimore Cooper, who worked tirelessly in essays and stories to discover and communicate that Nature had an intrinsic value misunderstood and unrealized by economic appraisals. In fact, Catlin states clearly his desire to be included among these thinkers. During his stay with the Mandan, he

records, "I find myself surrounded by subjects and scenes worthy the pens of Irving or Cooper . . . rich in legends and romances, which would require no aid of the imagination for a book or a picture" (*Letters and Notes* 80). While Catlin admired and was influenced by, for example, the *Leatherstocking Tales* of Cooper, he feels he has surpassed Cooper. Where Cooper's Natty Bumppo character in these tales adopts a wilderness lifestyle as he sadly watches the forests rapidly decline and the passenger pigeon fall toward extinction, Catlin need not tap into a fictional imagination to experience scenes and peoples reflecting Cooper's beloved wilderness. Catlin needs only to record his experience. In turn, if he records faithfully, his reader does not need fiction. The ethnographer can surpass the fiction writer and offer romantic adventure found in real, albeit threatened, landscapes. Like a true Romantic, connection with natural purity and the opportunity for a life of inspired adventure give the West a value for Catlin, a value surpassing the economic profits to be made from its timber, furs, minerals, and fields.

Other contemporaries of Catlin share this view that nature, beyond its material resources, offers something transformative for the human spirit. Emerson, in his 1836 essay "Nature," claims:

> The lover of nature is he whose inward and outward senses are truly adjusted to each other; who has retained the spirit of infancy even into the era of manhood. . . . In the woods, is perpetual youth. Within these plantations of God, a decorum and sanctity reign, a perennial festival is dressed, and the guest sees not how he should tire of them in a thousand years. In the woods, we return to reason and faith. (10)

The spirit of infancy, that spirit of approaching the world with open curiosity, rather than the preconceived notions of adulthood, allows humans to transcend daily trivialities and false opinions of the world and see "a perennial festival," an unchanging understanding of the essence of the universe. When in "the woods," when in nature's "plantations of God," Emerson says, "I become a transparent eyeball; I am nothing; I see all; the currents of the Universal Being circulate through me; I am part or particle of God" (10). Nature peels away the layers of

identity and social position; nature enables one to *be* in the world and to *see* the world as it is, not as we have decided to see it on a certain day or in a certain era. Emerson sheds his ego ("I am nothing"), and in so doing, the world opens up ("I see all"), a world with spiritual, not just economic, value. Once a person understands the world's value and understands oneself as an inseparable part of that world, not just a consumer or interpreter of it, one can become a "part or particle of God." In this way, the Emersonian romantic view of nature challenges the extractive logic of expansion that Catlin detested. At the same time, however, Emerson abstracts Nature from material environments for human enlightenment, in a similar manner as Peale, Jefferson, Audubon, and Catlin—further perpetuating the assumed separation and instrumental relationship between humans and environments. Emerson's Nature, although valued in new ways, is wrapped in an ideology of environmental disconnection. Even his beloved "woods" have primary value as a portal to something abstract and "transcendental" for humans.

Henry David Thoreau takes Emerson's romantic philosophies even further by attempting to live them out, both through his living experiments for two years at Emerson's Walden Pond and through his refusal to pay taxes to support a slavery-expanding Mexican War in the mid-1840s.[2] He sought ethical deliberateness. He sought a life based on an awareness of essential human needs, a process of simplifying one's life down to those needs, and in turn a life liberated from unnecessary and unjust labors—liberated from working excessively and desperately for things one does not need to become a fulfilled human being. "Let us first be as simple and well as Nature ourselves, dispel the clouds which hang over our own brows, and take up a little life into our pores" (Thoreau, *Walden* 63). Reflecting to some degree Emerson's transparent eyeball, Thoreau suggests that excessive needs spark modes of unnecessary thought and block an open experience with the world. He hopes that an understanding of how nonhuman nature comes to fulfillment will teach humans to simplify their own lives, let go of desperate thoughts, and finally allow "life into our pores." In this way, a person can experience a clarity of life approaching human enlightenment. For Thoreau, Nature is the vehicle to this life, because it offers the best model of life that functions deliberately and fulfills its needs

simply. As with Emerson, the woods have a romantic value, as a place for humans to transcend their society's view (not unlike Catlin's reverie of seeing his world from the skies)—whether for the sake of challenging the injustices of slavery and industrial society or for the sake of liberating the human soul from mere material life. As Thoreau states (in what has become one of the most quoted passages in American literature), "I went to the woods because I wished to live deliberately, to front only the essential facts of life and see if I could not learn what it had to teach, and not, when I came to die, discover that I had not lived" (72).

Both Emerson and Thoreau, then, implicitly and explicitly challenge popular methods of determining nature's value, such as through board feet of timber or rising prices of furs. They hold a romantic view that nature restores humans to their divine abilities. Nature models and inspires in humans ways of living parallel to the truths of the universe. Although these writers do not necessarily approach nature with the scientific discipline of Peale's enlightenment, they share the enlightenment view that "Nature" represents the essential meaning that can be divined from physical objects. They perpetuate the same view of environmental separation as Peale. But as romantics, these transcendentalists demand that humans become more than material consumers of objects. They insist that humans immerse their lives in the meaning behind universal objects—nature can be discovered through engagement with environmental entities and relationships, but "Nature" is ultimately beyond those material entities and relationships. Physical nature is the portal for human transcendence into abstract Nature.

Yet again, an ethical challenge in this era also participates in ideological assumptions about the extent to which Nature is an instrument for humans (this time a spiritual rather than an economic instrument). This view does challenge much of the logic of expansion in arguing that economic extraction is a limited and distracting way of using a separate nature, but it still confirms that Nature is something beyond environments and for human enlightenment. Historian Roderick Nash says of Thoreau, "Along with Catlin, Thoreau desired to prevent the extinction of Indians and wild animals, but he went beyond this to the position that protecting wilderness was ultimately important for the

preservation of civilization" (*Wilderness* 102). Nash points out that Thoreau's central interest was in preserving spaces that tamed both "wilderness" environments *and* the excesses of civilization. "The answer for Thoreau lay in a combination of the good inherent in wildness with the benefits of cultural refinement. An excess of either condition must be avoided. The vitality, heroism, and toughness that came with a wilderness condition had to be balanced by the delicacy, sensitivity, and 'intellectual and moral growth' characteristic of civilization" (92).

This romantic yet "middling position" (Nash, *Wilderness* 92) very much parallels Catlin's contemporary vision for a more humane frontier. Take, for example, Catlin's 1832 painting *River Bluffs, 1320 Miles above St. Louis,* painted during this trip on the *Yellow Stone.* On one hand, this is a classic picture of romantic anticonquest. One sees no evidence of future, past, or present U.S. land use. Nor does one see a suggestion that U.S. imperial land use would add value to the land. One sees an implicit critique of conquest. The glowing green landscape is fulfilled in itself; it has intrinsic value prior to its instrumental value. Compare this with Frances Palmer's *Across the Continent, Westward the Course of Empire Takes Its Way* and John Gast's *American Progress.* In those two paintings (each painted in the final years of Catlin's life), the linear movement of civilization appears to complete the unsettled spaces. Wilderness, in these paintings, awaits industry; it requires the removal of Indians and buffalo to be fulfilled. The land has value as future civilization, both paintings promoting a desired progression from Indian homeland, to logging and mining cornucopia, to farmed settlements, to happy cities. *American Progress* even shows the Goddess Liberty, in white flowing robes, floating across the soon-to-be-enlightened landscape. Catlin's *River Bluffs,* conversely, shows a solitary Indian content within a fulfilled wild landscape and within a homeland content with him.

The vital and beautiful green of *River Bluffs,* especially when contrasted with the work of Palmer and Gast, undercuts ideologies of conquest claiming that the land must be "transformed" in order to have value. Catlin does not in any way set out to celebrate transformation or resource extraction in this painting, as western painters who succeed him clearly do. However, this painting does "encode" the land as *disponible* (available) (Pratt 61). Catlin conveys a view of wilderness as

George Catlin, River Bluffs, 1320 Miles above St. Louis, *1832. Smithsonian
American Art Museum, Washington, D.C., Gift of Mrs. Joseph Harrison, Jr.*

precultural. It is "like fairy-land" because it is a land shaped by some
force beyond Catlin's imagination—separate from social forces that do
not appear to have any role in shaping it. His delineation of the land-
scape as naturally constructed, as from "the true source," renders im-
perial transformation of the landscape less of a cultural injustice, so
long as precise images of Indians in this landscape are preserved. That
is, if the flora and fauna of the land were shaped by nature, devoid of
the influence and human geography of Indian cultures, then settling
and transforming the land would not violate Indian ownership. In-
deed, the painting shows the landscape fulfilled by the Indian's pres-
ence, but it does not make an argument for Indian ownership—it does
not convey any history of Indian use or property rights. In Catlin's
painting, since Indian peoples are destined for obliteration from this
naturally generated "fairy-land," it is available for so-called improve-
ment, whether or not Catlin consciously agrees with this.

While Catlin expresses elsewhere a sincere desire to preserve "green fields," or at least to limit the ability of civilization to destroy them, in the "fairy-land" passage he resolves the tension between nature and civilization, from the point of view of civilization. In the same sentence in which he views the Upper Missouri shores as "fairy-land," he observes the animals "taking their own way, and using their own means to the greatest advantage possible, to leave the sight and sound of the puffing of our boat; which was, for the first time, saluting the green and wild shores of the Missouri with the din of mighty steam" (*Letters and Notes* 18). On one hand, he shows the animals leaving him and this technological mystery, this new medicine, for their life of bounding. One expects a critique of the project that brings Catlin to this place, since elsewhere he critiques expansionism. However, he reaffirms technology's power over nature. The ship that acts as the snake in this garden is simultaneously the respectful gardener, as it was "saluting" with its "mighty steam" the green and wild world that its presence threatens. In many ways this steamboat acts as a perfect metaphor for Catlin himself. In his mind, the consequences of his power do not contradict the ethical integrity of his project, so long as he "salutes" through his acts as their historian, his gaze at their beauty, and his preservation of their Nature.

Catlin often equates Indians, nature, land, and wilderness. "They are almost all entirely in a state of primitive wildness, and consequently are picturesque and handsome, almost beyond description" (23). He constructs Indians as if they are part of nature, as if they do not have history and culture, as if they have not shaped the land with technology and knowledge. He in part wants to inspire care for Indian cultures and western landscapes because he sees them as equally uncorrupted works of God. When he states, "I am an enthusiast for God's works as He left them," he is referring to both Indians and nature (162).

In less preservationist moments, when he expresses a desire to convert Indians to Christianity, he again equates them with the land and with nature. "His mind is a beautiful blank on which anything can be written if the proper means be taken" (184). Indians know only what God and nature have taught them, and their minds are "blank" (albeit a "beautiful blank"), because they have not replaced nature's laws with civilization's laws. On the same page as his fantasy that Indian minds

are blank slates, Catlin suggests the same thing regarding Indian land-scapes: "the land about their villages is of the best quality for plough-ing and grazing, and the water just as such would be desired" (184). Catlin neglects to see the land as *used* (cultivated), just as he refuses to see Indian minds as learned despite his admiration for their intricate customs—they seem more inspired by the wilderness than social fore-thought. He is unaware that this assumption consents to the most po-tent historical justification for the theft of lands that he hates to see stolen—such lands are seen as unused and thus unowned and as no-body's property.

Catlin sincerely desired to break stereotypes that Indians were vio-lent drunks and brutish, cultureless beasts. He set out, in part, to show the world that "a wild man may be endowed by his Maker with all the humane and noble traits that inhabit the heart of a tame man. . . . I feel bound to pronounce them, *by nature,* a kind and hospitable people [emphasis added]" (9). Catlin felt that when Americans saw drunk and violent Indians along the frontier, they saw the results of the corrup-tions of civilization, not the primary character of Indians as "en-dowed" by their "Maker." He hoped that his paintings and writings about tribes far beyond the frontier would reveal the inaccuracy of American prejudices toward Indians. However, at the heart of those stereotypes was the notion that Indians were less civilized and that a frontier existed in a way that starkly divided culture from nature, the civilized from the primitive. Catlin ultimately reaffirms the deepest premise of these stereotypes, asserting that Native Americans did not cultivate land, mind, or culture. He affirms that Indians are driven nat-urally rather than culturally.

The historians William Cronon and Richard White, with the advan-tage of 150 more years of historical hindsight than Catlin, have studied Indian impacts on the land and Indian systems of thought. In a con-versation entitled "Indians in the Land," they remark that the stereo-typical view of Indians as one with nature "makes [Indians] seem sim-ply like an animal species, and thus deprives them of culture. . . . It's a crude view of the environment, and it's a crude view of Indians" (20). In the late 1990s, anthropologist Shepard Krech III asserted, "Images of noble and ignoble indigenousness . . . are ultimately dehumanizing" (26). David Mazel, in an essay subtitled "George Catlin, the Death of

Wilderness, and the Birth of the National Subject," agrees: "Catlin's writing strikes me generally as familiar and right[,] . . . but his union of wild landscapes and 'wild' people strikes me as decidedly problematic, for the notion of rendering an entire people into a living tableau is clearly the product of an *imperialist* sensibility, while the idea of deploying such a 'specimen' to an admiring world just as clearly suggests a nationalist sensibility" (130). Catlin, in his honest attempt to subvert this crudeness by challenging Indian stereotypes, deeply reaffirms it. More than anything, his vision of how he serves Indians reveals the heart of this stereotype. He asserts, "A nation of Indians in their primitive condition, where there are no historians, have but a temporary historical existence . . . and their history, what can be certainly learned of it, may be written by a very small compass" (*Letters and Notes* 182).

Catlin wanted to preserve for future generations his knowledge and his impressions of the beauty of Indian cultures and lands. In a way, just as the Mandan (and later the Sioux) perceive in his powers the ability to make canvases live, to instill a partial immortality onto the canvas, Catlin himself believes that he can grant a kind of immortality to the natural essence of his Indian sitters. He offers the immortality of a moment in time when a culture is being "inevitably" and unalterably transformed. Moreover, and consistent with the mentoring he received in Peale's Museum, Catlin, as discussed earlier, hoped to preserve a Nature embodied in but separate—abstracted—from Indian lands and cultures, believing that the material lands and cultures themselves were "doomed to perish." Catlin believed deeply in his ethical mission. His record of Indian people was a serious endeavor. His belief that it could preserve Nature itself made the idea of the actual subjects vanishing more palatable.

The ultimate instance of Catlin's desire to preserve Indian nature and culture for enlightened gazing is perhaps best found in his famous vision of a national park. As quoted earlier, Catlin wants

> a *magnificent park,* where the world could see for ages to come, the native Indian in his classic attire, galloping his wild horse, his sinewy bow, and shield and lance, amid the fleeting herds of elks and buffaloes. What a thrilling specimen for America to preserve and hold up to the view of her refined citizens and the world, in fu-

ture ages! A *nation's Park!*, containing man and beast, in all the wild and freshness of their beauty! (261–262)

Historians praise Catlin as the intellectual founder of the national park concept (Nash, "American Invention" 728; Weber 19); he has justifiably been anthologized as a leading voice in environmental ethics owing to this call for a nonextractive, nonsettled space in the West. Catlin's idea is also significant because it justly includes Indians within its preservationist scheme (unlike actual national parks that sprung up later in the century). These are not just images on a canvas; his concept involved generations of real people continuing to wear "classic attire" and hunt on the land of their forebears. But they are still valued based on aesthetic criteria of "wild . . . freshness," and for the sake of American gazing and national identity. Nonetheless, it is still a component of conquest.

Catlin's vision of preserved Indian cultures seeks first and foremost to sanitize the impacts of western civilization. In his mind, art and science embody civilization at its best. He wants to preserve "the looks" of the people and the spectacle of their exotic lifestyle (which he saw as the underlying essence of Nature itself), but not the socioeconomic realities and autonomy of the cultures themselves. "Man and beast" have value as iconographic contrasts to the corruptions of civilization. Once his paintings and his imagined park preserve the image and customs of the natural human, once nature is captured to enlighten the gaze of Americans in perpetuity, then Catlin would feel ethically sanctioned to convert Indian cultures and economies, "if [Americans] would introduce the ploughshare and their prayers amongst these people, who are so far separated from the taints and contaminating views of the frontier, they would soon . . . be able to solve to the world the perplexing enigma, by presenting a nation of savages, civilized and Christianized (and consequently *saved*) in the heart of the American wilderness" (*Letters and Notes* 184). This is not quite a nation's park. One sees not a hope to perpetuate Indian lifeways, but a desire to utilize the savageness and wilderness embodied in Indian cultures as a way of critiquing and purifying the "contaminating" aspects of civilization. One also sees a confidence, on the level of Peale, in the ability of art and science to purify an expanding society. When Catlin says

"*saved*" in this passage, he sees artistic and scientific "delineation" as fundamental prerequisites to *saving* in the sense of social and Christian assimilation.

Catlin's *Letters and Notes,* ultimately, is not a treatise to preserve wilderness or Indian lands. He believes in the refinements of his sprawling American civilization: "I have always been, and still am, an advocate for missionary efforts amongst these people, but I never have had much faith in the success of any unless they could be made amongst the tribes in their primitive state" (2: 244). To Catlin, the primitive state promises to accentuate the virtues of civilization; it offers a blank slate on which civilization could (for the first time in what Catlin saw as an appalling history of civilization) develop without corruption.

Catlin despises the frontier, because the frontier brings out the worst elements of civilization. On the frontier, he exclaims, "Oh insatiable man, is thy avarice such! Wouldst thou tear the skin from the back of the last animal of this noble race, *and rob thy fellow-man of his meat, and for it give him poison!*" (2: 260). Catlin watched buffalo dwindle along with Indian populations, and he felt that Indians had become addicted to whiskey to the point where they were willing to kill buffalo not to survive but to serve markets that promised them more whiskey. He wanted to convert the Indians, but without such vices. Reciprocally, he wanted to decontaminate the colonial expansion of his civilization, not refute it. He wanted to keep it from frontier and, according to him, semicivilized habits that subverted "the simplest laws of Nature, and thus turn[ed] civilized man, with all his boasted virtues, back to worse than savage barbarism" (2: 224). The act of properly civilizing Indians would, for Catlin, allow the virtues of civilization to flourish. "Beaten into a sort of civilization, [frontier Indians] are very far from being what I would be glad to see them, and proud to call them, civilized by the aids and examples of good and moral people" (256). As the historian Patricia Nelson Limerick concludes, Catlin "handled Indian virtues like darts thrown to deflate American pretensions" (183).

Indian cultures and natural landscapes serve as conceptual resources and political metaphors for Catlin. He hopes to preserve the conceptual far more than the physical resources, as he has resigned

himself to physical obliteration and favors environmental and cultural "cultivation." Indians are a resource of political philosophy, allowing him to critique, reenvision, reaffirm, and naturalize the virtues of civilization. But to do this he must fight to preserve Nature and convince others to appreciate this Nature on his canvases, in his proposed park, and in more humane settlement practices. This philosophy causes him to affirm the Jacksonian imperialist project, albeit a cleaned-up, more sober version. While deeply held, and perhaps unexamined, this philosophy obstructs his genuine, ethical hope for a "conscience clean" in providing "justice" for native peoples and landscapes.

Most important, however, these lands and peoples are a resource of beauty for him, a resource for his gaze:

> The wilderness of our country [affords] models equal to those from which the Grecian sculptors transferred to the marble such inimitable grace and beauty; and I am now more confirmed in this opinion, since I have immersed myself in the midst of thousands and thousands of these knights of the forest; whose whole lives are lives of chivalry, and whose daily feats, with their naked limbs, might vie with those of the Grecian youths in the beautiful rivalry of the Olympic games. (15)

He is indeed an artist, and thus loves them for their beauty, feeling that he can preserve this beauty's truth and essence through his art. Within a larger desire to convert Indians to Christianity and their lands to agriculture, the notion that their preconverted "natural" beauty could be preserved through the gaze of art sanitizes his goals of conversion. Since Indians and the land find their essential value as picturesque scenery and enlightenment Nature, then certainly a painter can preserve this value. Catlin hopes that an enterprising painter can become a catalyst in inspiring a more ethical future for his country. However, as with Peale's enlightenment science, early portraiture, and the romantic philosophies of Emerson and Thoreau, separations dominate nineteenth-century science, art, and literature—even when devoted to renegotiating the benefits humans can extract from Nature. Artistic talent separates Catlin from the realities of his social position, scientific curiosity separates him from the consequences of his cultural

power, and preserved Nature separates him and his republic from ethical accountability regarding vanishing environments and cultures.

CONCLUSION

One final example from *Letters and Notes* epitomizes the tremendous extent to which Catlin's gaze into beauty, art, and knowledge is necessarily intertwined with imperial aftermaths in the West. In 1832, just as he began to venture beyond Ft. Leavenworth, Catlin shoots a buffalo on a now infamous buffalo hunt with two fellow frontiersmen. The buffalo does not die immediately, but stares at Catlin as it struggles to live. Instead of putting it out of its misery, Catlin "drew from my pocket my sketch-book, laid my gun across my lap, and commenced taking his likeness. He stood stiffened up, and swelling with awful vengeance, which was sublime for a picture" (26). Continuing this process, the artist "rode around him and sketched him in numerous attitudes, sometimes he would lie down, and then I would sketch him; then throw my cap at him, and rousing him on his legs, rally a new expression, and sketch him again" (26). Finally, he finished drawing this "buffalo bull, whom I then shot in the head and finished" (26).

Once again, in the same work in which Catlin criticizes the evils of the buffalo trade, his privileged search for art and knowledge causes him to reaffirm the underlying power-relationship of the trade. His art and his violence are intimately connected in this scene. Yet it is not violence to Catlin, because his gaze values the act as the pursuit of knowledge, beauty, and preservation of the vanishing rather than as an act of slaughter (it turns out that the buffalo is too old to have meat appetizing enough to eat).

These assumptions. including the previously discussed one of how one preserves "Nature" through gazing, enable tremendous power. That is, his privileged position as artist-scientist, his need to see in order to record suffering in the West, allows him to justify continuing the animal's suffering, *because the viewer's knowledge is at stake*. Truth trumps; vision trumps; preserved Nature trumps—all at the cost of an animal's pain; all at the cost of environmental relations. It justifies atrocities and actions not condoned elsewhere in the text (when buf-

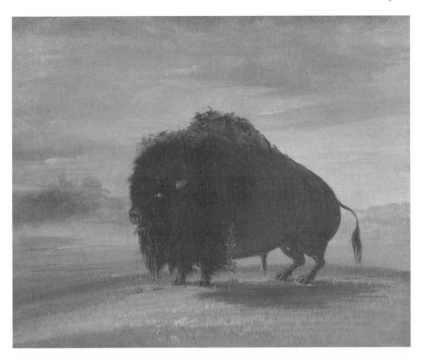

George Catlin, Wounded Buffalo, Strewing His Blood over the Prairies, *1832–1833. Smithsonian American Art Museum, Washington, D.C., Gift of Mrs. Joseph Harrison, Jr.*

falo are slaughtered for profit in the whiskey trade, for example) (260). Moreover, this power of knowledge is couched within the position that comes from his connection to a military, economic, and political regime in the West. The buffalo-market-driven *Yellow Stone* can transport him home; he has a gun, a safe fort to return to, and enough food not to need the buffalo's meat. Because of the self-effacing power of the pursuit of knowledge, Catlin's act of sketching the dying buffalo imposes as much power over his West as does his gunshot—and perhaps as much, ideologically, as does the buffalo trade. Catlin, though sincerely a believer in ethical anticonquest, in practice visits the West with and prepares it for "imperial eyes."

*In the Great American Indian novel, when it is finally written, all of the white
people will be Indians and all the Indians will be ghosts.*
—Sherman Alexie

There is a thin line between saving and lamenting the dying. For individuals losing loved ones, for communities struggling to maintain a sense of place, or for activists compromising a cause, it is difficult to identify the appropriate moment to let go of something one holds dear and to accept its exit from life as inevitable. In some cases there is no such appropriate moment; in some cases the assumption that loss lies on the horizon is false, an unjust mirage. Even more difficulty lies in trying to save something one has already recognized as dying, especially when the victim might not agree with the prognosis. Who is to decide when a lament for those "passing" is an accurate response to reality? Who is to decide when the fight to sustain should justly become the moment to memorialize? And who is to decide when social justice is to be branded unattainable, reduced from a movement to a monument? The move from saving to lamenting indeed crosses a thin line, carrying major consequences and implying tremendous power—the power to declare a death sentence to those facing perhaps only an apparent death. George Catlin walked such a line when he returned from his western journey in the mid-1830s.

Catlin assumed that his artistic ability and scientific focus would preserve the essence of Indian culture. His gaze into Indian cultures and environments sought to understand, depict, record, and "save" those images, in the belief that his images would save the fundamental value of the environmental relations, cultural practices, and individuals of the West. This meant preserving the aesthetic, philosophical, and political truths that Nature could offer civilization. Going back to his days in Peale's Museum, Catlin assumed that a two-dimensional representation of nature preserved the core value of natural relationships and cultural systems. These systems could be socioeconomically

and spiritually saved by "the ploughshare" and "prayers," and cultur-
ally and naturally saved by Catlin's pen, brush, and imagined park.
Thus, Catlin's "saving" carried power. It carried power, in his mind, to
preserve through the scientific and artistic practices of civilization that
which civilization threatened—"the grace and beauty," but not neces-
sarily the relationships, "of Nature" (Catlin, *Letters and Notes* 2).

Across the thin line from saving is lamenting. Catlin returned east
with Indian images, artifacts, and, eventually, individuals. Separated
from their complex histories, environments, and societies, such arti-
facts were shared with eastern audiences in hopes of generating com-
passion to "save" Indians from the brutalities of frontier life. From 1833
to 1839, in the eastern cities of Pittsburgh, Philadelphia, Washington
D.C., Boston, and New York, Catlin could bring his western icons on
stage—a public rescue. On this stage, he lamented the death of the or-
ganic relations from which these "rescued" icons came. He condemned
the lethal effects of frontier alcohol and fur trading on Indian life and
lands (Dippie, *Green Fields* 46). Waxing lyrical and in romantic dirges
he asked the audience to lament with him. Sometimes audiences in the
thousands shared Catlin's indignant sadness for the injustices exacted
upon native peoples and environments.

It seems logical to assume that this lament, this cry in the face of the
"inevitability" of injustice, would function in the service of saving.
That is, lamenting injustice rationally seems more in line with dissent-
ing against than consenting to injustice. It seems more a part of the
compassionate solution than of the brutal problem.

However, though Catlin sincerely mourned the death of cultures
and environments, and though he censured the injustices of white con-
tact with Indians, his lament works in the service of Jacksonian Indian
removal. When viewed in isolation, when artificially abstracted from
the historical and ideological conditions in which it functioned,
Catlin's lament indeed seems to contribute to his critique of Jackson-
ian-era practices. But when viewed within the multifaceted context
of Indian removal, and within the complex of laments found before
and during the height of his career, Catlin's lament joins a chorus of
voices preparing American audiences to accept themselves as imperi-
alists and to explain themselves as compassionate beneficiaries of a
now, though sadly, "empty" continent.

UNDERSTANDING CATLIN'S LAMENT

To be clear, Catlin's lament was far from a fantasy, as it responded to stubbornly concrete realities facing Indians. In 1820, a short decade before Catlin's six-year (on and off over five trips) journey into the West, 120,000 Indians lived west of the Mississippi (Thernstrom et al. 1045). By 1844, in the prime of Catlin's career performing Wild West shows in Europe, the trans-Mississippi Indian population had dropped to 30,000. By Catlin's death in 1872, due to a combination of smallpox and war, the entire American Indian population from coast to coast had tragically diminished to 12,534 (Thernstrom et al. 1045). By 1890, 95 percent of original pre-Columbian Indian numbers had been depleted (Moore 44).

As startling and disturbing as these numbers appear to the twenty-first century reader, Catlin found them even more shocking. He had a personal relationship with the deceased. These were not merely abstract numbers for George Catlin. He visited over forty distinct tribes in his six-year journey. He witnessed their religious and domestic lives, portrayed their leaders, ate meals for weeks at a time in their homes, conversed with them on their codes of social organization, and explored their sacred places.

Catlin particularly enjoyed the Mandan. He watched, albeit appalled, with intent to understand their O-Kee-Pa ceremony of four-day fasts and ascetic rituals; he persuaded their leaders to let him paint them. He interacted with them on an intimate and personal level, setting out to perceive and portray their deepest humanity. The dramatic and statistical population declines represented real people for Catlin, people who would eventually follow him around the world as part of his Gallery Unique, people whose stories he continued to tell with passion to global audiences. In 1837, a mere four years after his visit to the Mandan, smallpox devastated the tribe (Hight 120). We can only imagine how these statistics, disturbing in the twenty-first century, felt to Catlin in the 1830s.

Moreover, the controversial scientific thesis of species extinction was gaining ground throughout American society. Catlin himself saw the skeleton of Peale's Mastodon, a species quite extinct. According to Catlin scholar Robert Moore, "If animals could thrive and become ex-

tinct, so could races and cultures. These discoveries gave a sense of mission to [Catlin]—the urgent preservation through art and description of the lifeways of the original Americans, who were being overrun by Euro-American interlopers and seemed on the threshold of extinction" (22). American intellectual circles were beginning to complicate the biblical view that God had unalterably determined the character of life on earth.

Though Catlin accepted the theory that species could go extinct, he was horrified at the prospect that not only ancient species went extinct, but that species like the buffalo he had hunted and admired might go extinct in his lifetime. The lament expressed in *Letters and Notes* reflects this shock:

> It is truly a melancholy contemplation for the traveler of this country, to contemplate the period which is not too far distant, when the last of these noble animals [buffalo], at the hands of white and red men, will fall victim to their cruel and improvident rapacity; leaving these beautiful green fields, a vast and idle waste, unstocked and unpeopled for ages to come, until the bones of one and the traditions of the other will have vanished, and left scarce an intelligible trace behind. (256)

He does not sugarcoat the eradication of the buffalo. Further, he includes his usual "red" victims as victims of white frontier culture to the point that they too become complicit in the eradication of their own western environments. The corruption of the frontier causes them to destroy their own traditional places. So Catlin faced the "melancholy" disappearance of people he knew and buffalo he admired (and himself killed) within his lifetime. He lacked the emotional and distantly historical calm with which he could approach Peale's mastodon. Catlin felt a duty to transform his melancholy into a memorial—a lament. Thus, given that his gaze limited his access to the complex subjectivity and autonomy of Indian peoples, and given his knowledge of widespread death and disease, one can only expect Catlin to define native peoples as vanishing. From his social position's limited perspective, why would he not assume Indians were "lost to the world"? Why would he not perceive them as "at last sunk into the earth" (16)?

The riddle of Catlin's lament does not concern whether or not he should have logically seen Indian cultures as eradicated "to death," especially when one considers the limited perspective of his social position and the evidence presented to him in his times. The riddle concerns how his lament, understandable or not, operates in society as a further participant in ideologies of removal. The riddle lies in whether Catlin's lament functions as a further participant in cultural and environmental extinction. His construction of Indians and environments as "monuments" participates in a complex and highly visible ritual found throughout American society in the 1830s.

LAMENT AND REMOVAL, FROM JEFFERSON TO JACKSON

Since the early revolutionary era, half a century before Catlin's prime, white laments imposed assumptions of imminent death on living Indians and cultures.[1] According to Robert Berkhofer's *White Man's Indian*, "Disease and warfare decimated the aboriginal population in the face of White advance and gave rise by the time of the American Revolution to the idea of the vanishing race. If Whites regarded the Indian as a threat to life and morals when alive, they regarded him with nostalgia upon his demise—or when that threat was safely past" (29). This rhetoric of the "vanishing race" appeared in literature, theater, political philosophy, congressional hearings, educational curricula, public practices, government documents, and popular culture. The rhetoric became so widespread and such a deeply ingrained assumption in so many areas of American life that it becomes a discourse. By *discourse*, I mean the rhetoric became the fundamental language for premising, articulating, and practicing "truth." This truth served a society economically in need of removing Indians and ethically in need of an explanation for the injustices underlying its prosperity. The lament provided a discourse, a language, for this ideological explanation.

Jefferson's Lament for Logan

The basis for both the lament and policies of Indian removal emerged in the years following the American Revolution. This revo-

lution was partly fought for the "freedom" to expand into Indian lands beyond the 1763 "Proclamation Line," a region supposedly immune to colonial settlement based on an agreement between the British and Ottawa following the French and Indian War. Thomas Jefferson's classic *Notes on the State of Virginia*, written throughout the 1780s, offers a famous and early lament supporting such revolutionary demands on Indian lands.

Jefferson claims that Indians, as opposed to blacks, are naturally equal to whites. He finds, however, inferiority in Indian culture—in terms of his misguided conclusions on Indian impotence, poor treatment of women, and physical strength—but for Jefferson their inferiority stems from cultural traditions, not from their "racial" nature. Differences are "to be found, not in a difference of nature, but of circumstance[;] . . . nature is the same with them as with the whites" (58–59). Because he sees difference in culture rather than nature, Jefferson believed (in the 1780s) that Indians could become equal, civilized, republican citizens with whites, if and only if they abandoned the cultural practices that rendered them weak. Such practices include matrilineal societies of women dominating political decisions, farm labor, and other forms of economic production. Jefferson sees the existence of strong female roles as a marker of cultural inferiority and as unnatural, stating, "It is civilization alone which replaces women in the enjoyment of their natural equality" (57).[2]

In contrast, Jefferson's view of blacks as racially or biologically inferior causes him to promote the removal of blacks from society. Though he felt blacks deserved a natural right to emancipation (despite himself owning slaves), he argued, "When [the black] is freed, he is to be removed beyond the reach of mixture" (138). So Indians, to Jefferson in 1781, need not be removed so long as they could be civilized. In the context of this preremoval confidence in assimilation, Jefferson's lament for massacred Indians conveys sadness for a society never given the chance to assimilate into what he viewed as the superior Anglo-American society.

In a famous passage known as "Logan's Lament," Jefferson tells the disturbing story of an Indian named Logan whose entire family was murdered by whites in 1774. Lamenting the death of Logan's family, Jefferson empathizes with Logan's vengeful response. Logan, according to

Jefferson, gathered Indian forces from "Shawanese, Mingoes, and Delawares" to fight "a detachment of the Virginia militia" (60). Logan's army was defeated, and Jefferson repeats Logan's speech as an example of native eloquence and as an example of the injustices of Virginia governor Lord Dunmore's treatment of Indians. Jefferson quotes Logan:

> Such was my love for the whites, that my countrymen pointed as they passed, and said, 'Logan is the friend of the white men.' I had even thought to have lived with you, but for the injuries of one man. Colonel Cresap, the last spring, in cold blood, and unprovoked, murdered all the relations of Logan, not even sparing my women and children. There runs not a drop of my blood in the veins of any living creature. . . . Who is there to mourn for Logan?—Not one. (60–61)

There are several political dimensions to this lament, each revealing how Jefferson's constructions of Indian cultures ideologically serve his new republic. First, he is able to criticize Lord Dunmore (a Loyalist who embodied the old British America) and to position himself as representative of the new American intellect. Even though the military and political Revolutionary War had ended, Jefferson's *Notes* represents a cultural Declaration of Independence. This lament allows Jefferson to declare himself and his country independent from past British atrocities against Indians.

Second, Jefferson's lament limits the reader's imagination of the forces threatening Indian life and culture. A significant portion of the Continental Congress's complaint during the Revolution concerned Britain's enforcement of the Proclamation Line banning colonists from settling on lands granted by treaty to Indians. Jefferson and Washington were among the wealthiest and most extensive landholders in the colonies, with holdings stretching into Indian territories. Some of these holdings, for example, were questionably purchased from the Iroquois (Wallace, *Jefferson* 9). Jefferson's lament for Logan, though potentially sincere on an individual level, individualized the problem of injustices against Indians, focusing on the "cold blood" of Colonel Cresap rather than on economies of expansion that placed people like Cresap and Jefferson in Logan's midst. Individualizing the problem and

Americanizing the solution through this lament removes ethical accountability from the economic needs and political support for land theft driving Jefferson's and Washington's wealth. The lament distracts from the problem's source, from Jefferson's economic interests—citing him and the "natural" nation he constructs as the solution.

Now that Jefferson rhetorically positions himself as the solution and individual brutality as the problem; that Jefferson's lament distracts the reader from the material realities of economic practices underlying the American republic and destroying Indian cultures; and that Jefferson has "scientifically" established Indians as natural equals requiring cultural guidance, assimilation (forced abandonment of culture, including the abandonment of land and traditional environmental relations) becomes the just and logical destiny for Indians. The lament underlies this whole process.

This vision becomes even more complicated when Jefferson acquires the Louisiana Purchase in 1803. Upon its signing, he doubled the size of the republic, which in 1803 already included the lands between the old Proclamation Line and the Ohio River. Jefferson, not foreseeing the industrial and immigration revolutions to come, assumed it would take yeoman farmers many hundreds of generations to fill up the lands east of the Mississippi (Moore 18). He began to conceive of removing Indians to the West. At the time, it was intended as a humanitarian alternative to a false dichotomy dictating that Indians must choose between assimilation and extermination. Jefferson began losing confidence in assimilation. Removal seemed a way out of extermination, particularly when based on the belief that for centuries whites would not need the land onto which Indians would be removed. "Logan's Lament" blames the injustices of Indian relations on brutal British treatment, distracting from the political and economic institutions upon which Jefferson's personal wealth and vision for America were based. The lament empowered removal from its inception.

Cooper's Lament

In an 1825 address to Congress, President James Monroe reiterates Jefferson's sentiment in the form of an official but unaccepted legal proposal:

The removal of the tribes from the territory which they now in-
habit . . . would not only shield them from impending ruin, but
promote their welfare and happiness. Experience has clearly
demonstrated that in their present state it is impossible to incor-
porate them in such masses, in any form whatever, into our system.
It has also demonstrated with equal certainty that without a timely
anticipation of and provision against the dangers to which they are
exposed, under causes which it will be difficult, if not impossible
to control, their degradation and extermination will be inevitable.
(111–112)

In the time between Jefferson's vision and Monroe's proposal, as the
case for removal built toward the climax of the 1830 Indian Removal
Act, the lament gained prominence in the American consciousness. For
example, James Fenimore Cooper's *Leatherstocking Tales* reveal Cooper
as an American who values wilderness, empathizes with the lifestyles
and struggles of Indians, and bemoans the reckless march of civili-
zation. In Cooper's *Last of the Mohicans* (1824), the early republican
reader encountered such lyrical references to Indians as "a departed
race,— / Long vanished hence" (qtd. in Lepore 210).

Cooper's highly popular *Mohicans* questions America's destruction of
woodlands to support fuel-hungry and expanding cities, while Cooper's
1824 *The Pioneers* bewails the destruction of the passenger pigeon as ev-
idence of America's unjust theft of Indian land and destruction of envi-
ronments. Sharing Audubon's concerns, Cooper's main character, Natty
Bumppo, also known as "Leather-stocking," complains:

"This comes of settling a country!" [Bumppo] said—"here have I
known the pigeons to fly for forty long years, and, till you made your
clearings, there was nobody to skear or hurt them. I loved to see
them come into the woods, for they were company to a body; hurt-
ing nothing; being, as it was, as harmless as a garter-snake. But now
it gives me sore thoughts when I hear the frighty things whizzing
through the air, for I know it's only a motion to bring all the brats
in the village. Well! The Lord won't see the waste of his creaters for
nothing, and right will be done to the pigeons, as well as others, by-
and-by." (248)

In Cooper's fictional landscape, wildlife and wilderness earn a value different from their use as fuel for cities or sacrificial toys for sport and leisure. Bumppo watches as his neighbors from the city shoot indiscriminately into the sky without even aiming, causing multiple pigeons to rain down. "If a body has a craving for pigeon's flesh, why! It's made the same as all other creater's, for man's eating, but not to kill twenty and eat one" (249). He then shoots a single bird in order to illustrate that the bird's value lies in its use for individual sustenance, not for sport. In this early argument for conservation—"it's much better to kill only such as you want, without wasting" (250)—Cooper expresses the hope that society can learn nonwasteful uses of its resources.

Nevertheless, Cooper's hope is for a sustainable civilization ingrained into a continent wherein Indians have "long vanished hence." The lament does draw attention to the tragedies of removal during a time when easterners found it easier and easier to ignore the problem. But Cooper specifically draws attention to them as disappeared, not as dynamic and struggling members of a society's present or future. Disappeared, they are now a safe literary resource for improving the values of the new republic. As Jeffrey Mason points out, Cooper's novel *The Wept of Wishton Wish* "presents Metacomet [the Wampanoag Indian chief King Philip³ of the seventeenth-century New England war that bears his name] as an Indian avatar of George Washington . . . a visionary, a prophet who listens politely as an English ambassador makes his case, although privately intuiting the present and future truth about the inevitable dealings between red and white" (98). Like Jefferson's Logan, Cooper's Indian reflects "natural" virtues that represent a growing American exceptionalism—a society more natural than corrupt England and more civilized than "savage" Indians. Cooper's is an exceptional, American society that deserves to inherit the continent, so long as it corrects the remnant wastefulness of European influences found in the pigeon hunt.

Irving's Rearticulation of Jefferson

Jefferson's lament for Logan, during this time of growing literature on the lament, finds its way into Washington Irving's *Sketchbook*. Irving quoted Jefferson, and schoolchildren across the country memo-

rized Logan's Lament as standard curriculum (Wallace, *Jefferson* 1). The lament transcended literature to become cultural ritual, an institutionalized condemnation of brutal individuals in a way that distracts from the institutions enabling such brutalities.

Washington Irving, like Cooper, also rewrote the story of King Philip's War. Historical revisions of King Philip's War became prominent throughout the republic, contemporaneous with President Monroe's arguments for an official policy of Indian removal. When reading these revisions of King Philip's War, one must ask if such historical stories functioned as sincere and effective forms of cultural resistance to current political injustices, or if they, like Jefferson's lament for Logan, served as bedtime stories explaining to readers that Indians *had* to vanish.

"Philip of Pokanoket," Irving's version of the war, laments the destruction of the Wampanoags of Rhode Island in the 1670s. During the time in which this story is set, the New England Puritan population exploded. As many first-generation Puritans lived longer lives than expected, their second and third sons, plus a surge of English immigrants, spread across the New England landscape in search of land, wealth, and autonomy (Faragher 46). Such expansion required sacrifice of the New England environments, mainly in the form of farmland and timber (Steinberg, *Down to Earth* 31–35). In other words, the environments autonomously controlled and cultivated for centuries by the Wampanoags became necessary real estate in the minds of Pilgrims. This economic desire, this struggle for land and resources, led to King Philip's War.

The conflict killed 4,000 Algonquians and 2,000 colonists, and destroyed numerous towns. "The war marked the end of organized Indian resistance in New England" (Faragher 47). Philip, although in his own time villainized as a savage terror obstructing civilization's inevitable progress, receives empathy and an identity of heroism in the memorializing words of Washington Irving. Memory often reveals more about the memorializer's explanation of himself and society (to himself and society) than about the events recalled. The story "Philip of Pokanoket" is no exception.

From the beginning, Irving constructs Philip as a hero. He places him among the "remarkable characters that flourished in savage life"

(386), portraying him as a diamond in the rough of the savage wilderness. Philip is an example of the virtuous moral benefits that the new American civilization should, but fails to, extract from nature. In civilizations that do not benefit from the truths of nature, Irving finds that "the bold and peculiar traits of native character are refined away" (387). Without adopting native cultural practices and economies, he hopes civilization can benefit from the natural lessons found in Indians such as Philip. "The Indian . . . free from the restraints and refinements of polished life, and, in a great degree, a solitary and independent being, obeys the impulses of his own inclination or the dictates of his judgment; and thus the attributes of his nature, being freely indulged, grow singly great and striking" (387).

This primitivist valuation causes Irving to condemn anything threatening the perceived "primitive." He makes a radical statement during a time in which the stress on Indian lands to support expanding white populations dwarfs the pressures found in Puritan New England. "It is painful to perceive, even from these partial narratives, how the footsteps of civilization may be traced in the blood of the aborigines" (387). Irving's narrative of Philip's demise, then, traces one example of this bloody ground left for and by civilized footsteps.

One suspects that Irving's lament might lead to empathy and respect for all Indian peoples. That is, Irving offers a very human (neither a noble nor a brutal savage) portrait of Philip. He shows how, despite Philip's view that whites were "extending an influence baleful to savage life" (391), Philip was still able to live in peace with whites. Portraying an individual capable of negotiating injustice through diplomacy, Irving also praises Philip's "military genius and daring prowess[;] . . . we find him displaying a vigorous mind, a fertility of expedients, a contempt of suffering and hardship, and an unconquerable resolution, that command our sympathy and applause" (395–396). Irving openly disagrees with traditional interpretations of Philip, interpretations biased toward justifying the violently expansionist actions of Puritans. He argues, "Philip is reviled as a murderer and a traitor; without considering that he was a true born prince, gallantly fighting at the head of his subjects to avenge the wrongs of his family . . . and to deliver his native land from the oppression of the usurping strangers" (395).

At once, one finds several forms of dissent and resistance against

Anglo-European assumptions. Irving reconstructs Philip as *not* a murderer; his Philip is not a traitor against previous Puritan allies. Irving shifts blame to Puritan greed and "oppression." He redefines Philip as a freedom fighter, defending not only his culture but also "primitive" nature for the benefit of all humankind. The character Philip, fictionally re-created within a generation of the American Revolution and within three years of the War of 1812, is a "true born prince." He is not an arbitrary prince that one might find in "the restraints and refinements of polished life" in Europe. Philip gains his virtue—and thus reflects the essential aristocracy of virtue envisioned by Thomas Jefferson and John Adams—from nature itself. So on some levels, Irving's lament recognizes Indian intelligence and impeaches European destruction of nature, both in terms of natural habitats sustaining Indian culture and in terms of models of natural virtue offered by Indian individuals.

However, by focusing his critique on the British and his lament on Philip as an individual manifestation of nature's virtue, Irving's story morphs the essence of nature, and thus the essence of Indian cultures, into extractable resources for specifically American patriotic identities. According to literary scholar Jeffrey Mason, "Irving casts Philip as 'a patriot attached to his native soil . . . proud of heart, and with an untamable love of natural liberty,' fighting at the head of a band of freedom fighters, seeking against hope to 'deliver his native land from the oppression of usurping strangers'" (98). Ironically, this lament fuels the very patriotism that argues the continent is naturally fit for the expansion of the new republic. Again, the enemies are Europeans. They are British, not American. The geographic sites of injustice have long become "American" spaces, far removed from the threats of Indian responses to injustice.

The only authentic Americans in the story are, in essence but not in reality, Philip and the narrator himself—Washington Irving. First, Philip shows the revolutionary spirit in his fight to "throw off the yoke of [his] oppressors" (392). Second, Irving becomes the American who can sift through the corruptions of European civilization to find the true seeds of the American spirit in colonial history. It takes an American to recognize it. Thus in describing Philip's death, Irving explains, "With heroic qualities and bold achievements that would have graced

a civilized warrior, and have rendered him the theme of the poet and the historian, he lived a wanderer and a fugitive in his native land, and went down, like a lonely bark foundering amid darkness and tempest—without a pitying eye to weep his fall, or a friendly hand to record his struggle" (407). The United States offers this "pitying eye," absent among the colonial British. Americans can become this "pitying eye" as they read Irving cathartically, perhaps shedding some tears, perhaps internalizing a self that feels removed from responsibility for expanding economies and continuing atrocities. They can lament and condemn historical individuals, a powerfully cathartic distraction from their culture's practices.

Moreover, Irving is that "friendly hand." But this friendly hand records struggle as inevitably lost, as all "lonely" barks must fall. Indians, like trees, follow the law of nature and make way for "civilization." The moral of "Philip of Pokanoket" is that Indians who do not assimilate or make room for civilization through removal face extermination. Following extermination, the lament offers natural models of patriotism, of defending the republic. Lamenting native peoples and adopting natural aspects of the American continent *renders the Anglo-American patriot virtually native to the continent.* Anglo-Americans deserve the continent under this logic. It makes them neonatives.

Staging the Lament: Nineteenth-Century Theater and Indian Removal

Inscribing the American patriot onto the Indian histories of the continent can also be found in a highly popular form of the lament: the American theater. An abundance of literature and drama with Indian themes arose during the precise time of Indian removal, revealing the complex intersection of Indian plays and Indian removal.

Indian melodramas were among the most widespread forms of entertainment in the early stages of U.S. popular culture, especially in the 1820s, 1830s, and early 1840s. In the 1820s, over sixty such plays were written and performed (Gaul 21). One play alone, the Indian melodrama *Nick of the Woods*, filled New York's 3,000-seat Bowery Theater for three straight weeks (Mullen 81). During this same time, Indians faced war and removal. President Monroe sent delegations of Indians

throughout eastern cities so they could contemplate land cessions while witnessing the extent of American power, and so audiences could witness the beauty and sadness of fallen Indians while contemplating their own role in the continent's future. These delegations became a popular and profitable curiosity in early American popular culture. One could view the fictional Indian of the American stage and a delegation of "real" fallen Indians in the same night. It was this type of delegation during this exact time period that first inspired Catlin's epiphany to go West; it was such a delegation that led Catlin eventually to turn his lectures into the first Wild West shows with "real Indians" (Reddin 24).

Originally, over a decade before Monroe, these delegations intensified following the Jefferson-sanctioned Lewis and Clark journey, after which Jefferson invited Indians east to recognize their "Great Father" (the U.S. president) and to witness the nation's power (Wallace, *Jefferson* 220–226). In the 1820s, as Monroe shaped Indian removal into a viable proposal, Indian delegations served a new purpose beyond the trade relations Jefferson hoped to build with tribes accustomed to trading with British companies. According to Rosemarie Bank's "Staging the 'Native,'" "Delegates had been feted, entertained, outfitted, and gifted, stared at, painted, given medals, invited to teas, balls, and official receptions, and taken to visit museums, theaters, circuses, churches, military installations, farms, dignitaries, and civic organizations, all with the purpose, according to the President's formal reception speech of 4 February, of exposing them to the comforts and might of white society" (461). These delegations functioned for whites as a kind of Indian funeral march through a new American regime of truth. In other words, they marched through the cultural, political, military, and economic achievements, the "inevitable" transformation, that the eastern portions of the continent had enjoyed and that the western regions had better prepare to embrace. Shortly thereafter, Andrew Jackson drew up the policy for the Indian Removal Act, signed into law on May 28, 1830 (Wallace, *Long Bitter Trail* 128).

Indian plays reached the height of their popularity during this time. These plays, like the writings of Jefferson, Cooper, and Irving, implicitly asked audiences to face, explain, and ethically digest the eradication of Indian tribes. For example, the play *Carabasset* features a dying

tribe facing the rapacious English. The main character Carabasset ultimately jumps off of a cliff instead of surrendering to the English (Anderson 802).⁴ Assimilation is not an option for these Indians; it is vanish or remove. Removal seems humane when framed in comparison with Carabasset's forced suicide.

In 1836 the playwright Richard Emmonds opened *Tecumseh; or the Battle of the Thames*. Emmonds avoids portraying this chief as the stereotypical noble savage. In the play, Tecumseh cries over seeing the scalps of his children rather than expressing the clichéd stoic emotions. However, his and his people's deaths are inevitable. Upon this inevitable death, the ever-popular Goddess of Liberty descends from the clouds, gracing the advance, albeit tragic, of a better civilization.

The Goddess of Liberty icon made appearances throughout the history of American Manifest Destiny, most notably in the form of John Gast's painting *American Progress*. Gast's picture embodies the essence of Manifest Destiny. Though the railroad and the telegraph had yet to be developed and institutionalized in 1836, his painting features the effect of the Goddess Liberty (guiding the march of civilization in flowing robes while rolling telegraph lines) on the American nationalist psyche. The Indians and buffalo in the picture, often equated as emblems of a "vanishing" world, have only to run from the march of civilization. There is no violence in their vanishing from the picture and from their environments. They must move, for they cannot assimilate. The viewer is forced to contemplate if the laws the Goddess carries in her right hand, if the farming the settlers guarantee, and if the technologies and beauties of civilization promised in the picture could exist without the Indians leaving. The Goddess naturalizes and sanitizes exploitation and removal. She translates the American invasion of Indian territories into heavenly sanctioned civilization.

Returning to Emmonds's play, its ending with Liberty shows that the continent now embraces a better society. The wilderness will not turn the British in the story into savages, though they commit savage acts. It turns them into Americans, now sitting in the audience, now independent of Britain but still in touch with a potent combination of Liberty and Nature. The combination requires both removal and cultivation of "wild" elements from an otherwise perfectly "natural" continent.

This perfect nature is found in the constructed bodies of Indians, as argued in Alexander Macomb's play *Pontiac*. In the play, Indians are by nature good and moral, but the British turn them from noble to brutal savages. The play represents a fall from grace (Anderson 802). Pontiac is stabbed when he does not assimilate. Once again, even though it is tragic, the only alternative to assimilation is death. According to theater historian and critic Marilyn Anderson, the play *Pontiac* "accepts as a matter of political reality that the white man will continue to expand Westward and that the Indian must adjust to an agricultural rather than a hunting economy" (802). Thus this "political reality," saturating the eastern stage, limited the political imagination from conceptualizing any options beyond removal, framed by a constructed dichotomy of assimilate or exterminate. Such a limited political imagination frees the white viewer from rethinking his or her practices of consumption and his or her culture's practices of economic expansion and cultural removal.

It is no surprise, then, that the most popular Indian plays had the theme of "last" in their titles.[5] In addition to Cooper's novel *The Last of the Mohicans*, one finds plays such as *The Last of the Serpent Tribe*, *The Last of the Noridgaewocks*, *The Last of the Shkikellemus* (Bird 22). Chief among these plays was the most popular American play of its time, a play that defined the genre of Indian plays and the identity of the American theater in this era: John Augustus Stone's 1829 play *Metamora: The Last of the Wampanoags*. Edwin Forrest, America's most prolific actor of the nineteenth century, produced and starred in *Metamora*.

Like Cooper's work *The Wept of Wishton Wish* and Irving's "Philip of Pokanoket," Stone and Forrest's *Metamora* revises the history of King Philip's War. *Metamora* blends its plot of King Philip's War with a romantic story. Individualism, as with other aspects of the Indian drama, becomes a significant distraction from the workings of institutions, and the romantic story provides emotional connections with the individuals in the story. The romantic plot is based on Oceana, the daughter of an English colonial leader named Mordaunt. Mordaunt finds himself in the New World because he assassinated an English king (it is, after all, a melodrama). He arranges a marriage for his daughter that will exonerate him, through family connection, from the responsibil-

ities and consequences of that murder. Oceana does not want to marry Fitzarnold, the man her father picked for her. Already one senses deep levels of Jacksonian-era American exceptionalism embedded in the story. The audience is reminded of the corruptions of Europe, with its regicides, forced arranged marriages, and political privileges based on blood not virtue.

Meanwhile, the audience can identify with the continent as their native home through the character Metamora (King Philip). Metamora, played by Forrest and dominating in his strong physical presence, enters the story representing nature as colonial idol and mentor. He is depicted on a "craggy rock . . . as if a sculpture's hand had carved him there . . . the grandest model of a mighty man" (Stone 10). He represents another side of American exceptionalism, the access to natural truth and beauty that only an escape from European corruption could provide. When Oceana describes him as a heathen, her friend Walter answers, "True, Oceana, but his worship though untaught and rude flows from his heart, and Heaven alone must judge of it" (12). Nature, not his society or family or history, gives Metamora unfiltered virtue. But this nature is not for Metamora any longer. Puritan society encroaches on his land; he is asked to assimilate. He responds, "The red man's heart is on the hills where his father's shafts have flown in the chase . . . the war and the chase are the red man's brother and sister" (11).

The audience is presented with a dilemma: on the one hand, the nature and wilderness of the continent must be exploited to translate European corruption into American exceptionalism. On the other hand, Metamora, a character for whom the audience cares and laments, is part of that wilderness, of the rock and landscape. His "heart is on the hills." Again, one finds an example of Indian drama that limits the audience's political imagination. He will not assimilate; he must be exterminated. Removal, within this limited dichotomy, suddenly sounds humanitarian—like the guillotine in a time of drawing and quartering. Cultural assumptions in popular culture often construct the boundaries of what political arguments can even be conceptualized. The prospect of rethinking American entitlement in order to rethink old European patterns of resource extraction, luxury, and land use is less imaginable within the dichotomous assumptions constructed by the theater. When just choices are limited, consent to injustice comes easier.

The play explains how to escape this predicament of assimilate or exterminate. At the end of the play, as King Philip's war becomes a hopeless cause, Metamora hides. His talents can no longer serve his people or the culture and environment of his ancestors—"the silent spots where your kindred repose . . . the bright lakes which the Great Spirit gave you when the sun first blazed with the fires of his touch" (36). While Metamora hides, Oceana tries to escape her arranged fiancé, Fitzarnold, who attempts to rape Oceana in front of her parent's tomb. Miraculously, Metamora has been hiding in the tomb and emerges to save Oceana. He uses his talents to protect "pure," white womanhood while his people are dying at the hands of her father. Furthermore, the way Stone and Forrest construct Metamora's rescue is significant. Rather than keeping a man (Fitzarnold) from violently attacking Oceana, Metamora is described as protecting "purity" abstractly more than Oceana specifically. During a time when women were kept in domestic spheres, could not vote, and could not own property based on arguments that their purity required them in the home, Metamora's talents work more in the service of this patriarchal American nationalism than for his own people.[6] He concludes that "we are destroyed—not vanquished; we are no more, yet we are forever" (38). "Forever" how? They are "forever" in the American connection with "Nature," which promises to liberate New World society from the corruptions of Europe. They are "forever" as preserved icons of Nature, legitimating expansion across a suddenly cultureless and available continent. One finds the same Nature separated from environmental and cultural contexts as in the preservation of Peale's Museum and Catlin's gaze.

This view of Americans as exceptional, as more naturally endowed than Europeans and more civilized than Indians, requires a description of Metamora as *by nature* what Americans become through reason and courage. At one point in the play while fighting the British (a popular topic for Jacksonian audiences), Metamora shouts, "Our lands! Our nation's freedom! Or the grave!" (36). Audiences must have loved this, and knowing the active nature of Jacksonian audiences, some may have shouted back, "Give me liberty or give me death!"[7] Now Metamora could be "forever," through the practice of American freedoms, including the freedom to settle throughout the country and use its resources.

Any lingering Indians sat in cultural purgatory and had better remove, assimilate, or face extermination. The audience could also act out a deeply cathartic lament for those the British brutally killed—ethically detaching this Metamoran freedom-loving audience from expansionist practices. The lament represents American exceptionalism in its most potent form.

The play sanctions removal. Self-conscious about lacking Europe's ancient ties to geography and history (Runte 38), Americans inscribed their revolutionary principles onto their Indian characters, including Metamora. In turn, this inscribed the nativeness of the staged Indian (speaking in Revolutionary language against the British) onto the American self (Mullen 75; Lepore 200; Anderson 800).

Thus, *Metamora*'s lament, although on the surface critical of the destruction of Indian cultures and environments, functions in Anglo-American society to supplement the distraction from institutional problems, the forgiveness of individual actions, the faith in American exceptionalism, the dichotomy of assimilation or extermination, and the naturalization of white patriotism on the continent necessary for the political argument of Indian removal to have the endorsement of the dominant cultural narrative. It participates in a politics of nature. If one does not take into account the complexities and power of the ideologies listed above, one could logically conclude that the lament would condemn removal. But political decisions and political persuasion do not exist in a vacuum. They are never, in reality, merely intellectual arguments and deliberations. Political decisions are the result of a cultural and institutional *longue durée*. The moment of decision rests on the full spectrum of cultural ideologies and contexts. The lament *contributed to* the ideology that Indians would inevitably vanish, and the lament preserved the "Nature" harvested from "vanished" Indians as a resource for a new society of people superior to the British villains found throughout these Indian plays and stories. Rhetorically, the lament made the continent American and identified Americans as the most "natural" natives, once one accepted and mourned the "reality" of vanishing. With these assumptions ingrained and in turn perpetuated by literature and theater, it would be difficult to expect Americans to imagine other, more just decisions as all that realistic. The lament would render such just alternatives as unfeasible and out of

synch with the natural order of things. Historian Brian Dippie does not exaggerate when he asserts, "The belief in the Vanishing Indian was the ultimate cause of the Indian's vanishing" (*Vanishing* 71). The remaining, and central, question leading from this contextual intersection of the lament and removal is this: does Catlin finally offer a form of critical lament that escapes the unintentional perpetuation of removal? Or is his lament implicated within this problematic ideology?

CATLIN'S LAMENT AND INDIAN REMOVAL

One can understand from Catlin's social position, from his thorough faith in the scientific-artistic gaze, and from the realities of Indian disease and war, why Catlin translated his fear of vanishing Indians and corrupted nature into a lament. In his mind, his lament became his critique, a form of advocacy that he carried to eastern American urban audiences. This journey spanned the period from 1833, when he set up his Pittsburgh studio, to his giving up on efforts to sell his Gallery Unique in New York City in 1839 and embarking for Europe to perform. It became his fight to show the human side of Indians and to argue that some be preserved in a "nation's Park" while most be humanely introduced to agriculture and Christianity. It became his fight to sell his collection to Congress so that Americans would always have a monument to the purity of Nature found in the West before its inevitable cultivation into oblivion.

Catlin sought to challenge. In addition to the nation's park idea and to his attempts to sell his collection in Congress, he challenged the way in which audiences valued western spaces. He also challenged dominant views of the Indian throughout the late 1830s by presenting his Gallery Unique through a multimedia show including art, artifacts, lectures reflecting the sentiments and observations of his essays, and reenactments, which eventually included "real Indians." Readers and audiences across the East flooded to see this educational medium. At first, the presentation of his Gallery included a two-to-three-hour lecture detailing the objects and paintings of the Gallery Unique, followed by a question-and-answer period, during which audiences sometimes questioned Catlin's authority and the truth of this presentation.[8] Ac-

cording to the *Philadelphia Gazette* review in the 1830s, "The boundless woods have been [Catlin's] home, and dwellers of the wilderness the sitters of his art. So far as Indian life is concerned, the reader will find every thing in Catlin's gallery; not of faces merely, but of grand western life and scene" (qtd. in Catlin, *Eight Years' Travels* 236).

Catlin's lectures, arguing that Indians were dignified, human examples of the advantages of the prefrontier primitive state, led invariably to a melancholy discussion of their inevitable destruction. According to the *Philadelphia Evening Post* in the 1830s, one of many papers across the United States and Europe that reviewed Catlin's show, "The Indian is truly fortunate in having so faithful and industrious a champion, historian, and painter as Mr. Catlin, who will no doubt rescue their name from the mass of trading libelers that have so long corrupted and then slandered them" (qtd. in Catlin, *Eight Years' Travels* 225). On another occasion, the *United States Gazette* claimed that Catlin's work will "rescue and retain the almost incredible appearances and habits of a race of men and animals now fast disappearing in the march of civilization, upon the remembrance and record of history" (qtd. in *Eight Years' Travels* 228). On yet another occasion, the *Philadelphia Herald and Sentinel* declared, "it has never happened, in the history of the world, that a savage people has been approached and depicted with this intelligent completeness" (qtd. in *Eight Years' Travels* 233).

These newspaper reviews and the objective, opinion-free, scientific nature of Catlin's catalogs that accompanied his shows suggest that Catlin limited his goals to ethnographically recording vanishing peoples.[9] But his ethnography was couched in a critique of civilized expansion and a hope that his art and ethnography would help him find an ethical path to success that challenged his audience as it profited from them. At times, his melancholy discussion led him to share his outrage with audiences. Historian Paul Reddin explains:

In Catlin's opinion . . . unless Americans came to their senses, a "noble race" would "disappear from the face of the earth." This prospect moved Catlin to passion, outrage, and criticism of those he held responsible: traders, trappers, Indian agents, slaughterers of buffalo that fed the Plains Indians, and those who offered the "poisoned cup of intoxication." He even told audiences that all

white Americans were "indirectly the cause" of the destruction of Indians. (16–17)

When viewed within the intellectual expressions of Catlin's good intentions, it would seem surprising to theorize Catlin's lament as complicit in the history of laments that embolden removal. However, a look at how his work functions within the larger context and discourse of the lament, reaching its height during his prime, shows complex forms of support for removal.

Removing Black Hawk*

Indian removal as a policy was not unanimously accepted, despite the fact that Jefferson envisioned it, Monroe constructed it as a policy, and Jackson pushed it into law in 1830. When the bill passed the Senate, New England senators voted against it 11 to 1, hoping assimilation could work. Although southern senators voted 18 to 0 to approve it, "a vast horizon of opinion stretched over the nation—but the vast majority of Americans supported removal" (Lepore 209). How could they not? The choices were ideologically defined as assimilation or extermination, and, under this dichotomy, removal seemed humane (Dippie, *Vanishing* 60)—not to mention economically viable for exploding cotton, wheat, cattle, and timber kingdoms desperately in search of Indian lands. In addition to plays, stories, and delegations that defined these falsely limited options, ships and taverns were named after Metamora; schoolchildren recited lines from Logan's lament and from *Metamora*. Historian Philip Deloria details how thousands of white males joined organizations such as the Tammany Society, where they dressed up in Indian garb and "played Indian." According to Deloria:

The society [co-opted] the interior, aboriginal identity of the Indian—now fused to a Greco-Roman history. As an artifact vanished

*An earlier version of this Black Hawk section was published as John Hausdoerffer, "'That Shocking Calamity': Revisiting George Catlin's Environmental Politics," in *Natural Protest: Essays in the History of American Environmentalism*, ed. Michael Egan and Jeffrey Crane (New York: Routledge, 2008).

forever in the ancient past, however, Indianness was also exterior, far removed from the American society of the present. Tammany members could visualize Indian contemporaries—the challenging savages on the border—as simply predead Indians who, upon dying, would become historical, locked in a grand narrative of inevitable American progress. (*Playing Indian,* 58)

From daily practices to methods of forming community to entertainment to government displays, the discourse of the lament everywhere limited the ethical imagination. Newspapers were no exception. Across the country they depicted Indians as not having a right to their own autonomous nations within expanding American states. These papers argued that Indians could become citizens of the new states, but it would be unconstitutional for the U.S. federal government to force state governments to recognize nations that were within their state boundaries but uncontrolled by their state constitutions. The papers justified that the progress of civilization and the destiny of extinction worked hand in hand, creating an equation that fueled removal (Mason 104).

Not only did the language of the Indian Removal Act concur with this, but Andrew Jackson offered his own lament in proposing and defending the Removal Act, in December of 1829:

[The Indians'] present condition, contrasted with what they once were, makes a most powerful appeal to our sympathies. Our ancestors found them the uncontrolled possessors of these vast regions. By persuasion and force, they have been made to retire from river to river, and from mountain to mountain; until some of the tribes have become extinct, and others have left but remnants, to preserve, for a while, their once terrible names. . . . This fate surely awaits them, if they remain within the limits of the States, does not admit of a doubt. Humanity and national honor demand that every effort should be made to avert so great a calamity. (qtd. in Wallace, *Long Bitter Trail* 123)

Jackson's answer is removal. This argument is not limited to Jackson's words, nor is its rhetorical power based on only his words. That

is, Jackson's argument rides on the history of the unexamined assumptions offered by multifaceted cultural, social, political, economic, and philosophical laments that melded into each other to form a discourse, to form a language for understanding and enforcing a political "truth."

This is strongly conveyed in Catlin's narrating, painting, and staging of Black Hawk, the Sauk chief from the recent Black Hawk War. In 1832, not long after Jackson signed the Indian Removal Act into law, Black Hawk led Sauk and Fox Indians back into their traditional territory in present-day Illinois. White settlers strongly resisted this move, and Black Hawk instilled much fear in these local settlers, resulting in the short war. It ended brutally, with Sauk men, children, and women slaughtered by Illinois militia, U.S. Army, and Sioux warriors as they fled across the Mississippi. Of Black Hawk's 1,000 people, 150 died in this fight (Wallace, *Long Bitter Trail* 108).

Andrew Jackson tried to appropriate this tale for himself. Jackson, struggling in the North to gain support for his removal policy, used the Black Hawk War as a vindication for Indian removal in the midst of an election year (Bank 475; Moore 28). He preyed on dormant northeastern fears of what happens when Indians neither assimilate nor remove nor vanish—they were believed to revert to savage behavior, as exemplified in Illinois. Jackson imprisoned Black Hawk and other Sauk leaders in St. Louis. Far from solitary confinement, this imprisonment became among the most popular media spectacles, and Jackson devised it in order to publicize his new evidence for why his Removal Act was necessary and inevitable.

Black Hawk's 1832 return to his homeland (originally sparking the war) was neither savage nor arbitrary. He had lost his lands in 1830, when General William Clark made a deal with the Sauk chief, Kee-oKuk, who was a disputed authority among the Sauk. This deal ceded the lands of Black Hawk and the 1,000 Sauk who returned two years later to reclaim their lands, illegitimately given away. Catlin attended this and a series of other treaty negotiations as Clark's personal, invited guest (Roehm, *Letters of George Catlin* 48). It was around this time that Catlin painted Clark, and Catlin did not hesitate to paint rapidly as many Indian portraits as he could. It was also during this trip that Catlin made many of his connections with the American Fur Company, which eventually escorted his legendary journey west.

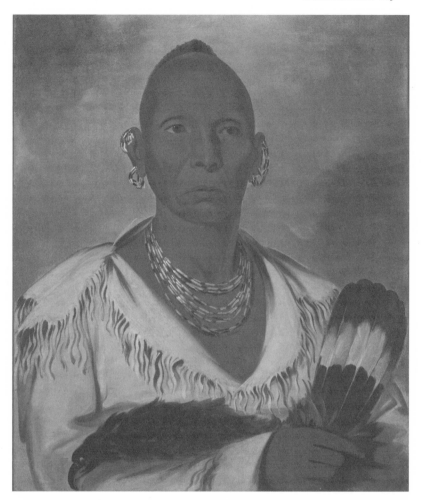

George Catlin, Múk-a-tah-mish-o-káh-kaik, Black Hawk, Prominent Sac Chief, *1832. Smithsonian American Art Museum, Washington, D.C., Gift of Mrs. Joseph Harrison, Jr.*

In 1832, Black Hawk and his coleaders sat in Jefferson Barracks in St. Louis, public curiosities receiving visitors and leading Indian lamenters, such as Washington Irving and George Catlin. In fact, the latter returned from his legendary trip specifically to paint the imprisoned Black Hawk. In a way, this prison was Catlin's first staging of Indians. Black Hawk's cell had found a life in the newspaper stories, gossip, and

folklore of American frontier life and throughout eastern cities. T. D. "Jim Crow" Rice, credited by many historians as the infamous 1828 inventor of the blackface minstrel show, wrote and starred in the play "Black Hawk" at the Bowery Theater. Catlin entered this now famous cell and painted the chief for posterity.

But another, less celebrated, painting from that day is perhaps more significant to understanding the tension between Catlin's intentions and ideologies. The other portrait from that day (not completed as a painting until the 1860s) is much more obscure, hard to find both in Catlin's publications at the time and in public treatments of Catlin's work since. *Black Hawk and Five Other Saukie Prisoners* never made it into *Letters and Notes* and was not emphasized in Catlin's lectures. It is not included in Truettner's thorough catalog of Catlin's galleries. It has not been commemorated (in his time or ours) as an example of Catlin's commitment to free his audiences "as far as possible from the deadly prejudices which [Americans have] carried . . . against this most unfortunate and most abused part of the race of his fellow man" (*Letters and Notes* 7). This painting is quite different from his more conventional portraits. Rather than depicting Black Hawk in a dignified pose, dressed in traditional garb, and distinguished in the "noble savage" mode, this second portrait features Black Hawk and his warriors in chains—a near-documentary representation of their prison conditions.

In fact, Catlin never intended this second portrait. He set out to paint them as noble icons of vanishing cultures, but as he sketched the conquered Black Hawk and his men in their cell, Neopope, one of Black Hawk's countrymen, pleaded for Catlin to include their shackles in each portrait (Bank 476). As Benjamin Drake narrated in his 1838 account of the event, Black Hawk's ally Neopope "seized the ball and chain that were fastened to his leg, and raising them on high, exclaimed with a look of scorn, 'make me so and show me to the Great Father'" (202–203). In demanding his shackles be included in the portraits, Neopope asked Catlin to show the world that their fight for their lands continued. Further, he asked the painter to portray them as neither brutal nor noble savages, but as displaced yet dynamic dissidents of an unjust system. Neopope also requested of Catlin, famous for public laments for the plight of Indians, that he move beyond white lament

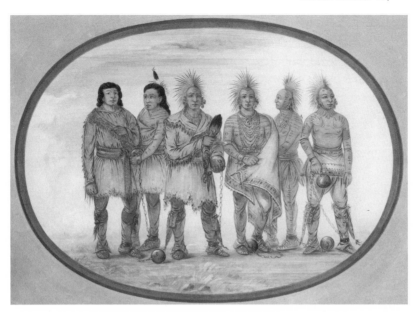

George Catlin, Black Hawk and Five Other Saukie Prisoners, *1861/1869. Paul Mellon Collection. Image Courtesy of the Board of Trustees, National Gallery of Art, Washington, D.C.*

and use his art to support their protest. "Refusing to paint him as he wished," despite the fact that Neopope "kept varying his countenances with grimaces, to prevent [Catlin] from catching a likeness," Catlin chose instead to portray each subject "as though free and at repose" (202–203). Only later did Catlin grant Neopope's wishes, drawing the warriors in their chains, in a painting that ultimately saw little public light (Price 22–23).

At least on that day, and for decades in his galleries, essays, and lectures, Catlin chose instead to portray them "as though free and at repose" (Bank 476). Perhaps Catlin did not want to humiliate Black Hawk by showing him so confined. Perhaps the artist-ethnographer hoped that humanizing the man described by Jackson and the mainstream papers as savage and undeserving of cultural autonomy as in fact a caring, proud, and thoughtful person would subvert Jackson's propaganda. Perhaps Catlin thought that portraying Black Hawk in his traditional garb would argue against the notion that he was a poorly

assimilated savage. Maybe Catlin wished that portraying Black Hawk as a kind, caring man who felt deeply for his lands, as evidenced by the nurturing way in which he embraces the hawk in the painting, would convey his being motivated by far more than arbitrary anger. When describing this picture in *Letters and Notes,* Catlin comments that Black Hawk is not as much to blame for the war as other leaders of the Sauk. He also points out that Black Hawk is more "distinguished as a speaker or counselor rather than as a warrior" (2: 211). Catlin de-savages Black Hawk and breaks stereotypes spun by sensationalized media stories with firsthand observation of a human being worthy of empathy and perhaps justified in his resistance. Viewing the portrait, we see that Catlin clearly had intentions to humanize Black Hawk and to sympathize with his personal loss. But great intentions do not in themselves reconfigure the extensive cultural ideologies of vanishing that this painting taps into.

In the context of the lament and of ideologies of vanishing, this painting ideologically functions in society in complex ways. To recognize the Sauk request that they be depicted as trapped in jail and shackled in chains would contradict Catlin's central assumption that Black Hawk and the Sauk will sadly but inevitably vanish; it would cause him to shatter his view of destiny, and thus his entire worldview. Moreover, it would shatter his sense of mission that the most just thing he could do in a vanishing world is represent Indians with timeless dignity, not capture them in the impoverished light in which contemporaries like Audubon depicted them. Such an accurate rendering of their imprisonment would convey Black Hawk, the Sauk, and Native Americans as active and influential contributors to the American dialogue on how best to expand its republic, rather than as memorialized icons of nature, abstracted to compassionately make room for "ploughshares" and "prayers." Much like in the "last of" plays, accurate depiction of the present is less pressing in this painting than an ideal memory of the past.

This image decontextualizes Black Hawk from his continuing struggle—it initiates his vanishing. Catlin's portraits of American leaders such as Clinton or Clark offer distinct backdrops that give the viewer a context for understanding how the sitter participated in the dialogues of the American republic. Black Hawk's backdrop has vanished.

Both the homeland environments Black Hawk fought for and the prison serving as Black Hawk's future home are decontextualized by Catlin's attempt to freeze the "distinguished" chief in time. Black Hawk, in fact, seems to emerge momentarily, a beautiful, melancholy ghost from this vanishing background. Catlin removes the Indian leader not only from the context of the prison and from his own Illinois landscape but also from any recognizable context of American life. Ultimately, this example supports the shared assumption of Catlin's America: the key role of actual Indians in society is one of disappearance. The viewer can now safely admire the beauty that is Nature and Indianness without considering their continuing struggles against or criticisms of U.S. expansion.

The spectacle for Black Hawk did not end in the cell, the papers, or on Catlin's canvas. A significant part of his prison sentence and Jackson's publicity stunt was "a tour of eastern military installations and cities to fully absorb the extent of white might. Transported by steamboat, stagecoach, and railroad, the Sauk prisoners-of-war were newsmakers everywhere they were displayed" (Bank 476). As Catlin said, Black Hawk was "held a prisoner of war, and sent through Washington and other Eastern cities, with a number of others, to be gazed at" (*Letters and Notes* 2: 211). Jackson intensified the relationship between the Indian delegation and continental power found with Jefferson and Monroe's delegations. Jackson's was a blatant message that those who attempted to challenge his regime of truth were so powerless that they became automatons in Jackson's reelection spectacle. These forced tours that Black Hawk endured "were conducted with ceremony to the theaters, the public gardens, the arsenal, and other places of interest . . . amid fireworks, balloon ascensions" (Bank 478). And because this Jacksonian shock and awe fit right in with the Indian plays of the time, authenticity was added to the laments that declared Indians naturally dead and rendered the audience compassionate inheritors (and, rhetorically, neonatives) of the continent.

In 1837, Catlin presented Black Hawk on his stage, in person after years of appearing in image. Viewed by an audience of 1,500, Black Hawk was accompanied by a delegation of Sauk, Fox, Iowa, and Sioux (Reddin 1999). Having Sioux and Black Hawk together on stage is significant, since the audience could now safely admire previous threats

and previous rivalries—it was a Sioux war party that helped the U.S. military defeat Black Hawk's people. Safe from the dangers of Indian complaints of injustice, audiences could focus on their lament and envision a new era in which they could spread across the continent upon which they were now, ideologically, neonatives—especially if they helped Catlin preserve in image those natural cultures and environments paying the consequences for such continental prowess. Catlin's staging of delegations not only answered his critics, who earlier accused him of inauthenticity; the delegations filled theaters for Catlin in a way that his previous combination of lectures, paintings, and ethnographic explanation of artifacts could not.

Even without an Indian delegation to grace his stage, Catlin emphasized famous fallen Indians, individual icons of the vanishing he regretted. In one 1838 playbill for a Boston exhibit, he advertises "Portraits of the most distinguished Indians of the uncivilized regions, together with Paintings of their VILLAGES, BUFFALO HUNTS, DANCES, LANDSCAPES OF THE COUNTRY, &C. &C." He specifies the show will have 330 portraits and emphasizes "BLACK HAWK and Nine of His Principle Warriors, painted at Jefferson Barracks, while prisoners of war, in their War Dress and War Paint." He also foregrounds the "Annual Religious Ceremony of the Mandans," which he calls a "Penance, by inflicting the most cruel tortures upon their own bodies." Finally, he highlights "TWELVE BUFFALO HUNTING SCENES." Just as in his earlier career as a portraitist, he understood how to evoke his sitter's desired self-image, so in this playbill he shows an ability to fill an auditorium based on audience assumptions of Indian life, culture, and celebrities. In very fine print at the bottom of the page, one sees Catlin's sincere mission: "The great interest of this collection consists in its being a representation of the *wildest tribes of Indians."* He does not offer "wildest," in this case, in a sensationalist manner. He couches "wildest" in how he philosophically intended to reimagine what Indians would mean for American audiences. In even finer print, one paragraph lower, Catlin elaborates on the type of Indian he hopes to offer—one that will "enable the public to form a just idea of the Customs, Nature, and Conditions of the Savages yet in a state of nature in North America" (qtd. in Hight 120). The ad concludes with instructions on how and when to attend the lecture, as well as the price of 50 cents—a day's pay for the average worker.

The playbill is interesting in understanding how Catlin's work, despite his intentions, functions in the discourses of Jacksonian America. His ethical intentions end up footnoted in fine print, emotionally swept away for a reader excited to see hunting scenes; to satisfy curiosity concerning "cruel tortures" upon the "bodies" of vanished Mandan; to gaze at famous, inevitably fallen, and now entertaining warriors such as Black Hawk; and to appreciate compassionately the residual images of western landscapes and cultures. These "specimens," now aesthetically available and necessarily separate from the historical, cultural, and environmental conditions that produced them, could be consumed. Through that consumption, the white American identifies with the continent as a neonative—not unlike the customer who might have cried over *Metamora* in an American theater on that same August night. But with Black Hawk in 1837, suddenly a legendary fallen warrior (equal in stature to Metamora) enters the stage, in the flesh rather than in the person of Forrest.

Black Hawk was perhaps more a prisoner on Catlin's stage than in Jefferson Barracks. In Jefferson Barracks he could consider himself a prisoner of war—an activist and rebel. On stage he was entertainment. He was entertainment that ideologically distracted the audience from the fine print; he distracted the audience from the hope for a "just idea" of Indian relationships. Thus, he was a prisoner of an American imagination expanding across a quickly sanitized continent. Catlin's gaze, no longer just that of an individual traveling west, was now the gaze of an audience of 1,500. Black Hawk's subjectivity, his arguments against the policy of removal, his chains, and the power of his body as a potential resister and alternative to removal vanish.[10]

The same could be said of the tribes featured, particularly the Mandan.[11] "The Annual Religious Ceremony of the Mandan" pronounces the doom of the Mandan in his shows, and during these same years, smallpox decimated the tribe. Catlin's reputation for authenticity, profit, and performances all surged after this tragedy. His family understood the opportunities of the Mandan tragedy. The event offered the audiences the chance to lament in public a living tragedy, a far better buy than the historicofictional one offered by plays like *Metamora*. As Catlin's father, Putnam, puts it in an 1838 letter: "[George] mourns the dreadful destiny of the Indian tribes by the small pox, which report

is verified, but unquestionably that shocking calamity will greatly increase the value of his expertise & works" (*Letters of George Catlin* 127). This value not only relied on the death of the tribe itself (a death that Catlin sincerely mourned) but also depended thoroughly on Catlin's ability to tap into the discourse of the lament during this time of removal, war, and disease. An 1838 playbill for a show in Washington, D.C., shows him continuing to foreground the Mandan in the same way, giving the tribe its own unique, bold font (Moore 118).

Osceola

Catlin also advertised his famous painting of Osceola, the Seminole leader captured in war. During the height of Indian removal in the South, those years surrounding the Cherokee Trail of Tears and the Creek and Chickasaw removals, the Florida Seminole faced a unique predicament. The Seminole consisted of an ethnic mix of Creeks and escaped African American slaves. These escaped slaves moved high in the ranks of Seminole society, intermarried, and had children within the tribe. United States slave laws dictated that the Seminole be returned to slavery. "Removal," for them, meant a return to bondage, in addition to the horrors of displacement. Contemporary policy limited their choices even more violently than it limited Cherokee choices. For a significant portion of Seminole society, removal meant a return to American plantations while for others it would mean a move west to make room for more plantations. The Seminole fought the U.S. military so tenaciously that their removal was never complete (Moore 34).

Osceola led this resistance. He even went so far as to kill a Seminole chief who agreed to move west, forfeit their land, and surrender a significant portion of their society to laws that could reenslave some members of the tribe. Osceola understood the history of chiefs signing away land without the people's legitimate consent. He also took the potential consequences of slave laws seriously, since his own wife had been kidnapped and enslaved. In another instance, Osceola shot and killed agent Wiley Thompson, who once imprisoned Osceola for speaking out against Indian removal at a "peaceful parley" (Wallace, *Long Bitter Trail* 97).

This act of revenge against Thompson and the Seminole Agency in

1835 sparked the Second Seminole War. The Seminole fought effectively, and Osceola had significant success in his resistance. Finally, in 1837, after the United States recognized the abundance of resources required to win the Seminole War, General Thomas Jesup ended the war through deception, seizing Osceola in a meeting supposedly protected by a truce flag. Jesup shackled the Indian leader in irons and sent him to Charleston as a prisoner (Wallace, *Long Bitter Trail* 100). Another imprisoned Indian star, in chains, muted, and now safe to the American citizenry, was born.

George Catlin, upon hearing of this 1837 event, immediately traveled to Charleston to paint Osceola. Catlin's father in a letter to George's brother Francis, wrote, "George has gone to Charleston, S.C. to take the portrait of Osceola & the other chiefs, there in confinement, he left NY . . . in a steam-packet expecting to be absent two weeks[;] he has directions from the Sec'try at War to take five portraits for the War Department. It will be important to his Gallery as it will bring thousands of visitors" (Catlin, *Letters of George Catlin* 125). It appears that the secretary of war, perhaps having learned from the Black Hawk experience or the long history of delegations, understood the power of painting a fallen Indian warrior and advocate. That is, painting an image of a previous threat dilutes that threat as a past memorial, not a future challenge. The ability of Americans to appreciate the beauty, exoticness, or even bravery of the Seminole leader rendered whatever speeches against Indian removal or wars against kidnapping, enslavement, and displacement a thing of the past—a past memorial to fuel a future, American, national, neonative identity.

Osceola "thought it very strange, when it was explained to them that their Great Father wanted their portraits[,] . . . but they soon construed it into a compliment" (Dippie, "Green Fields" 54). Catlin clearly understood that this request was far from strange. He took advantage of the desire in American audiences to say goodbye compassionately to vanishing Indians; to fulfill ethnographic, scientific curiosity about Indians; and to move on with expansionist policies and commodious lifestyles.

When one views the painting of Osceola, which Catlin inevitably made into a centerpiece of his show and advertising, one notices the same "vanished" backdrop found with Black Hawk. Absent is the visual

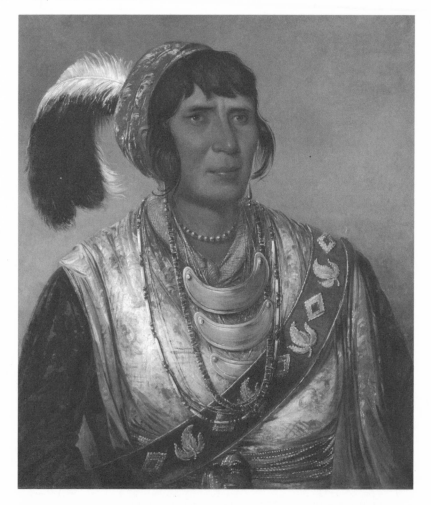

George Catlin, Os-ce-o-lá, The Black Drink, a Warrior of Great Distinction, *1838. Smithsonian American Art Museum, Washington, D.C., Gift of Mrs. Joseph Harrison, Jr.*

background contextualizing social power found in Catlin's Clinton and Clark portraits. One also notices, perhaps more than in any other of his paintings, the tremendous degree of individual humanity attributed to this man known for his relentless skills in battle and brutality in exacting revenge. He is given such gentle, almost feminine features and is presented as far from a caricature. In this painting, Catlin lives

up to his promise that his images would "form a just idea" of a group stereotyped as savage. Still, also as with Black Hawk, Osceola's contributions to the dialogue over Indian removal, as well as his resistance to its consequences, are decontextualized here. The "just idea" lives in an image of Indians that Catlin will eternalize. The subjective message of resistance offered by the brilliant leader (especially brilliant from the point of view of the stymied American generals, who needed to deceive and break the laws of diplomacy) is erased into the past. Such paintings were "useful in reminding the Boston audiences that the Indian 'threat' was, along with the Indian people themselves, a 'vanishing' worry" (Hight 120).

Catlin's contribution to this vanishing worry, and in turn to the growing ideology of removal as the only humane solution, was not limited to his paintings. Along with the Osceola portrait, Catlin's story of his time with this Seminole hero became the highlight (in addition to the stories of Black Hawk and the destruction of the Mandan) of his show. The day after Catlin's 1837 visit to the Fort Moultrie Prison in South Carolina to paint Osceola, the Seminole leader died of a throat infection. This fueled the discourse of inevitable vanishing (and the audience desire to lament such inevitability) that sold Catlin's shows. Again, Catlin's father recognizes the value of Indian death for his son's prosperity, reputation, and fame. He writes to his son Francis that George painted "Osceola just before his death" (*Letters of George Catlin* 127). Putnam connects this death to the successes sure to come from the death of the Mandan as part of that "shocking calamity" that will increase the value of Catlin's painting and show.

Catlin seems to have taken his father's advice and immediately "paid one printer $83.25 in a six-week period for 5,100 'advertisements,' 350 circulars, 1,000 handbills, 200 prospectuses for his prints of the Seminole leader Osceola, and 2,000 copies of his catalog. This totaled 8,650 items, or about 206 pieces of printed materials per day" (Reddin 12). The audiences knew Osceola was dead immediately, as they had been following the story of his war, capture, and imprisonment. Catlin promised to add details of his conversations with Osceola and to narrate his death. In fact, Catlin was in close contact with Osceola's last doctor. This Dr. Weeden not only supplied Catlin with tales of Osceola's death but also "secretly beheaded the chief immediately

after his death and took the head with him on his return to St. Augustine, where it remained in his study for several years" (Hight 121).

The popularity of Catlin's shows—resulting from stories of the "vanished" Mandan (the last of his favorite tribes), from painting and then staging the imprisoned Black Hawk (the last leader of any Indian war to protect land in the old Northwest), and from painting and telling the stories of Osceola (the fallen leader of the last effective resistance to removal in the South)—transformed them. What began as lyceum-like lectures and descriptions of paintings became a spectacle. From that point forward, Catlin spoke from the entryway of a "twenty-five-foot white Crow tepee beside a pole with real scalps attached" (Reddin 20). He hiked admission to one dollar for his staging of "real Indians," for his dressing up in Indian garb, for his participation in mock pipe-smoking ceremonies and war whoops. His wife, Clara, reveals the connection between the show's rising popularity and the extent to which Catlin sensationalized the Indian experience:

> George's reception here has been very gratifying. He lectured three weeks, to a good audience every night, although it was a most unfavorable time, as most of the wealthy inhabitants are out of town. . . . His portraits are becoming very valuable every day [page torn] number of the far western tribes, having become totally extinct, by the smallpox, during the past year. If the bill for its purchase is not passed this writer . . . George will probably go to Europe early in the Spring. (Catlin, *Letters of George Catlin* 139)

CONCLUSION

Like the Tammany Societies contemporaneously "playing Indian" and like the abundance of such plays as *Metamora*, Catlin could offer access to a neonative identity ready to adopt the continent. He also provided access to a construction of the continent as available. Nothing else could fuel removal more than these two ideologies. Andrew Jackson illustrates their power in his 1830 Second Annual Address: "what good man would prefer a country covered with forests and

ranged by a few thousand savages to our extensive Republic, studded with cities, towns, and prosperous farms, embellished with the improvement which art can devise or industry execute, occupied by more than 12,000,000 happy people, and filled with the blessings of liberty, civilization, and religion?" (qtd. in Mason 101–102). The "good man" compassionately lamenting the death of Indians and the vanishing of cultures and environments can also be the "good man" agreeing with this lyrical though subtly violent picture offered by his president. Catlin's lament benefits from and perpetuates this argument that it would be an injustice to nature were one to "prefer a country covered with forests and ranged by a few thousand savages" to "the blessings of liberty, civilization, and religion."

One finds a final manifestation of the lament that enabled Jackson's logic, ironically in the form of arguments to Congress promoting the purchase of Catlin's Gallery. As Catlin's wife confirms, he hoped to sell his Gallery to Congress. He argued that it was a national treasure, and that if he could not sell it, he would take it to Europe. This was an attempt to use patriotism and exceptionalism to sell his work. He threatened to de-Americanize the lament. The *United States Gazette* reiterated this threat: "I am grieved to see that this noble product of American genius is in a few days to leave its native soil. . . . Whether in justice or in wrong, our treatment of the Indian nations has been a reproach to us throughout the world. Let it not be in a stranger's power to show how noble and how elevated a race we are thus accused of having injured" (qtd. in Catlin, *Eight Years' Travels* 227). No one bought it—neither the argument nor the Gallery. The politics of the Jacksonian era, now under the watch of President Martin Van Buren, resisted funding public institutions (Kohl 68–69) and would hardly be inclined to buy Catlin's Gallery for anywhere between $50,000 to $100,000 (Catlin, *Letters of George Catlin* 132). An economic depression and a fear that federal expenditures would contradict Jacksonian individualism left Catlin broke and tired of performing. He set sail for Europe in 1839.

Ten years later, in 1849, Catlin made another attempt to sell his Gallery to Congress. This time, he looked to his friend Daniel Webster to argue his case in the Senate. Webster, a master debater and orator

of an era with many great orators, used the lament in his argument. Catlin quotes Webster in his *Life among the Indians:*

> These tribes, sir, that have preceded us, to whose lands we have suc-
> ceeded and who have no written memorials of their laws, their habits,
> and their manners, are all passing away to the world of forgetfulness.
> . . . And here they are [in Catlin's Gallery], better exhibited, in my
> judgment, better set forth and presented to the mind and the taste
> and the curiosity of mankind, than in all other collections in the
> world. I go for this as an *American* subject—as a thing belonging to
> us—to our history—to the history of a race whose lands we till, and
> over whose obscure graves and bones we tread, every day. (8)

In this classic lament, in the style of Catlin and the entire discourse, Webster shows Indians inevitably passing away, he shows whites as possessors of the continent, and he shows the public act of memorializing tragedy as that which makes Indians an "*American* subject" and in turn *makes the continent American.*

Webster is no Jacksonian; he is a true opponent of the Jacksonian vision of the continent. Nevertheless, like Catlin's work, Webster's lament functions in a discourse that lays the groundwork for a classic Jacksonian argument. Even General Lewis Cass, the U.S. secretary of war and an aggressive proponent of Indian removal, enacts the discourse of the lament. Of Catlin's paintings (also quoted in Catlin's *Life among the Indians*), Cass says:

> Among them I recognize many of my old acquaintances, and every-
> where I am struck with vivid representations of them and their cus-
> toms, of their peculiar features, and of their costumes. Unfortu-
> nately, they are receding before the advancing tide of our
> population, and are probably destined, at no distant day, to disap-
> pear; but your collection will preserve them, as far as any human art
> can do, and will form the most perfect monument of an extin-
> guished race that the world has seen. (9)

This sentiment fuels Cass's fervent belief that "a barbarous people, depending for subsistence upon the scanty and precarious supply fur-

nished by the chase, cannot live in contact with a civilized community" (qtd. in Zinn 132). The assumption of "chase"-based barbarism, coupled with a lament for inevitable vanishing, renders displacement necessary and just—a deadly political combination. Not exactly the sentiment Catlin had expressed, this is nonetheless, without question, the sentiment that Catlin's lament had perpetuated and legitimated.

> *The ideology that construes seeing as inherently passive and curiosity as*
> *innocent cannot be sustained.*
> —Mary Louise Pratt

The career-narrative of George Catlin often reads like a tragedy. After Catlin left New York City in 1839 for a two-decade tour in Europe, his shows in Europe eventually featured more "Wild West" role-playing, more whites dressing up as Indians, and more Indians pretending to scalp their victims in reenacting war. As a result, Catlin's lyceum-style lectures—detailing paintings of natural environments, lamenting cultural extermination, and challenging stereotypes—faded. At one point, the 2-foot-tall, 15-pound General Tom Thumb appeared in Catlin's show dressed as Napoleon, sharing the stage with Sauk Indian leader Joc-o-sot (Dippie, *Contemporaries* 102–103; Reddin 38). By 1846, many of the Indians under Catlin's care had died of smallpox. By 1852, Catlin had spent time in a London debtor's prison, sold his gallery in exchange for his debts, lost his son to disease and custody of his children who survived the European journey, and sadly sent the remains of his recently deceased wife, Clara, back to New York. Retiring from performing, Catlin went into the business of land speculation, promoting the practice in his *Notes for the Emigrant to America*. In this book, he calls Indians "cruel savages" (Reddin 48). He delivered lectures such as "The Valley of the Mississippi, and Its Advantages to Emigration, with Some Account of the Gold Regions of California" (Mulvey 76–77) during the heart of the gold rush that further decimated Indian environments and cultures.

Indeed, Tom Thumb singing "Yankee Doodle" on stage with an Indian leader and Catlin singing the praises of westward expansion and resource extraction seem a dramatic departure from lamenting cultural and environmental loss. Catlin's personal and financial life certainly crashed. His reputation as part of the solution to the problems of colo-

nial expansion suffered. Collectively, when one compares these misfortunes with the idealism of his Philadelphia ambitions, his life represents a downfall of tragic proportions.[1]

Although Catlin likely experienced a personal downfall, his behavior on the European stage does not contradict the underlying ethos of his original objectives. His failures in Europe do not represent, in fact, an abandonment of his "first principles." The view that Catlin abandoned his principles requires a prior confidence in the unexamined ideologies underlying his original ethical intentions. As said, Catlin at times gives ample reason to credit him with such intentions. In his *Letters and Notes*, one finds a Catlin who, on the surface, serves as an "advocate" for the "rights" of Indian cultures and western environments (98). The text offers the memoir of a man who hopes to eradicate prejudice, to generate American empathy for Indian cultures, and to lend "a hand to a dying nation" (*Letters and Notes* 3). But Catlin's expressed intentions are premised upon problematic and unexamined assumptions driving both the position from which he gazed at the West and the way in which he offered a national lament through his gaze. The sensational spectacles that Catlin produced for European audiences represent the *embodiment of* rather than a *departure from* his view of environmental and cultural preservation. These spectacles highlight a pattern long marked by this friction.

A close reading of Catlin's 1848 two-volume chronicle of his European experience, *Notes of Eight Years' Travels and Residence in Europe*, illustrates this core embodiment of original, underlying principles. On the one hand, *Eight Years' Travels* shows his attempts to critique European custom and represent Indian points of view. Even in his most sensational of European moments, the book still features Indians subverting the presumed superiority of European high culture. On the other hand, this publication exhibits how Catlin's unexamined assumptions underpin even these moments of critique. These assumptions are not sudden symptoms of a specific "downfall"; they go as far back as Peale's Museum and as far west as the mouth of the Yellowstone. Just as Catlin's first epiphany should not be understood as a spontaneous event separate from his foundational ideologies, so his downfall should not be seen as a sudden ethical lapse.

THE CHALLENGES OF AMBITION

The historian Brian Dippie, in *Catlin and His Contemporaries*, describes Catlin's European trip with detail, claiming, "The story of these fifteen years constitutes one of the greatest sagas of enterprise and thwarted ambition in the annals of nineteenth-century American art" (98). In Catlin's own words, he arrived in Europe eager "to inform the English people of the true character and condition of the North American Indians, and to awaken a proper sympathy for them" (*Eight Years' Travels* 6).[2] On the level of fame, he gains early recognition and attention from both the English royalty and the intelligentsia. He earns the admiration of leading theologians hoping to learn about "savage" religions and how best to convert Indians to Christianity; he lectures to leading geologists fascinated with the landscapes surrounding the Rocky Mountains; he speaks before the Royal Institution of scientists of Great Britain; he attends dinners of the Royal Geographical, Geological, and Historical Societies (64). At each occasion, Catlin finds himself flooded with questions; he is treated as a highly respected scientist, artist, and intellectual in the highest circles of English society and culture.

Receiving such praise and intellectual confirmation inspires Catlin to venture beyond his expertise on the American West. He begins making connections between the injustices he lamented in the American West and those resulting from global colonialism. His expressed principles have never been clearer. Freed of the art critics and reactionary Jacksonian patriots of eastern America, Catlin lets loose more sophisticated critiques of colonialism than ever before. He offers these ethical challenges in Egyptian Hall, perhaps London's most respected lecture hall, immersed in the central city of the central nation of the central time period of global colonialism. In a time when the "sun never set on the British Empire," Catlin laments to his audience:

The march of civilization is everywhere, as it is in America, a war of extermination, and that of our own species. For the occupation of a new country, the first enemy that must fall is *man*, and his like cannot be transplanted from any other quarter of the globe. . . . But

to complete a title, man, our fellow-man, the noblest work of God, with thoughts, sentiments and sympathies like our own, must be extinguished; and he dies on his own soil, unchronicled and unknown. (62–63)

This bold evaluation cuts at many of the fundamental realities of colonial success and luxury not just "in America," but "everywhere . . . a war of extermination." He is troubled that the spread of civilization, supposedly the spread of the Christian God, has required that "our fellow-man, the noblest work of God," must be sacrificed. He even goes so far as to intellectually equate disempowered, colonized cultures with the intellectual leaders filling Egyptian Hall, a courageous move in a time of white supremacist, British imperialism. He subverts the views of racial inferiority that justify colonial domination. Those who die at the hands of colonialism have "thoughts, sentiments, and sympathies like our own." They are subjects, not objects. It is unjust that their suffering serves civilization. The hall erupted with applause.

Furthermore, in these lectures to the Royal Societies, and privately at the nightly dinners he attended, Catlin extended his critique to the conditions supporting *British* luxury. And again he received applause. The applause, however, came less from Catlin's critique and more from the "favorite subject" arising from his critique (61). His "favorite subject" was a new idea of his, expanded from his hope to sell his Gallery to Congress. He advocated for a universal "Museum of Mankind."

For Catlin, the solution to global colonialism was not to rethink European definitions of luxury, freedom, need, and wealth in order to sustain social and environmental stability for all cultures. His solution was to preserve images of nature and thus icons of knowledge to enlighten the colonizer in hopes of inspiring a more humane global frontier. He states, "From England, from France, and the United States, government vessels, in this age of colonization, are floating to every part of the globe, and in them, artists and men of science could easily be conveyed to every race, and their collections returned free of expense, were there an institution formed and ready to receive and perpetuate the results of their labours" (63). Just as when he appropriated images and artifacts from the Red Pipestone Quarry, in London Catlin excuses the pursuit

of art and knowledge (and himself as pursuer) from ethical complicity in the pursuit of empire. The imagined scientists and artists of this quote, like his own presence on the *Yellow Stone* in 1832, would sanitize colonial ventures; their art and enlightened knowledge would ensure that no "fellow-man" go "unchronicled and unknown." He assumes and accepts that the material disappearance of cultures would follow their being chronicled and known. For Catlin, it should not only be the skins of animals that gain great value in museums (62–63). The cultures, too, he suggests, should have value gained from intellectual, but not from material, preservation. These early lectures epitomize how Catlin's time in Europe, even his most successful and most principled writings and lectures for London society, represents continuity with his earliest of unexamined assumptions learned in Peale's Museum.

Catlin's early fame continued into 1842, when he visited Queen Victoria to display his popular painting of Niagara Falls. He writes home to his father, "To think that, from a little *go-to-mill-boy* I have worked my way across the Atlantic & at last into the Palace & presence of the Queen of England, and more than all that, received from her own lips her thanks for the interesting information I had given her" (*Letters of George Catlin* 234). Beyond reaching this personal pinnacle of fame, he shares with the Windsor Palace audience his political hope to preserve knowledge of Indians in the face of "extermination." He reports that the queen complimented him on the work he had done on behalf "of the Indians, for whose rights they well knew I was the advocate" (98). Catlin does not compromise his concern for Indians. He does not self-censor his desire to create a "Museum of Mankind," even in front of the queen in Windsor Palace—the epicenter of the colonial world.

Catlin also enlarged his critique of colonialism to a more universal critique of industrial society. From the very beginning, he writes *Eight Years' Travels* as a symmetrical work to complement his *Letters and Notes*. Each constructs Catlin as the foreign yet rational and objective witness. He shows an early fascination with the contrast between the "Far West" of the American frontier and the "Far East" of European cities (viii). He uses this contrast as a tool, inverting cultural assumptions dictating which extreme actually represents dark wilderness and which extreme represents enlightened civilization.

To a foreigner entering London . . . the first striking impression is the blackness and gloom that everywhere shrouds all that is about him. It is in his hotel—in his bed-chamber—his dining-room, and if he sallies out into the street it is there even worse; and added to it dampness, and fog, and mud, all of which, together, are strong inducements for him to return to his lodgings and adopt them as comfortably as a luxury. (15)

The London of 1840 epitomized the carelessness of nineteenth-century urban planning, resource consumption, and industrial production. Forests around London had long been eradicated for fuel and housing; coal was being used on aggressive levels (McNeill 66). London's Industrial Revolution had happened earlier than America's, and Catlin witnessed the environmental disaster that resulted. This critique of London's pollution, of the industrial savagery of the "Far East," frames Catlin's praise of Indian culture found elsewhere in the book. In fact, given the context of Catlin's praise as tied up in a lament that opened North America to American audiences, one must wonder how this critique of London functioned. That is, with the "Far West" "doomed to perish" and the "Far East" shrouded in "blackness and gloom," he further constructs the white American as the ideal inheritor of the North American continent.

This inversion of East and West, Civilization and Wilderness, extends beyond environment, especially in Catlin's mockery of European popular audiences. He rhetorically frames European ignorance through a creative dialogue that he describes between himself and nameless, voiceless audience members following one of his shows. An adept writer, Catlin writes this as a comic burlesque.

Virtuous?—Yes, I should say they are quite as much so as the whites, if the whites would keep away from them and let them alone. . . . The Indians in *America are not cannibals*. . . . They *do* get drunk sometimes, but white people sell them rum and make them so, therefore I don't think we ought to call them drunkards exactly. . . . Reason! Yes, why, do you think them wild beasts? To be sure they reason as well as we do. (48)

Catlin portrays his contrast between "Far West" and "Far East" quite effectively. The reader finds a classic Catlinian defense of Indian humanity. In every answer, he breaks a stereotype, from fears of brutal savagery to caricatures of alcoholism and intellectual inferiority. He portrays the "Far West" as superior in many ways.

Moreover, Catlin offers a critique of the "Far East" through the implied absurdity of his invisible European characters. These Europeans are denied voice, denied subjectivity, thus inverting the colonial view concerning which discourses are the sites of rationality. Only an irrational culture would act on the presumption that another culture is cannibalistic. Catlin's almost rhetorical question "why, do you think them wild beasts?" does not need an answer when posed to his rational reader. In this comical scene the reader is thus positioned as the rational person who (along with Catlin) does not need an answer to such a simple question. Civilization at its highest point must be quite flawed if such questions (posed in Egyptian Hall, no less) are seen as legitimate.

Finally, Catlin blames the "Far East" not only for stupid assumptions but also for perpetuating the conditions that would lead to these assumptions. That is, if Europeans would let "them alone" and if "white people" would stop selling "them rum," Indians would never even have the *appearance* of lacking virtue. This dialogue constructs Americans as the rational center between two "Far" extremes, and further stakes the American continent as belonging to those inhabiting the space between the extremes of East and West (so long as Americans blend their destined expansion with Catlin's humane lament; so long as they lament that which pays the fatal consequences of their own expansion).

Catlin's work in Egyptian Hall briefly continued in the traditional form of lectures on his paintings and artifacts. However, despite the levels of fame attained, he struggled financially. In letters home during the period, Catlin complains: "I see no great fortune in London unless I sell my collection, of which there is some chance. My rooms are what they call here 'well attended' & fashionable, but expenses eat up most, but not *all* of the receipts" (*Letters of George Catlin* 171). In another letter to his father, Catlin says, "London is no place to make money by exhibition" (197). [3]

Indeed, Catlin had many debts and struggled to sell his Gallery or make a profit from his shows; indeed, he moved to more sensational

methods of attracting attention to his shows as his novelty wore out; and, indeed, Catlin's outward approach to his shows moved from education to entertainment. On several occasions he dressed up in Indian garb from his Gallery and appeared at upper-class London balls posing as an Indian, along with his nephew and an associate acting as an interpreter. In one instance, at the Polish Ball, Catlin and five friends dressed as Indians. He included his wife in the practical joke: "my dear little *Christian* Clara . . . proposed to assume the dress of an Indian woman and follow me through the mazes of that night as an Indian squaw follows her lord on such occasions" (*Eight Years' Travels* 88). They had the audience duped. They pretended to speak broken English, and they danced Indian ritual dances until their sweat washed off their face paint, revealing their non-Indian selves to an appreciative and ecstatically "humbugged" audience.

As far as Catlin reports, no one at this ball discussed with him the injustices of colonialism; no one discussed the need to create a Museum of Mankind; no one shattered stereotypes. Instead these stereotypes were performed to the pleasure of a crowd that had grown tired of spending money on his lectures and presentations of his Gallery. Catlin discovered a new medium for selling wildness to an "over-civilized" society. Doomed to perish and safely preserved on Catlin's canvas, Indian identity becomes for Catlin a pliable tool for financial success in the "Far East," implemented from behind a mask of savagery.[4] But his substitution of performance for presentation does not contradict his original principles. It only enhances his ability to preserve in mere image a culture that was in fact facing injustice. It is not a break from but a further manifestation of Catlin's assumption that Nature, in a world of inevitable vanishing, is best preserved apart from environments. Referring to the collection of portraits he called his *tableaux vivants*, he states, "By them I furnished so vivid and lifelike an illustration of Indian life as I had seen it in the wilderness" (94).

THE SUBJECTIVITY OF "REAL INDIANS"

Catlin's problematic ideology of preservation continued to emerge when an entrepreneur brought a delegation of "real" Ojibwa Indians

to London in 1843. Catlin worked out a deal to employ Indians in his shows, rather than using English actors dressed as Indians. After the Ojibwa left in 1844, Catlin hired a group of Iowa Indians (sent by P. T. Barnum), and then another group of Ojibwa from 1845 to 1846.

Throughout these four years and three tribal delegations, in engaging these Indians and in explaining his use of them, he reveals at once both the pinnacle of his best intentions and the pinnacle of his problematic ideology. Catlin, in his own words, "always [was] opposed to the plan of bringing Indians abroad on speculation; but as they are in the country, I shall, as the friend of the Indians under all circumstances, feel an anxiety to promote their views and success in any way I can" (101). His duty to "promote their views" trumped his initial resistance against profiting off of Indians. So how do we assess the role of this decision in the ethical arc of George Catlin's career?

It would be incomplete either to view Catlin's use of Indians as a downfall or to consider his use of them as consciously manipulative or objectifying. The most impressive aspect of his portrayal of Indians in *Eight Years' Travels* is the extent to which he lets Indians speak, develop sophisticated characters in his narrative, and subjectively interpret the foreign European world. When combined with his earlier European lectures questioning global colonialism, Catlin's attempt to let Indians speak in his text deconstructs European power by showing the point of view of the traditionally objectified and colonized.

Just as his negative view of London pollution questions which world ("Far East" versus "Far West") *really* signifies wilderness, so his use of Indian voices questions which world *really* signifies enlightened society. Catlin frequently describes the daily routine of his shows, where Indians danced before European audiences, endured or enjoyed (depending on the individual) flirtatious female audience members, reenacted war scenes, and allowed the excited audience to touch and gaze at them after the show. In such moments, Catlin portrays European audiences as wilder than his Indian actors. Meanwhile, and just as frequently, he offers the reader of *Eight Years' Travels* a backstage look at Indians after the show, sharing a peace pipe, mocking the audience, interpreting artifacts of European culture witnessed that day, and making fun of each other. These snapshots, again, invert Europeans as the savages and Indians as the more rational, more civilized individuals.

Such moments of inversion occur in the many instances of Indians meeting religious leaders hoping to convert them. Despite Catlin's apparent enthusiasm for Indian conversion, the scenes illustrate Indian aptitude at inversion. Of such situations, Catlin says, "It was one of the greatest satisfactions I could have during their stay in England, to promote as far as in my power such well-meant efforts to enlighten [Indian] minds, and to enable them to benefit in that way by their visit to this country" (*Eight Years' Travels* 2: 38). This is what follows the lament on the American stage for Catlin, the only justice beyond preserving Indians on canvas—assimilation and "enlightenment." His ideologies and intentions mix here, revealing his part in declaring their customs and lifeways part of the past, functional only for European knowledge—in hopes of helping American civilization grow without adopting the corruptions of Europe.

In one example, after Catlin gains reluctant Indian approval for each religious leader's visit, an unnamed reverend professes to his audience of Iowa Indians, "Did it ever occur to you, that the small pox that swept off half of your tribe, and other tribes around you, a few years ago, might have been sent into your country by the Great Spirit to punish the Indians for their wickedness and their resistance to this world" (2: 41)? Catlin records the Iowa war chief Neu-mon-ya as replying, "If the Great Spirit sent the small pox into our country to destroy us, we believe it was to punish us for listening to the false promises of white men" (41). In another scene of failed conversion, Neu-mon-ya states to Catholic evangelists, "My Friends,—Our ears have been open since we came here, and the words we have heard are friendly and good; but we see so many kinds of religion, and so many people drunk and begging when we ride in the streets, that we are a little more afraid of the white man's religion than we were before we came here" (61). Again, Catlin's literary windows into Indian subjectivity, reportedly recorded verbatim, invert which culture's religion leads to just social practices and which culture's religion leads to poverty, lack of virtue, and savagery. In a similar but nonreligious moment, Catlin depicts an incident when several Iowa Indians donate $500 to a poorhouse (226). Other scenes show them stopping in the street to give change to a beggar (143). Again, Catlin emphasizes Indian subjectivity and inverts dichotomies of savagery and civilization.

In some moments powerfully depicted by Catlin, this inversion leads to Indians brilliantly deconstructing European power. For example, while in France with a delegation of Iowas, a phrenologist requests permission to study Iowa skulls. With regard to slavery and African colonialism, scientists argued that whites were superior to other races, an extra step above the animal kingdom. Phrenology attempted to prove empirically such a chain of being, thus justifying white intelligence as legitimately in control of the labor, bodies, and environments of "other" cultures. As Catlin does with evangelists, perhaps because he trusted Iowas to make up their own minds on such aggressive European practices, perhaps because he subscribed to a more moderate version of those practices, he supported the phrenologist's request: "we conversed with the Indians, and assured them that there was not the slightest chance of harm, or witchcraft, or anything of the kind about it, and they agreed to let him come in" (247).

Jim, also known as Wash-ka-mon-ya, the Iowa interpreter, mocks the phrenologist throughout their meeting with the scientist. As the scientist begins to study Jim's shaved head, Jim tells him, "I don't think you'll find any [hair] in my head; we Indians shave a great part of our hair off, and we keep so much oil in the rest of it" (247). The room of Iowa Indians erupts in laughter at the doctor. Jim turns this joke into an inversion of colonial power, telling the scientist, "We have all waited upon you and given you a fair chance, and I now want you to sit down a minute and examine *your* head" (249). The scientist, having little choice in this moment, concurs, and Jim proceeds to "examine" the scientist with a knife, joking about the "quackery of his patient," pretending to scalp him, and inspiring more laughter from his friends.

Catlin depicts an individual moment of triumph over a dehumanizing and violent imperial ritual. He shows how Jim understands the power that the individual scientist seeks over him in this isolated moment; Jim understands that the scientist's position of knowing reflects and implies immense power over Jim, the object of knowledge. By showing how Jim outsmarts the doctor and subverts the doctor's power, Catlin breaks stereotypes of Indian ignorance. Still, while he dislikes this individual doctor (who he claims was rude, condescending, and did not engage the Iowas in respectful dialogue), Catlin does not himself offer a systematic critique of the practice—he sees "not the

slightest chance of harm." A scientific activity, he sees it as harmless and, like his own scientific endeavors, immune to the injustices of other colonial practices. In narrowing his frustration to an individual, disrespectful "quack," Catlin individualizes the remaining struggle of Indians following his lament. Left to individuals lost in the context of dying cultures, the only individual choice short of joining this death is assimilation. Catlin promotes respectful methods of converting— "knowing," measuring, and preserving vanishing Indians. To him, the acts of conversion and phrenology themselves are potentially acceptable, *if done respectfully.* He is similarly happy to show Indians subverting individually rude missionaries while promoting the larger systematic goal of a "Christianized" West (Catlin, *Letters and Notes* 184).

These two scenes present strong evidence of the long-term, ambiguous relationship between Catlin's intentions and his ideologies. On the level of intentions, his *Eight Years' Travels* offers the reader access to Indian subjectivity while inverting and subverting the dichotomies of civilization/wilderness, enlightenment/savagery. On the other hand, the book legitimates polite religious assimilation and scientific study of diminished races as praiseworthy contributors to the preservation of dying cultures. Even though Catlin lectures against the "extermination" of cultures, includes Indian voice in his account, and inverts corrupt aspects and individuals of European civilization, on an ideological level he leaves unquestioned complex cultural systems of power and imperialism.

THE POLITICS OF AUTHENTICITY

By 1843, Catlin's upper-class European admirers showed up less and less. He began to advertise his shows with placards and newspaper announcements reading, "Wild Enough! Nine Real Indians from N. America" or "War Dances with Other Dances, war-whoops, and other Ceremonies in their rudest and wildest character" (qtd. in Reddin 35). Even more than with the *tableaux vivants* of Catlin's pre-Indian career in Europe, one could understandably see his sensational use of Indians as the climax of his downfall.

Indeed, Catlin's sensationalism intensifies.[5] He began to embellish

Indian scenes of warfare with real scalps (but not live scalping). But Catlin explained these embellishments as scientific innovations in the field of cultural preservation, claiming that "this was probably the first time that the Scalp Dance, in its original and *classic* form, was ever seen in the city of London, and embellished by the presence of real and *genuine scalps*" (*Eight Years' Travels* 2: 30). He saw the scalps as central to his priorities; they improved his ability to offer an authentic view of Indian life. In his mind, the preservation he advocated became more authentic when "genuine scalps" were involved. Moreover, the use of real Indians and scalps ensured that audiences witnessed an "original" exhibition, as a scientist views an experiment in a lab—Catlin believed he had removed the filter of production and performance. Once again, Catlin in the "Far East" shows an ideological continuity with his "authentic" days in the "Far West." In both cases, as found with his slaughter of the buffalo ten years earlier, scientific and artistic contact with "real" nature renders his work more authentic. He reveals an unquestioning belief that such contact provides more authenticity than if he had refused to study and display images destined otherwise to "vanish." The pursuit of enlightenment knowledge frees him from ethical obligation. "I felt satisfied that I was bringing before the eyes of the audience the most just and complete illustration of the native looks and modes of the red men of the American wilderness" (2: 12).

The European press disagreed. The satirical magazine *Punch* remarked, "Think of that ladies and gentlemen; the real skins and hair of a human creature. Is that not attractive!" (qtd. in Reddin 41). Catlin continued to feature scalping in his show. Even if he was motivated by profit, he justified his act as a positive moral good far more than as a necessary financial evil. He framed the faux scalps as part of his philanthropic mission. That is, the public reenactment of scalping was in his mind all part of his larger effort to preserve these images of nature and wilderness through science, art, and performance.

Catlin offers even stronger evidence of this view of sensationalism-as-positive good in his reaction to audience protesters. On one evening in 1843, an audience member yells across Egyptian Hall, "Do you think it right, Sir, to bring those poor ignorant people here to dance for money?" Another proclaims, "I think it is degrading to these poor people to be brought here, Sir, to be shown like wild beasts, for the pur-

poses of making money; and I think, more than that—that it is degrading to *you*" (*Eight Years' Travels* 153). Catlin turns the tables on the protesters. He criticizes them for assuming the Indians are mere objects on stage, "ignorant" and without agency. Catlin replies, "These Indians are men, with reasoning faculties and shrewdness like to our own, and they have deliberately entered into a written agreement with the person who has the charge of them" (154). Catlin separates individual Indian choices from the conditions of disempowerment that forced his actors (in this case the first group of Ojibwas) to leave their families and home countries, to risk death at sea or by disease, to face the humiliating gaze and feverish consumption of European audiences, in order to send money home and perhaps gain support from the world for their plight.

This defense of his intentions reveals an underlying tension within Catlin's ethical goals. In answering these criticisms, and in letting his Indian actors speak for themselves and their people, Catlin offers a precarious combination of seeking to preserve the vanished while recognizing the poverty that causes them to vanish. He nearly breaks the mold of the lament, nearly crosses the line between lament and struggle, and nearly rejects the ideologies of inevitability that drove this era of manifest destiny. Catlin records the Ojibwa Gish-ee-gosh-ee-gee stating to a religious leader, "We are here away from our wives and children to try to get some money for them, and there are many things we can take home to them of much more use than the white man's religion. Give us guns and ammunition, that we can kill food for them, and protect them, and protect them from our enemies, and keep whiskey and rum sellers out of our country" (165). Clearly, Catlin knows the Indians perform not to preserve their image for posterity nor to establish a "Museum of Mankind" but, rather, to struggle for cultural survival.

He seems aware of this struggle and chooses to feature it, declaring, "I had undertaken to stand by them as their friend and advocate—not as wild beasts, but as men . . . labouring in an honest vocation, amid a world of strangers, wiser and shrewder than themselves, for the means of feeding their wives and little children" (154–155). Catlin finishes by challenging the audience to send food and blankets to Indian families, rather than complain about his sensationalizing. In the end, he recognizes that impoverished Indian environments have in part led his ac-

tors into this situation. But Catlin's solution is one of individual charity for the vanishing, in hopes that some lives can be spared in order to assimilate. As he declared in *Letters and Notes,* he hoped someday to present "a nation of savages, civilized and Christianized (and consequently *saved*) in the heart of the American wilderness" (184). Indeed, from his perspective years later in *Eight Years' Travels,* Indian cultures now inhabit a postlament, postinevitable disappearing political reality. Once one accepts this constructed reality, presenting them on stage can only help in the now necessary and mutually reinforcing process of preserving nature and assimilating culture.

CIVILIZATION AND ITS DISGUISES

This underlying belief in assimilation, this underlying ideology concerning the need to impose civilization on a vanishing wilderness (albeit without the corruptions of frontier vices), is most clearly expressed in Catlin's final discussion of using Indians on stage. Years after these audiences and newspapers protested, between 1845 and 1846, Catlin managed a second delegation of Ojibwa in France. They performed before King Louis-Philippe, Charles Baudelaire, and George Sands. During that time, seven of the twelve Ojibwa died of smallpox under Catlin's employment (*Eight Years' Travels* 2: 302). Catlin regarded smallpox, along with whiskey (which he prohibited Indians from drinking in Europe), as the symbol of European corruption of Indians. Smallpox was a central example of the devastating influence Europe had on Indians, and he now sees himself as an agent of this influence. Finally, he sees himself and his medium as complicit in the consequences of political, military, economic, *and* performative colonialism. Catlin, crushed, concludes, "I therefore am constrained to give judgment here against the propriety of parties of Indians visiting foreign countries with a view of enlightening their people when they go back" (309).

As a tribute to the complex and disturbing power of unexamined ideologies, the way in which Catlin now speaks out against displaying Indians, the way he learns from his supposed downfall, ironically perpetuates his underlying ideological continuity. That is, the reasons he

now offers for *why* one should not display Indians abroad are the strongest manifestation of his ideology that Indians must assimilate into an exceptional American civilization that has justly inherited the American continent—so long as Indian iconography has been preserved in a Catlinian manner. Catlin's ethical critique, at its highest pitch after learning from his own perceived tragic flaw, intertwines with his underlying ideologies, also at their highest pitch. It is in this moment that his unrecognized contradictions reveal themselves to the reader. The implicit becomes explicit:

> One of the leading inducements for Indians to enter into such enterprises, and the one which gains the consent of their friends and relations around them, and more particularly is advanced to the world as the plausible motive for taking Indians abroad, is that of enlightening them—of opening their eyes to the length and breadth of civilization, and all the inventions and improvements of enlightened society . . . and making them suitable teachers of civilization when they go back to the wilderness. (2: 305)

Knowing that Catlin has just sworn off taking Indians abroad ever again and that he considers his recent experience as "a shocking argument against the propriety of persons bringing Indians to Europe," one expects him to reject the whole premise, based on a defense of Indian dignity. But the remainder of Catlin's argument cuts through this expectation and ties into ideologies he held from the beginning. He states, "By all who know me and my views, I am known to be, as I am, an advocate of civilization" (308).

Catlin's critique of displaying Indians is based on the notion that in order to reach his goal of civilizing Indians, one must avoid showing them too many of the realities of "civilization." If they see too much of civilization and its realities, with its air pollution, poverty, religious fanatics, drunkenness, tasteless scientists, and greedy crowds, he fears they will reject assimilation and will refuse to convert fellow Indians back West to civilized habits when they return. Catlin thus promotes "gradual steps that can alone bring man from a savage to a civilized state" (309). Indians

should, with all of their natural prejudices of civilized man, be held in ignorance of the actual crime, dissipation, and poverty that belong to the enlightened world, until the honest pioneer, in his simple life, with his plough and his hoe, can wile them into the mode of raising the necessaries of life, which are the first steps from savage to civil, and which they will only take when their prejudices against white men are broken down, which is most effectively done by teaching them the modes of raising their food and acquiring property. (309)

This is the most telling statement of Catlin's career. In *Eight Years' Travels,* where the reader lives in the language of Indian leaders questioning the virtues of European civilization, it seems that these questions are posed in order to reveal how Indians react to the "Far East" and thus all forms of European civilization. However, Catlin, "an advocate of civilization," writes this work, inverts wilderness and civilization, undercuts colonialism, and shares Indian subjectivity all to illustrate how to convert Indians to civilization more effectively and humanely. This is a how-to guide on assimilation. He wants Indians to choose Euro-American civilization based on a paternally managed "ignorance of" the actual social and environmental vices that support it and separate from the cultural conditions and consequences that arise from it. Never does he suggest that they should make a completely informed, rational choice to adopt "civilized" practices, flaws and challenges included, as nonetheless the best, most feasible way of living; nor does he defend Indian autonomy and choice. He merely teaches how to create fetishes of civilization to which Indians would likely consent. In so doing, Catlin in turn consents (intentionally or not) to the domineering colonial ideologies of the Jacksonian age.

Thus, just as Catlin offers imagery (which Audubon thought to be exaggerated and sanitized) of a vanishing West for American and European audiences to desire without destroying, so he hopes to offer decontextualized images of "civilization" for Indians to desire without rejecting. In both cases, the virtue of his imagery is based on distracting the viewer from its material realities. And in both cases, a filtered view of the reality is required. The separation from environments necessary in knowing "Nature" in Peale's Museum, the separation of

knowledge from problematic power in Catlin's journey west, the separation of lamented Indians from their ongoing political struggles in Catlin's American paintings and lectures, and now the separation of "civilization" from the poverty, pollution, and exploitation that sustain it are all revealed as continuous disguises throughout Catlin's career. These disguises join with a newly emerging, mid-nineteenth-century profusion of commodity fetishes of nature that justify ideologies of Indian assimilation and Euro-American expansion.

CONCLUSION

On a beautiful day in 1844, Catlin and his Iowa guests were invited to Ealing Park in London. He expresses to the reader of *Eight Years' Travels* the joy he found in bringing his Indian guests to this "natural" setting, and the scene he paints vividly captures his need to separate reality from image in order to promote his worldview of American civilization, cleansed of both the brutal destiny of the "Far West" and the corruptions of the "Far East." Moreover, this scene and the ideology driving it powerfully capture the extent to which Catlin's use of Indians in Europe epitomizes rather than breaks from his deepest ideologies, despite his financial struggles, his tragic loss of family, his transformation of education into entertainment, and the deaths by smallpox. Immediately upon entering Ealing Park, Catlin comments:

> Here was presented the most beautiful scene which the Ioways helped to embellish whilst they were in the kingdom—for nothing more sweet can be seen than this little paradise, hemmed in with the richness and wildness of its surrounding foliage, and its velvet carpet of green on which the Indians were standing and reclining, and the kind lady and her Royal and noble guests, collected in groups, to witness their dances and other assemblies. (2: 80–81)

Catlin found "paradise." For the reader, this passage exposes levels of ideology of which Catlin himself was likely unaware. The park alone, the "wildness of its surrounding foliage" alone, would not be nearly as much of a "beautiful scene" without Indians to "embellish"

it. Catlin does not desire a world unexploited by the markets of industrial civilization. He does not believe the sophisticated relations of Indians, buffalo, and prairies can persist autonomously. Catlin wants civilization always to have access to a "hemmed in" version of paradise, for the viewing pleasure of the civilized gaze.

Hemmed into this "little paradise" in this moment was an entirely depoliticized Indian. Just as Catlin painted away the politics of Black Hawk's chains and Osceola's resistance, this Ealing Park scene fulfills Catlin's lament. Audiences can "witness" the "richness" of Indian "dances and other assemblies" without engaging with Indian desires for land rights or their struggles to protect their cultural practices and environments—desires that brought Iowas to Europe in the first place. It is a sanitized view of both civilization and nature, both the "Far East" and the "Far West," removed from their contexts of poverty, pollution, and extermination. It reflects a hope to cut through prejudices on both sides of the frontier to create peace, but it is a peace without justice— an attempt to cleanse relations without addressing structural injustices driving expansion and exploitation.

After viewing this human menagerie, Catlin adds cornucopia to paradise. His version of paradise needs more than the beauty of nature separated from environmental conditions; it also needs the bounty of civilization separated from environmental consequences. "While those exciting scenes were going on, the butler was busy spreading a white cloth over a long table arranged on the lawn, near the house, and on it the luxuries they had been preparing in the kitchen" (82). Butlers serve roast beef and sirloin, parrots talk, Indians "recline" for the viewing pleasure of "the kind lady and her Royal and noble guests," while natural greenery frames it all. "One of the waiters [passed by] . . . with a huge and smoking plumpudding, and so high that we could just but see his face over the top of it" (2: 83).

This scene offers Catlin a surreal, microcosmic version of his famous "*magnificent park, where the world could see for ages to come, the native Indian in his classic attire, galloping his wild horse, his sinewy bow, and shield and lance, amid the fleeting herds of elks and buffaloes,*" envisioned at the mouth of the Yellowstone over ten years earlier (*Letters and Notes* 261–262). In fact, immediately following this culinary, visual, and ideological feast, Catlin takes the Indians to the

Surrey Zoological Gardens, "having the greatest curiosity to witness the mutual surprise there might be exhibited at the meeting of wild men and wild animals"—including a buffalo (*Eight Years' Travels* 87–91). Catlin's 1832 vision for a nation's park—recalling a time in his life before he stepped foot on a single stage, before he publicly sensationalized a single aspect of Indian life, or before a single Indian died as performer under his employment—required the same separation from environmental complexity and politically engaged Indians as the park he described on this day in 1844. Both parks represent a continuous assumption throughout his career, from Philadelphia to Paris and from ethical writings to sensationalist shows: vanishing nature and expanding civilization are best preserved, known, desired, and consumed when depoliticized and abstracted from the complexity of real environments.

The intentions of preserving an abstracted Nature and a static culture in both parks intimately coexist with Catlin's ideologies of lamenting away real Indians and environments while preserving their ghosts. Nonetheless, due to his deep faith in the ability of art and science to know the essence of nature through its frozen, humanly constructed, two-dimensional image, Catlin need not see them as ghosts. The use of Indians on stage, separate from the dignity of their family, community, and environmental relations in the West and produced for entertainment in the East, presents no downfall or tragedy. It presents the externalization and manifestation of Catlin's deepest, although most unrecognized, ideologies.

If we are content to regard nature as no more than a scenic vista, mere metaphoric and poetic description of it might suffice to replace systematic thinking about it. But if we regard nature as the history of nature, as an evolutionary process that is going on to one degree or another under our very eyes, we dishonor this process by thinking of it in anything but a processual way.
—Murray Bookchin

Once domination is complete, conservation is urgent. But perhaps preservation comes too late.
—Donna Haraway

In October 1872, George Catlin died at the age of seventy-six. He died forty years after visualizing "a nation's Park" from a solitary vantage point overlooking the Yellowstone River. Coincidentally, he died in the same year that President Ulysses S. Grant dedicated 1,600 square miles of Wyoming Territory as Yellowstone National Park. The official statute read that the park would be "set apart as a public park of pleasuring ground for the benefit and enjoyment of the people" (qtd. in Nash, *Wilderness* 108); not unlike Catlin's 1832 declaration that the park would be "for America to preserve and hold up to the view of her refined citizens and the world, in future ages!"[1]

But Catlin's national park idea did not dominate his public work. His business activities such as museums, galleries, and living performances of Indian life and western scenes overshadowed this protoconservationist revelation. One is hard-pressed to find much evidence of his reaction to debates over Yellowstone in the final years of his life. The extensive collection of Catlin's letters, compiled by Marjorie Roehm, and Catlin's catalogs of his shows do not discuss a park. His career aimed primarily to preserve a nature of a different kind from that of conservationists and national park advocates later in the century. He wanted to preserve "Nature" as that which makes the American "primitive" past intelligible, inspiring a generation of Americans whom he hoped would be more virtuous than their European counter-

parts and frontier predecessors—specifically because of exposure to this preserved Nature. Still, the temporal symmetry of Catlin's death coinciding with Yellowstone National Park's birth and the geographic symmetry of his original vision for a park occurring on a river bearing the park's future name have earned Catlin a historical reputation as the official founder of the Yellowstone idea.

Consequently, George Catlin's work—along with the natural sublime of William Bartram, the conservationism of James Fenimore Cooper, the animal empathy of John James Audubon, the transcendentalism of Henry David Thoreau, and the preservationism of John Muir—inhabits a spot in the pantheon of early American environmental thought, largely because of this brief, visionary call for a nation's park. Chief among the "firsts" that Catlin achieves in the historical imagination, in addition to first ethnographic painter of the West (Ewers, McCracken, Truettner, Allen) and first Wild West showman (Reddin, Dippie), historians find in him the first policy advocate for national conservation (Mazel, Nash, Kline, Opie). As Roderick Nash asserts, Catlin was "the *first* to move beyond regret to the preservationist concept [emphasis added]" (*Wilderness* 100). This connection to Yellowstone boosts Catlin's declaration to a timeless ecological identity.

Beyond rhetorical symmetry and literary symbolism, is it accurate to connect Catlin and the first national park so closely? The brevity of his vision makes it neither insincere nor trivial. His critique of the West concludes both volumes of *Letters and Notes*. His hope for a park closes the opening volume of *Letters and Notes*, a book that he wrote and revised for years, based on thousands of miles of travels and hundreds of shows exhibiting the fruits of those travels. Looking back in 1841 over a decade's experience exploring the West and engaging eastern audiences, Catlin made a decision in *Letters and Notes* to question his readers' views and uses of western spaces. Indeed, he leaves it to his reader, "Reader, I will stop here, lest you might forget to answer these important queries—these are questions which I know will puzzle the world—and perhaps it is not right that I should ask them" (264). His proposed park serves as the central symbol of "these important queries" posed by Catlin—unsettling queries about the buffalo trade, negative stereotypes of Indian lifeways, and the subsequent extermination of Indian societies. In this way, although brief, Catlin's vision

for a park marks him as a pioneer in social and environmental thought in the American West. It marks him as one who attempted to expand views and uses of the West beyond industrial extraction.

Perhaps more important, however, the early history of Yellowstone also epitomized the ideology that unifies Catlin's career and undermines his expressed ethical intentions, from his training in Peale's Museum to his misfortunes in Europe. Nineteenth-century Yellowstone exemplified the way in which Catlin abstracted Nature from environmental and cultural conditions in order to preserve and sell a palatable construction of it. Thus, just as he exemplified the complicated combination of seeking ethical change through entrepreneurial ambition, so Yellowstone marked an effort to preserve nature specifically through its commodification.

THE "NATURE" OF YELLOWSTONE

In many ways, of course, Yellowstone should be seen as a significant historical development toward conservation. Proponents argued that it was "a great breathing space for the national lungs" (Nash, *Wilderness* 114). The statute establishing the park suggests that the industrial extraction of "timber [and] mineral deposits" from the park would be prohibited, thus nationally recognizing and protecting the intrinsic value of certain environments in the face of intense commodification of the continent. But even Yellowstone was not free from being valued as a commodity that could be extracted for profit. It was packaged to serve the new interests of male, American tourists, frustrated with the emasculating confines of urban, middle-class life.

This new western tourist economy that eventually brought millions per year to Yellowstone was originally promoted by the powerful railroads of the late-nineteenth-century United States, which saw a "pragmatic alliance" with the parks (Runte 80). The political legs under Yellowstone came from profit-seeking railroad companies as much as wilderness advocates (Opie 398). Jay Cooke's Northern Pacific Railroad lobbied Congress and heavily advertised the park throughout the 1870s. Yellowstone was not alone in its railroad connections. The Northern Pacific promoted Rainier National Park in 1897; the Great

Northern pushed for Glacier National Park in 1899; the Union Pacific advocated for the Grand Canyon, while the Southern and Central Pacific railroads supported Yosemite (Sellars 12). These railroad companies, also the driving force behind opening up the prairies and forests of the West to aggressive timber harvesting, cattle ranching, wheat farming, mining, and cotton planting, pushed for parks that would not allow the extraction of raw materials. The central asset of these regions, equally as profitable (from the railroad's point of view) as meat and wheat and ore, was what Yellowstone's statute called "natural curiosities, or wonders . . . in their natural condition" (qtd. in Nash, *Wilderness* 108).

When Congress approved Yellowstone, they mainly approved the donation of land. As with Catlin's Gallery Unique half a century earlier, Congress refused public funding to run the new park, except for deploying the army to protect the borders from Native Americans. Yellowstone's early superintendent, Philetus Norris, was given little money for his park and had to rely on railroad-driven tourism (Chase 109). The American interest in "natural curiosities," enjoyed since P. T. Barnum promoted General Tom Thumb and Catlin advertised "real" and "wild" Indians, would dominate the view of Yellowstone's "Nature." Even the Hayden Survey's scientific arguments to Congress on behalf of Yellowstone argued for the preservation of a place where people could see "freaks and phenomena of Nature" along with "wonderful natural curiosities" (qtd. in Nash, *Wilderness* 113). Nash concludes that "Yellowstone's initial advocates were not concerned with wilderness; they acted to prevent acquisition and exploitation of geysers, hot springs, waterfalls, and similar curiosities" (108).

The construction of a "natural" landscape of curiosities and freaks, prepared for the public's viewing pleasure, distracted the public from the complex, 10,000-year history of the area's environment and culture. Defending a national natural space during a time of Manifest Destiny, proponents argued that Yellowstone offered Americans a heritage rooted in the beauty of God's work. Contrasted with Europe's claim to an ancient connection to place based on ruins of cities, cathedrals, and castles, through national parks and "Nature" the United States could connect to an exceptional and ancient past on their newly adopted continent—a movement that historian Alfred Runte calls monumen-

talism, as opposed to the early "environmentalism" for which the parks are often credited (Runte 29–33). Just as Catlin gave Americans an exceptional and future inheritance of the West through his lament, Yellowstone now offered an ancient inheritance of the same continent, in the form of vast, uniquely carved, "monumental" space. Yellowstone translates Catlin's postvanished cultural monumentalism into a post-vanished environmental monumentalism, preserving the awe-inspiring, Godlike essence of American Nature.[2]

However, God or Nature alone did not carve Yellowstone. Indians had shaped much of the land's flora and fauna found by American tourists in 1872. Shoshone, Crow, and Blackfoot Indians had "immeasurably" altered the ecosystem of the region over a *longue durée* (Chase 105). Over these millennia, Indian hunting practices influenced the extinction of megafauna, while broadcast burnings of forests and prairies regenerated nutrients requisite for diverse vegetation and, in turn, grazing for diverse species of animals (Krech 23). The breathtaking and abundant wildlife was in part the product of centuries of intelligent land use. Slowly, tribes molded to the land and the land molded to the practices of Indian economies and cultures. What Grant inaugurated as "natural" was the product of extensive human knowledge of and social organization within a dynamic, ever-shifting ecosystem.

Tragically, large numbers of Shoshone, Crow, and Blackfoot were decimated by smallpox. Moreover, ethnocentric assumptions dating back to the earliest periods of American colonialism considered Indians "part" of nature. Indian cultures were deemed incapable of meeting a criterion of ownership rigidly defined through the private use of property and the taming of "wilderness" (Steinberg, *Down to Earth* 20). By 1872 the complex text of the Yellowstone landscape, written by a sophisticated history of Indian use, seemed written by God or Nature. Owing also to a fear that a native presence would scare off tourists, Superintendent Norris and railroad interests erased this environmental and cultural text from their promotions of the park. Norris told tourists that Indians traditionally avoided Yellowstone Park because of a primitive fear of spirits haunting the geysers. In fact, Indians cooked food over those geysers, but such information did not fit a construction of cultureless Nature that could guarantee pleasure, renewed vitality, and self-discovery for the white American consumer. The

Shoshone, Sheepeater, and Bannock tribes of Yellowstone had been *physically* removed to Idaho in the 1870s. The park *conceptually* removed them for another century (Chase 107–109).

Romantic ideologies conceptually extracted and abstracted "Nature" from complicated ecological cycles and cultural history. Not only was Nature separate from geography, "Nature" also shrouded environmental and cultural realities. In the context of the era's new market economy, this separation distracted mass audiences from ethical quandaries involved in producing and consuming the influx of commodities. The most viable connection between George Catlin and Yellowstone National Park exists in the fact that each represented environmental and cultural relations that produced "Nature" for mass consumption. The connection exists in fetishes of Nature.[3]

CATLIN'S FETISH: THE TROUBLE WITH NATURE

This view of Yellowstone as a fetish of nature, as a desired commodity separate from environmental and cultural histories, exemplifies Catlin's environmental ideology. As discussed throughout the chapters of this book, Catlin subscribed to scientific assumptions of his time and therefore abstracted nature from environments since the outset of his career. In Chapter One Catlin is shown separating parts of enlightenment Nature from the whole, complicated context of environments in the West. Just as Peale viewed western nature as best known and protected in eastern museums, out of the chaos of the unenlightened West, so Catlin felt the essence of Nature (which for him included Indian cultures) could be sufficiently preserved and made intelligible on a canvas or a stage, allowing tribes to be humanely (he hoped) assimilated in the West. The cultural and environmental relations needed to be hidden and depoliticized (intentionally or not) for this fetishized Nature to be preserved. Otherwise, if still politically activated and not hidden, the complex people behind these images would demand solidarity with continuing political struggles rather than attracting melancholy observation in the privileged comfort of an urban gallery.

Chapter Two explores the problematic politics of Catlin's attempt to portray Indian and western nature. In order to paint his suffering

buffalo, in order to argue that its death legitimately served scientific knowledge, Catlin needed to believe that Indian economies (required to perpetuate the buffalo's survival) were no longer feasible. He not only tried to sanitize his artistic gaze from other forms of imperialism in the West, he also fetishized Indians, animals, and landscapes as no longer complex, no longer organically functioning, no longer involved in future relations.

In Chapter Three, Catlin's lament, probably offered as a challenge to audiences, industry, and government, primarily distracted audiences from continuing political struggles. Though the lament celebrated the political struggles of Osceola and Black Hawk, it celebrated them as "ghosts."[4] *Ghosts* seem an appropriate analogy for the fetishes Catlin formed out of his lament, as his saddened acceptance of Indian death and his softening of their continuing dissent against the American republic reduced them, politically, to ghosts.

In Chapter Four, Catlin's performances in Europe illustrate the extent to which his lament (in Chapter Three) prepared Indians as commodities for exchange. In Europe, rather than exhibiting a downfall from high principles, Catlin's attempts to preserve Nature continued to hide environmental and cultural relationships, submerged since his first epiphany to go west. He merely exchanged his ghosts on a more blatant level in Europe. As with the founding of Yellowstone, throughout his career this suppression of continuing Indian environmental and cultural struggles enabled Catlin to construct a definition of Nature that claimed the continent as naturally Euro-American and fueled audience desires to consume "Nature." Similarly, Nature needed to be a fetish in order for railroads to promote underfunded national parks to a mass-market economy. The concept "fetish" not only explains Yellowstone's construction of a nature severed and distracted from its environment; the concept also explains the seemingly declensionist and hypocritical, but actually ideologically continuous career of George Catlin—continuous ideologies underlying equally continuous and quite hopeful visions for a more just society.

Forty years before Yellowstone's 1872 induction, however, Catlin was not alone in constructing both "civilization" and "wilderness" as separate from the underlying cultural, social, and environmental relationships that produced them. He was not alone in separating civi-

lization and wilderness from their material realities, thus ultimately making them more palatable and less ethically complicated for consumers. This very separation, in fact, defined the political and economic development, as well as the cultural and environmental exploitation, of Catlin's age—an age he sincerely attempted to challenge throughout his career.

Emerging global-market economies in the mid-nineteenth century required the disunion of commodities of desire from conditions of extraction and production. In *Down to Earth,* an environmental history of commodities in America, Theodore Steinberg explains:

> The single most powerful tool for parceling out resources was the concept of a commodity. By conceiving things such as water and trees as commodities, rather than as the face of nature, and putting a price on them, it became possible to efficiently manage and relocate what had now become resources. Reduced to economic units, elements of nature were moved about the country like pieces on a chessboard, redressing resource deficiencies whenever they arose and contributing to one of the greatest economic booms in the nation's history. (55)

Factories multiplied, railroads expanded, and canals were built—all to extract from complex natural ecosystems and cultural places resources that could be moved into factories and transformed into commodities for global markets. The Indian lands that Catlin fetishized on canvas, those "green fields" abundant with buffalo, were already commodities for the expanding republic. Ecologically and culturally complex buffalo commons (buffalo-based communities) became rationalized resources for wheat and cattle, and inanimate storehouses for commodities of bread and beef (61).

Does this mean that Catlin consciously translated relationships into fetishes to facilitate personal profit? Of course not, since ideological participation is rarely the consequence of conspiracy. Nonetheless, the disinclination to question his ideologies of Nature allowed Catlin in even his most high-minded work to support the underlying logic of a system that would destroy the lands and peoples he loved. That very system benefited greatly from separations from distant resource en-

vironments. Hidden behind bread or steak for sale were white-supremacist Indian removal policies employed to transform buffalo commons into wheat or cattle factories. Hidden behind the promise of land and opportunity was the fact that buffalo over the millennia had become a keystone species, inhabiting, consuming, weighing down, and fertilizing the prairie grasslands—creating habitat for hundreds of species of flora and fauna, and economic livelihood for numerous cultures. Hidden behind the logic of expansion was the fact that the reduction of prairie sites from 250 plant species to 4 species resulted from this desire for commodities (LaDuke 146). Hidden behind the claimed necessity of economic growth was the reality that perceptions of women as property justified the exploitation of female factory labor needed to alter massive amounts of abstracted resources into even more abstracted commodities. Hidden behind an expanding middle class were the polluted eastern rivers fueling these factories and absorbing their waste. Hidden behind churning machinery was the loss of a poor farmer's land, flooded in order to construct the dam necessary to power the factory (Steinberg, *Nature Incorporated* 140). And hidden behind the iconographic Goddess of Liberty were the brutalities of plantations, whose forced slaves harvested the timber and cotton necessary for this market revolution.

Without Indian removal, slavery, the exploitation of female labor, and the loss of biodiversity, one would have found it significantly more difficult to produce mass amounts of commodities. But few were asked to consider whether or not they ethically chose to consent to such commodities with this sweeping and spiraling context in mind. Few were asked to choose whether or not they agreed with the forms of labor, cultural, or environmental exploitation concealed behind a commodity fetish. Such is the "magic" of commodity fetishes, asking us only if we desire the final, polished product.[5] Steinberg concludes, "Commodities have a special ability to hide from view not just the work, the sweat and blood that went into making them, but also the natural capital, the soil, the water, and trees, without which they would not exist" (70). Commodity fetishes made the expansion and extraction of the nineteenth-century United States seem the best of all possible worlds, especially for those not living with the consequences of commodious comforts. Among the "firsts" attributed to Catlin, we

ought to look carefully and critically to him as the first "green capitalist." That is, Catlin was the first to offer Nature as a desirable commodity for popular markets in an effort to cleanse civilization of its faults; he is the first to hope that the capitalist exchange of certain "natural" commodities might preserve Nature and absolve America of ecocultural extermination.

If ethics is the attempt to shape individual choices to serve the public good beyond private benefit, then these emerging commodity relationships—hiding from view consequences and thus limiting fully deliberate choices—made ethics in this age of expansion extremely elusive. *Catlin's Lament: Indians, Manifest Destiny, and the Ethics of Nature* looks at one individual who set out to address the ethical conundrum of his times but enacted the very narratives that limited the possibility of ethics. Ultimately, rather than a moral judgment of Catlin, this analysis indicts the logic of domination that engulfed a formative era in U.S. history—to the point that it reduced even its most visionary critics to participants in consensus. This study, through an empathetic analysis of Catlin's "blind spots," fundamentally seeks to question individual ethical endeavors that leave such cultural narratives and underlying ideologies unexamined, thus leaving structural injustices unchallenged. Moreover, this study questions environmental and social solutions that accept as defeated, and thus silence as irrelevant, those disempowered voices challenging flawed assumptions.

When a devoted dissenter of an unjust era himself subscribes to an ideology that underlies the injustice, we have a responsibility in the present not to praise or blame that individual, but to do our best to understand and interrogate that ideology. As an imperfect being living with intricate conflicts between my own ethical hopes and unexamined ideologies in the twenty-first century, I, through my study of this influential environmental and cultural critic, am left with a humbling question. How is environmental ethics possible within an ideology that defines *Nature* as distinct from relentlessly intermingling human and ecological systems?

As we look to a human-caused climate crisis in which over a billion poor are predicted to lose the life-giving waters of vanishing Himalayan glaciers by 2035, as we witness the Inuit face a new kind of Indian removal resulting from melting ice, and southwestern tribes con-

fronting theirs from dwindling stream flows, Catlin's lament symbolizes a missed but still available environmental opportunity to engage with the protests of the disempowered (UNEP; Black; Hanna 22). It urgently calls upon us to involve displaced cultures as active and equal partners in sustainable solutions, rather than accept displacement as the inevitable consequence of a "natural" cycle. So long as a "Nature" constructed as separate from human societies and hierarchies is explained as the source of crises ranging from drought and hurricanes to human refugees and species extinction, we need to interrogate our history of thinkers who constructed and fought for the preservation of this abstract, cultureless Nature. Therefore, this book implicitly asks whether such a rethinking of Catlin, of a thinker who sparked still-formative environmental ideals, compels us to imagine an environmental ethic without "Nature."

Notes

INTRODUCTION: CATLIN'S ETHICS AND IDEOLOGY:
THE AGE OF JACKSON

1. Unless otherwise noted, I will refer throughout this book to volume 1 of George Catlin's two-volume classic, *Letters and Notes on the Manners, Customs, and Conditions of North American Indians.*

2. Throughout this book, the capitalized "Nature" refers to a romanticized, abstracted, and idealized definition of non-"settled" environments and cultures popular at the time. Moreover, this Nature was defined as the rational order driving the universe more than the actual objects found in the nonwestern, non-"civilized" world. It is this ideal Nature, developed by enlightenment thinkers of previous generations (some of whom sought to replace "God" with "Nature") and elevated to the level of the "sublime" by romantic and protoenvironmentalist thinkers like Catlin. Chapter One defines this concept with greater detail and historical context.

3. One does not find in Catlin's family letters or in his catalogs of shows extensive evidence that he spent the daily moments of his career contemplating his ethical responsibility to "vanishing" cultures and landscapes. However, and significantly, across his published literary career, from his 1841 *Letters and Notes* looking back on twenty years of his thought, to his 1848 *Notes of Eight Years' Travels and Residence in Europe,* to his 1861 *Life among the Indians,* Catlin makes direct choices to engage his readers ethically. He worked for years on each text, intended for a broad public and shaped by careful decisions concerning how to interest and concern his reader. It is important that he is particularly challenging in the introductions and conclusions of his works. The art and ethnography in these texts are framed and thus contextualized in terms of his ethical questions, cultural critiques, and political visions.

CHAPTER ONE: CATLIN'S EPIPHANY

1. One also notices the woman to the left. Her arms elevated in awe, she experiences the sublime moment of finally seeing primitive, chaotic nature transformed into her experience of Nature, of knowledge. She is a significant figure in this portrait, as women (guided by Peale's self-effacing hand) were

considered central to the early republic's success. Peale saw his museum as a site of class, cultural, political, and intergender engagement. He saw his museum as essential to an educated citizenry, and he places this woman in the service of this education. However, the woman embodies an essential component of Peale's mission of republican education, albeit in a highly patriarchal context—virtue. Given that Peale believed that laws of Nature would enlighten the viewer through his museum displays, the mastodon engenders an awe of nature in the woman that, in the ideological paradigms of gender in the early republic, would prepare her for perpetuating a virtuous home life and raising future male citizens—according to the dictates of enlightened Nature and its laws. As historian Jan Lewis states, "Marriage [and the family] was the republic in miniature [not unlike Peale's claim that his museum was nature in miniature] . . . like republican citizens, husband and wife were most likely to find happiness when . . . they shared . . . the same education" (710). Similar to the natural education offered to this woman in this moment, the mastodon from which she learns has gone through the process of becoming enlightened Nature. Thus, the mastodon represents the *process but not yet the product* (since it still is not yet entirely put together, judging from bones strewn about and the shaded tone) of enlightening a dark continent—a beast made divine. The woman represents the *product but not the political process* (the process is reserved for men like Peale) of Peale's vision to enlighten a dark continent through extracting, producing, and preserving Nature.

CHAPTER TWO: CATLIN'S GAZE

1. Critical theorist Michel Foucault offers a thorough examination of the relationships that arise when someone in an intellectual position of power gazes upon individuals and groups not in power. This examination is instructive in grasping how Catlin positions himself upon first contact with these "wild men." In *The Birth of the Clinic*, Foucault discusses the ways in which scientific approaches to knowledge in the early nineteenth century connected seeing with knowing, and in turn connected knowing with power. He names this approach a "gaze." Foucault's gaze assumes that anything that comes within one's visual focus will be known, almost possessed. The gaze establishes that something is known once it is seen—it determines which kinds of observation or experience get to be called "knowledge." As Foucault concludes: "The gaze is not faithful to truth, nor subject to it, without asserting, at the same time, a supreme mastery: the gaze that sees is a gaze that dominates" (39). I would alter

this slightly in stating that the gaze *does not necessarily dominate*, but it highlights what kinds of groups get to gaze (those rendered scientifically legitimate thinkers in Catlin's time), what kinds of groups get gazed at (nonwestern in Catlin's context), and therefore who is *in a position to dominate* when politically or economically necessary or convenient.

2. One fabled story about Thoreau and Emerson's relationship tells how when Thoreau spent his time in jail for refusing to pay taxes that supported slavery and war, Emerson asked him, "What are you doing in there?"—to which Thoreau replied, "What are you doing out there?" (Zinn 156).

CHAPTER THREE: CATLIN'S LAMENT

1. Brian Dippie's book *The Vanishing American* offers a thorough history of this ideology of Indian vanishing and its impact on white acceptance of U.S. Indian policy. Of Catlin's lament, Dippie rightly states, "The Vanishing American validated Catlin's entire endeavor" (28).

2. By "natural equality" here, Jefferson does not mean an equal role in society; he means "equal" in proportion to women's "natural" inferiority, setting an important precursor for the ideologies of "Republican Virtue" that dominated gender relations in the nineteenth century.

3. "King Philip" was a nickname given to Metacomet by his English enemies, out of shocked respect for his leadership skills.

4. The following interpretive list of Indian plays springs from Marilyn Anderson's detailed article "The Image of the Indian in American Drama during the Jacksonian Era, 1829–1845."

5. Other plays without "last" in the title, such as George Washington Parke Curtis's 1830 *Pocahontas; or the Settlers of Virginia* and Robert Dale Owen's 1837 *Pocahontas; or an Historic Drama* offer similar themes (Anderson 807). Richard Penn Smith's 1829 play *William Penn* shows Penn rescuing Indians from "ignorance, idolatry, and cruelty" (Anderson 808). Nathaniel H. Bannister's 1844 play *Putnam, the Iron Son of '76*, played seventy-eight straight nights in the Bowery Theater. Anderson, in concluding her sweeping summary of Indian plays, states, "Though they focused some attention on the gross mistreatment of the Indian, they also reinforced the idea that the red man was not fully a human being and that his displacement was ultimately justified" (810).

6. For more on the role of nature in legitimating this politics of purity and separate gender spheres, see Carolyn Merchant's "From Corn Mothers to Moral Mothers," in her *Earthcare*, pages 91–108.

7. Forrest was well known for his patriotic approach to acting. It was Forrest, after all, who hissed at British actor William Macready's portrayal of MacBeth, because Macready was too stuffy of an actor and did not reflect the exceptional passion of the U.S. actor. This hissing eventually led to a big rivalry between Forrest and Macready over who would best play the lead in Macbeth. The competition represented much more than acting; it indicated a struggle over national identity. The War for Independence long over, Americans in the Jacksonian era still hoped to break free culturally and show the superiority of the U.S. republic embodied in art, theater, and literature. Forrest represented the non-property-owning democratic citizen of the Jacksonian age, with his masculine, unpolished portrayals of characters, versus Macready's overtrained approach. When Macready played the lead in Macbeth at the elite Astor Place Opera House, Forrest played across town at the working-class Bowery Theater. According to historian Jim Cullen, the rivalry spilled outside of the theater, with Forrest's supporters waiting for Macready outside of Astor Place, holding signs reading "WORKING MEN, shall AMERICANS OR ENGLISH RULE in this city?" (58). By the end of the night, a militia had arrived and eventually opened fire. "At least twenty people died and over 150 were wounded" (59).

8. Living in an age of "humbug," an age in which audiences found themselves fooled by P. T. Barnum's "FejeeMermaid" (really a monkey's skull fused to a fish's skeleton; Harris 62–67), audiences were suspicious of Catlin's motives in filling theaters and galleries with such humanized and dignified views of Indians.

9. Catlin lists fifty different newspaper reviews of his shows, from both Europe and America, in "Appendix A" of *Notes of Eight Years' Travels and Residence in Europe.* "Appendix C" of *Eight Years'* prints his "Catalogue" from the mid-1840s.

10. Black Hawk's skeleton was displayed for years following his death. Catlin, however, did not display it. But one wonders how differently Catlin's painting of Black Hawk functioned in a context of removal.

11. Other individual Indians of note were also featured, in addition to other tribes. According to Kathryn Hight, throughout his playbills of this period, "the only identifiable Indian individuals mentioned were nationally famous men recently defeated and captured by superior white forces" (121).

CHAPTER FOUR: CATLIN'S TRAGEDY: CATLIN IN EUROPE

1. Many historians describe this as Catlin's "downfall" (Haberly 152). Historians depict his thirty-two-year journey to Europe as an odyssey of gradual

ethical abandonment of his first principles. Brian Dippie, in his extensively researched *Catlin and His Contemporaries*, states, "In England he had reordered his priorities, advertising his gallery as an elaborate amusement" (110). Paul Reddin, in his thorough work *Wild West Shows*, on Catlin as pioneer of these shows, claims, "financial exigencies had caused Catlin to stray from his first principles" (47). Dippie and Reddin suggest that the demands of European audiences and the pressures of financial loss led Catlin to sensationalize his educational message into entertaining spectacle. Mulvey, in an essay on Catlin, explains that "Catlin wanted to make a fortune as an entrepreneur and to make a reputation as an ethnographer, and those ambitions produced moral schizophrenia" (81). Sharon Fairchild, in an essay entitled "George Sand and George Catlin—Masking Indian Realities," argues that Catlin neglected his hopes to destereotype the Indian savage when faced with the assumptions and demands of European audiences. "Catlin knew very well that they were far from being native children of the wilderness. . . . Nevertheless, in Europe Catlin touted them as being living examples of noble savages" (442).

2. From this point forward in this chapter, unless otherwise noted, all Catlin citations will refer to his 1848 work, *Notes of Eight Years' Travels and Residence in Europe*.

3. According to Paul Reddin, "All of the $9,433 paid by 32,500 persons to hear the lectures and see the gallery that first year went to pay the bills" (31).

4. It also, as Reddin would point out, becomes a method of filling theaters and paying debts. As Reddin says, "Catlin apparently saw no contradiction between promoting the authenticity of everything in his show and role-playing" (32). Mulvey agrees with Reddin that the groundwork for a downfall had been laid. "Play acting as Indian was prelude to Catlin's including a theatrical dimension into his Indian Exhibition by hiring 20 men and women to put on Indian costume to make *tableaux vivants*. They staged eleven war scenes and eight domestic scenes to illustrate the lectures that Catlin gave on Indian life" (253).

5. Paul Reddin, in the company of a number of Catlin historians, concludes, "Such tastelessness would continue to mark Catlin's advertising" (35). According to Lloyd Haberly, Catlin "did not notice that evening clothes and refined faces were fewer and fewer among his hearers. Blinded by good American pride in the wild men that only his Wild West could breed, he proudly and exultantly repaired his downfall" (152). Marjorie Roehm highlights that Catlin was "condemned by the press for exploiting the Indians for his own gain[;]

. . . his good name took a fast swoop downward" (262). Reddin declares, "Catlin had moved from being an educator in the lyceum mold to an entertainer whose shows became sensational enough to invite ridicule" (37). Dippie points out this shift with even more detail: "Once he had been the Indian's champion, describing their unfamiliar cultures and pleading for justice in lectures brimming with conviction[;] . . . he had a claim on the public conscience, acknowledged when city officials granted him free use of Faneuil Hall for a month; he could say with Daniel Webster, 'Hear me for my cause' and expect the respect due a serious advocate. That was the company he had wanted to keep. But in England he had reordered his priorities, advertising his gallery as an elaborate amusement" (*Contemporaries* 109–110).

CONCLUSION: CATLIN'S FETISH

1. As mentioned, many environmental historians find enough compelling similarities to locate Catlin at the origins of American environmentalism. Benjamin Kline declares that Catlin's "arguments for preserving wilderness in the United States initiated the idea for national parks and, in particular, the creation of Yellowstone National Park" (35). Roderick Nash professes, "The birth of the national park idea in the United States can be dated quite precisely[,] . . . May, 1832" (*American Invention* 728), referring of course to Catlin's vision. Environmental historian John Opie concurs (370).

2. This monumentalist view eventually begets the protests of John Muir, in his failed efforts to preserve the Hetch Hetchy Valley of Yosemite National Park: "Dam Hetch Hetchy! As well dam for water-tanks the people's cathedrals and churches, for no holier temple has been consecrated by the heart of man" (262).

3. Economic theorists as far back as Karl Marx have expressed concern with the production of commodities in capitalist markets. The concern centers on the consequences for environmental, cultural, and labor conditions when commodities act as fetishes. Thomas Keenan, in his essay "The Point Is to (Ex)Change It," explains, "In these societies where the capitalist mode of production prevails, something (economic) shows itself by hiding itself, by announcing itself as something else in another form" (157). Upon reading this quotation, one reflects immediately on Yellowstone's need to "announce itself" as a "natural curiosity," a "freak" of nature, and thus to "hide itself" as a nonhuman space created by God and devoid of an environmental, cultural, or historical context (Nash, *Wilderness* 108, 113). This act of hiding whole contexts

within commodities of desire creates a "fetish"—a mere desired part, abstracted from an undesirable whole historical relationship.

4. Fetish theorists argue that commodities must be abstracted artificially as simple and equivalent parts from an otherwise complex and infinitely various whole in order to be exchanged (Keenan 164). In order to be exchanged as equivalents, things must be universalized in a way that hides and erases the far-from-equivalent environmental, cultural, or labor conditions producing them. What is left of a commodity's original environmental and cultural relations of production (now hidden), embodied in the commodity form it now presents to the world, is a ghost—a phantom of an actual relationship—"In the rigor of the abstraction, only ghosts survive. The point is to exchange them" (Keenan 168).

5. Commodities, as Emily Apter points out (quoting literary theorist Abdul R. JanMohamed) in her "Introduction" to *Fetishism as Cultural Discourse,* "transmute all the specificity and difference [of nature] into a magical essence" (7).

Works Cited

Alexie, Sherman. "How to Write the Great American Indian Novel." *The Summer of Black Widows*. Brooklyn, NY: Hanging Loose Press, 1996. 94.

Allen, J. L. "Horizons of the Sublime: The Invention of the Romantic West." *Journal of Historical Geography* 18 (January 1992): 27–40.

Anderson, Marilyn J. "The Image of the Indian in American Drama during the Jacksonian Era, 1829–1845." *Journal of American Culture* (Winter 1978): 800–810.

Apter, Emily. "Introduction." *Fetishism as Cultural Discourse*. Ed. Emily Apter and William Pietz. Ithaca, NY: Cornell University Press, 1993. 1–9.

Audubon, John James. "The Ornithological Biography." *Audubon: Writings and Drawings*. Ed. Christopher Irmischer. 1831; New York: Library of America, 1999.

———. "Missouri River Journals." *Audubon: Writings and Drawings*. Ed. Christopher Irmischer. 1843; New York: Library of America, 1999.

Bank, Rosemarie K. "Staging the 'Native': Making History in American Theater Culture, 1828–1838." *Theater Journal* 45 (1993): 461–486.

Bartram, William. *Travels through North & South Carolina, Georgia, East & West Florida, the Cherokee Country, the Extensive Territories of the Muscogulges or Creek Confederacy, and the Country of the Chactaws*. Ed. Thomas P. Slaughter. New York: Library of America, 1996.

Berkhofer, Robert F. *The White Man's Indian: Images of the American Indian from Columbus to Present*. New York: Vintage Books, 1979.

Bird, S. Elizabeth. "Introduction: Constructing the Indian, 1830's-1990's." *Dressing in Feathers: The Construction of the Indian in American Popular Culture*. Ed. S. Elizabeth Bird. Boulder, CO: Westview Press, 1996.

Black, Richard. "Inuit Sue over US Climate Policy." *BBC News*. December 8, 2005. http://news.bbc.co.uk/1/hi/sci/tech/4511556.stm.

Bookchin, Murray. "What Is Social Ecology?" *Environmental Philosophy: From Animal Rights to Radical Ecology*. 4th ed. Ed. Michael Zimmerman, J. Baird Callicot, Karen J. Warren, Irene J. Klaver, and John Clark. Upper Saddle River, NJ: Pearson/Prentice Hall, 2005.

Brilliant, Richard. *Portraiture*. London: Reaktion Books, 1991.

Bruchey, Stuart. *Enterprise: The Dynamic Economy of a Free People*. Cambridge, MA: Harvard University Press, 1990.

Cappon, Lester J., ed. *The Adams-Jefferson Letters*. Chapel Hill: University of North Carolina Press, 1959.

Catlin, George. *Letters and Notes on the Manners, Customs, and Conditions of North American Indians*. 2 vols. 1841; New York: Dover Publications, 1973.

———. *The Letters of George Catlin and His Family: A Chronicle of the American West*. Ed. Majorie Catlin Roehm. Berkeley: University of California Press, 1966.

———. *Episodes from "Life among the Indians" and "Last Rambles."* Mineola, NY: Dover Publications, 1959.

———. *Notes of Eight Years' Travels and Residence in Europe*. 2 vols. New York: Burgess, Stringer, & Co., 1848.

Chase, Alston. *Playing God in Yellowstone: The Destruction in America's First National Park*. Boston: Atlantic Monthly Press, 1986.

Conn, Steven. *History's Shadow: Native Americans and Historical Consciousness in the Nineteenth Century*. Chicago: University of Chicago Press, 2004.

Cooper, James Fenimore. *The Leatherstocking Tales*. 2 vols. 1824; New York: Library of America, 1985.

Crary, Jonathon. *Techniques of the Observer: On Vision and Modernity in the Nineteenth Century*. Cambridge, MA: MIT Press, 1990.

Cronon, William. *Nature's Metropolis: Chicago and the Great West*. New York: W. W. Norton, 1991.

Cronon, William, and Richard White. "Indians in the Land." *American Heritage* (August/September 1986): 19–25.

Cullen, Jim. *The Art of Democracy: A Concise History of the United States*. New York: Monthly Review Press, 1996.

Davis, Ann, and Robert Thacker. "Pictures and Prose: Romantic Sensibility and the Great Plains in Catlin, Kane, and Miller." *Great Plains Quarterly* 6 (Winter 1986): 3–20.

Deloria, Philip J. *Indians in Unexpected Places*. Lawrence: University Press of Kansas, 2004.

———. *Playing Indian*. New Haven, CT: Yale University Press, 1998.

Descartes, Rene. *Meditations on First Philosophy*. Trans. Donald A. Cress. Indianapolis: Hackett Publishing, 1993.

Dippie, Brian W. "Green Fields and Red Men." *George Catlin and His Indian Gallery*. Ed. George Gurney and Theresa Thau Heyman. Washington, DC: Smithsonian American Art Museum/W. W. Norton, 2002. 28–61.

———. *Catlin and His Contemporaries: The Politics of Patronage*. Lincoln: University of Nebraska Press, 1990.

———. *The Vanishing American: White Attitudes and U.S. Indian Policy*. Lawrence: University Press of Kansas, 1982.

Douglass, Frederick. *Narrative of the Life of Frederick Douglass: An American Slave, Written by Himself*. New York: Signet Classics, 1997.

Drake, Benjamin. *Life and Adventures of Black Hawk, with Sketches of Keokuk, the Sac and Fox Indians, and the Black Hawk War*. 1838; Cincinnati: George Conclin Press, 1846.

Emerson, Ralph Waldo. "Nature." *Emerson: Essays and Lectures*. Ed. Joel Porte. 1836; New York: Library of America, 1983. 5–50.

Ewers, John C. *George Catlin: Painter of Indians of the West*. Washington, DC: Smithsonian Institution, 1955.

Fairchild, Sharon L. "George Sand and George Catlin—Masking Indian Realities." *Nineteenth-Century French Studies* 22 (Spring–Summer 1994): 439–449.

Faragher, John, et al. *Out of Many: A History of the American People*. Brief 2nd ed. Upper Saddle River, NJ: Prentice Hall, 1999.

Foucault, Michel. *The Birth of the Clinic*. New York: Vintage Books, 1994.

———. "Truth and Power." *Power/Knowledge: Selected Interviews and Other Writings*. Ed. Colin Gordon. New York: Pantheon, 1980. 51–75.

Freccero, Carla. *Popular Culture: An Introduction*. New York: New York University Press, 1999.

Gaard, Greta, and Lori Gruen, "Ecofeminism: Toward Global Justice and Planetary Health." *Environmental Ethics*. Ed. Andrew Light and Holmes Rolston III. Malden, MA: Blackwell Publishing, 2003. 276–293.

Garraty, John A. *The American Nation: A History of the United States*. 8th ed. New York: Harper Collins, 1995.

Gaul, Theresa Strouth. "'The Genuine Indian Who Was Brought upon the Stage': Metamora and White Audiences." *Arizona Quarterly* 56.1 (Spring 2000): 1–21.

Gay, Peter. *The Enlightenment: The Science of Freedom*. New York: W. W. Norton, 1969.

Genovese, Eugene D. *Roll, Jordan, Roll: The World the Slaves Made*. New York: Random House, 1976.

"Global Warming Poses Major Threat to Ski Industry by 2050, Says 'State of the Rockies' Report." CollegeNews.Org., April 13, 2006. http://www.collegenews.org/x5563.xml.

Goodman, Amy. "Inuits to Sue over U.S. Global Warming." *Democracy Now*. December 16, 2004. http://www.democracynow.org/2004/12/16/ inuits_to_sue_u_s_over.

Gordon, John Steele. "The American Environment: The Big Picture Is More Heartening than All the Little Ones." *American Heritage* (October 1993): 37.

Gramsci, Antonio. *The Antonio Gramsci Reader*. Ed. David Forgacs. New York: New York University Press, 2000.

Groseclose, Barbara. *Nineteenth Century American Art*. New York: Oxford University Press, 2000.

Gurney, George, and Therese Thau Heyman, eds. *George Catlin and His Indian Gallery*. Washington, DC: Smithsonian American Art Museum, 2002.

Haberly, Lloyd. *Pursuit of the Horizon: A Life of George Catlin, Painter and Recorder of the American West*. New York: Macmillan, 1948.

Hampson, Norman. *The Enlightenment: An Evaluation of Its Assumptions, Attitudes, and Values*. New York: Penguin, 1968.

Hanna, Jonathan. "Native Communities and Climate Change: Legal and Policy Approaches to Protect Tribal Legal Rights." Natural Resources Law Center, University of Colorado, Boulder. September 19, 2007. http://www.colorado.edu/law/centers/nrlc/publications/ ClimateChangeReport—FINAL%20_9.16.07_.pdf.

Haraway, Donna. *The Haraway Reader*. New York: Routledge, 2004.

Harris, Neil. Humbug: *The Art of P.T. Barnum*. Chicago: University of Chicago Press, 1973.

Hart-Davis, Duff. *Audubon's Elephant: America's Greatest Naturalist and the Making of "The Birds of America."* New York: Henry Holt & Co., 2004.

Hassrick, Royal B. *The George Catlin Book of American Indians*. New York: Watson-Guptill Publications, 1977.

Haverstock, Mary Sayre. *Indian Gallery: The Story of George Catlin*. New York: Four Winds Press, 1973.

Heidler, David S., and Jeanne T. Heidler. *Indian Removal*. New York: W. W. Norton, 2007.

Hellenbrand, Harold. "Roads to Happiness: Rhetorical and Philosophical Design in Jefferson's Notes on the State of Virginia." *Early American Literature* 20.1 (1985): 3–23.

Hight, Kathryn S. "'Doomed to Perish': George Catlin's Depictions of the Mandan." *Art Journal* (Summer 1990): 119–123.

Irving, Washington. "Philip of Pokanoket." *Washington Irving's Sketchbook*. Ed. Philip McFarland. New York: Avenel Books, 1985. 386–408.

Jackson, Andrew. "Second Annual Address." *The State and Nature: Voices Heard, Voices Unheard in America's Environmental Dialogue*. Ed. Jeanne Nienaber Clarke and Hanna J. Cortner. Upper Saddle River, NJ: Prentice Hall, 2002.

Jefferson, Thomas. *Notes on the State of Virginia*. Ed. Thomas Perkins Abernethy. New York: Harper Torchbooks, 1964.

Jones, Sally L. "The First but Not the Last of the 'Vanishing Indians': Edwin Forrest and the Mythic Re-creations of the Native Population." *Dressing in Feathers: The Construction of the Indian in American Popular Culture*. Ed. S. Elizabeth Bird. Boulder, CO: Westview Press, 1996. 13–22.

Jordanova, Lumilla. "Medical Men, 1780–1820." *Portraiture: Facing the Subject*. Ed. Joanna Woodall. New York: Manchester University Press, 1997. 101–111.

Keenan, Thomas. "The Point Is to (Ex)Change It: Reading Capital, Rhetorically." *Fetishism as Cultural Discourse*. Ed. Emily Apter and William Pietz. Ithaca, NY: Cornell University Press, 1993. 153–185.

Kline, Benjamin. *First along the River: A Brief History of the U.S. Environmental Movement*. San Francisco: Acada Books, 2000.

Kohl, Lawrence Frederick. *The Politics of Individualism: Parties and the American Character in the Jacksonian Era*. New York: Oxford University Press, 1989.

Krech, Shepard, III. The Ecological Indian. New York: W. W. Norton, 1999.

Kuritz, Hyman. "The Popularization of Science in Nineteenth-Century America." *History of Education Quarterly* 21.3 (Autumn 1981): 259–274.

LaDuke, Winona. *All Our Relations: Native Struggles for Land and Life*. Cambridge, MA: South End Press, 1999.

Latour, Bruno. *The Politics of Nature: How to Bring the Sciences into Democracy*. Cambridge, MA: Harvard University Press, 2004.

Lepore, Jill. *The Name of War: King Phillip's War and the Origins of American Identity*. New York: Alfred A. Knopf, 1998.

Lerner, Gerda. *The Female Experience*. Indianapolis: Bobbs-Merrill Educational Publishing, 1977.

Levine, Lawrence W. *Highbrow, Lowbrow: The Emergence of Cultural Hierarchy in America*. Cambridge, MA: Harvard University Press, 1988.

Lewis, Jan. "The Republican Wife: Virtue and Seduction in the Early Republic." *William and Mary Quarterly* 44.3 (1987): 689–721.

Limerick, Patricia Nelson. *The Legacy of Conquest: The Unbroken Past of the American West*. New York: W. W. Norton, 1987.

Lomas, David. "Inscribing Alterity: Transactions of Self and Other in Miro Self-Portraits." *Portraiture: Facing the Subject*. Ed. Joanna Woodall. New York: Manchester University Press, 1997. 167–188.

Manning, Susan. "The Naming of Parts; or, The Comforts of Classification: Thomas Jefferson's Construction of American Fact and Myth." *Journal of American Studies* 30.3 (1996): 345–364.

Martin, Scott C. "Interpreting Metamora: Nationalism, Theater, and Jacksonian Indian Policy." *Journal of the Early Republic* 19.1 (Spring 1999): 73–99.

Marx, Karl, and Frederick Engels. *The Communist Manifesto*. New York: International Publishers, 1948.

Mason, Jeffrey D. "The Politics of Metamora." *The Politics of Performance: Theatrical Discourses and Politics*. Ed. Sue-Ellen Case and Janelle Reinett. Iowa City: University of Iowa Press, 1991. 93–106.

Matthews, Washington. *The Catlin Collection of Indian Paintings of 1890*. Washington, DC: Smithsonian Institution. Facsimile Reproduction of the Shorey Bookstore, Seattle, WA, 1967.

Mazel, David. "'A Beautiful and Thrilling Specimen': George Catlin, the Death of Wilderness, and the Birth of the National Subject." *Reading the Earth: New Directions in the Study of Literature and Environment*. Moscow: University of Idaho Press, 1998.

McCracken, Harold. *George Catlin and the Old Frontier*. New York: Bonanza Books, 1959.

McKelvey, Blake. *The Urbanization of America: 1860–1915*. New Brunswick, NJ: Rutgers University Press, 1963.

McNeill, J. R. *Something New under the Sun: An Environmental History of the Twentieth-Century World*. New York: W. W. Norton, 2000.

McPherson, James M. *Ordeal by Fire: The Coming of War*. 2 vols. New York: McGraw-Hill, 1993.

Melville, Herman. "Bartleby, the Scrivener." *The Heath Anthology of American Literature*. Ed. Paul Lauter. Boston: Houghton Mifflin, 1998.

Merchant, Carolyn. *Earthcare: Women and the Environment*. New York: Routledge, 1995.

————. *The Death of Nature: Women, Ecology, and the Scientific Revolution.* San Francisco: HarperCollins, 1976.

Midgley, Mary. *Science and Poetry.* New York: Routledge, 2002.

Miller, Lillian. "In the Shadow of His Father: Rembrandt Peale, Charles Willson Peale, and the American Portrait Tradition." *New Perspectives on Charles Willson Peale: A 250th Anniversary Celebration.* Ed. Lillian B. Miller and David C. Ward. Pittsburgh: University of Pennsylvania Press, 1991. 89–102.

Miller, Lillian B., and David C. Ward, eds. *New Perspectives on Charles Willson Peale: A 250th Anniversary Celebration.* Pittsburgh: University of Pennsylvania Press, 1991.

Millichap, Joseph R. *George Catlin.* Boise, ID: Boise State University, 1977.

Monroe, James. "1825 Message to Congress." *Native American Voices: A History and Anthology.* Ed. Steven Mintz. St. James, NY: Brandywine Press, 1995. 111–112.

Moore, Robert J. *Native Americans: A Portrait: The Art and Travels of Charles Bird King, George Catlin, and Karl Bodmer.* New York: Stewart, Tabori, & Chang, 1997.

Muir, John. *The Yosemite.* New York: Century, 1912.

Mullen, Mark. "This Land Is Your Land, This Land Is My Land: Metamora and the Politics of Symbolic Appropriation." *New England Theater Journal* 10 (1999): 63–81.

Mulvey, Christopher. "George Catlin in Europe." *George Catlin and His Indian Gallery.* Ed. George Gurney and Theresa Thau Heyman. Washington, DC: Smithsonian American Art Museum/W. W. Norton, 2002.

Nash, Roderick. "The American Invention of National Parks." *American Quarterly* 22 (Autumn 1970): 726–735.

————. *Wilderness and the American Mind.* New Haven, CT: Yale University Press, 1967.

Opie, John. *Nature's Nation: An Environmental History of the United States.* Ft. Worth, TX: Harcourt Brace College Publishers, 1998.

Outram, Dorinda. *The Enlightenment.* New York: Cambridge University Press, 1995.

Peale, Charles Willson. *The Selected Papers of Charles Willson Peale and His Family.* 5 vols. New Haven, CT: Yale University Press, 1983–2000.

Pietz, William. "Fetishism and Materialism: The Limits of Theory in Marx." *Fetishism as Cultural Discourse.* Ed. Emily Apter and William Pietz. Ithaca, NY: Cornell University Press, 1993. 153–185.

Pratt, Mary Louise. *Imperial Eyes: Travel Writing and Transculturation*. New York: Routledge, 1992.

Price, Joan Elliot. "Robert Sully's Nineteenth-Century Paintings of Sauk and Winnebago Indians." *Wisconsin Academy Review* 45.1 (Winter 1998–1999): 22–23.

Reddin, Paul. *Wild West Shows*. Chicago: University of Illinois Press, 1999.

Revkin, Andrew C. "Eskimos Seek to Recast Global Warming as a Rights Issue." *New York Times*. December 15, 2004. http://www.nytimes.com/ 2004/12/15/international/americas/15climate.html?scp=2&sq=revkin+ inter-american+inuit&st=nyt.

Roehm, Marjorie Catlin. *The Letters of George Catlin and His Family: A Chronicle of the American West*. Berkeley: University of California Press, 1966.

Runte, Alfred. *National Parks: The American Experience*. Lincoln: University of Nebraska Press, 1997.

Sellars, Richard West. *Preserving Nature in the National Parks: A History*. New Haven, CT: Yale University Press, 1997.

Sellers, Charles. *The Market Revolution: Jacksonian America, 1815–1846*. New York: Oxford University Press, 1991.

Sellers, Charles Coleman. *Mr. Peale's Museum: Charles Willson Peale and the First Popular Museum of Natural Science and Art*. New York: W. W. Norton, 1980.

———. "Good Chiefs and Wise Men: Indians as Symbols of Peace in the Art of Charles Willson Peale." *American Art Journal* 7.2 (1975): 10–18.

Slaughter, Thomas P. *The Natures of John and William Bartram*. New York: Alfred A. Knopf, 1996.

Souder, William. *Under a Wild Sky: John James Audubon and the Making of "The Birds of America."* New York: North Point Press, 2004.

Stanton, Elizabeth Cady. "Declaration of Sentiments." *The Heath Anthology of American Literature*. Ed. Paul Lauter. Boston: Houghton Mifflin, 1998.

Stein, Roger B. "Charles Willson Peale's Expressive Design: The Artist in His Museum." *New Perspectives on Charles Willson Peale: A 250th Anniversary Celebration*. Ed. Lillian B. Miller and David C. Ward. Pittsburgh: University of Pennsylvania Press, 1991. 167–218.

Steinberg, Ted. *Down to Earth: Nature's Role in American History*. New York: Oxford University Press, 2002.

———. *Nature Incorporated: Industrialization and the Waters of New England.* Amherst: University of Massachusetts Press, 1991.

Stone, John Augustus. "Metamora." *Metamora and Other Plays.* Ed. Eugene R. Page. Princeton, NJ: Princeton University Press, 1941.

Suffrin, Mark. *George Catlin: Painter of the Indian West.* New York: Maxwell Macmillan International, 1991.

Taylor, Quintard. *In Search of the Racial Frontier: African Americans in the American West, 1528–1990.* New York: W. W. Norton, 1998.

Thernstrom, Stephen, et al., eds. *Harvard Encyclopedia of American Ethnic Groups.* Cambridge, MA: Harvard University Press, 1980.

Thoreau, Henry David. *Walden and Civil Disobedience.* New York: Signet Classics. 1960.

Troccoli, Joan Carpenter. *First Artist of the West: George Catlin Paintings and Watercolors.* Tulsa, OK: Gilcrease Museum, 1993.

Truettner, William H. *The Natural Man Observed: A Study of Catlin's Indian Gallery.* Washington, DC: Smithsonian Institution Press, 1979.

UNEP: United Nations Environment Program. *The Environment in the News.* March 1, 2008. http://www.unep.org/cpi/briefs/2007May10.doc.

Virginia Museum of Fine Arts. *George Catlin: Medicine Painter, 1796–1872.* February 29, 2008. http://www.vmfa.museum/catlin/timeline.html.

Wallace, Anthony. *Jefferson and the Indians: The Tragic Fate of the First Americans.* Cambridge, MA: Belknap Press, 1999.

———. *The Long Bitter Trail: Andrew Jackson and the Indians.* New York: Hill & Wang, 1993.

Ward, David C. "An Artist's Self-Fashioning: The Forging of Charles Willson Peale." *Word and Image* 15.2 (April–June 1999): 107–127.

Ward, David C., and Sidney Hart. "The Waning of an Enlightenment Ideal: Charles Willson Peale's Philadelphia Museum, 1790–1820." *New Perspectives on Charles Willson Peale: A 250th Anniversary Celebration.* Ed. Lillian B. Miller and David C. Ward. Pittsburgh: University of Pennsylvania Press, 1991. 219–235.

Warren, Louis S. *American Environmental History.* Malden, MA: Blackwell Publishing, 2003.

Weber, Ronald. "'I Would Ask No Other Monument to My Memory': George Catlin and a Nation's Park." *Journal of the West* 38 (1999): 15–21.

West, W. Richard. "Introduction." *George Catlin and His Indian Gallery.*

Ed. Mary J. Cleary and Theresa J. Slowik. Washington, DC: Smithsonian Institution/W. W. Norton, 2002. 18–23.

White, Richard. "Discovering Nature in North America." *Journal of American History* 19.3 (December 1992): 874–891.

Wilentz, Sean. *The Rise of American Democracy: Democracy Ascendant, 1815–1840.* New York: W. W. Norton, 2007.

Wilson, John Wm. "Johannes Kepler." Georgia State University, Department of Physics and Astronomy Page. November 20, 2001. http://www.chara.gsu.edu/~wilson/NSCI%203001—7001/power%20points/Copernican%20revolution/Johannes%20Kepler.doc.

Woodall, Joanna. "Introduction: Facing the Subject." Ed. Joanna Woodall. *Portraiture: Facing the Subject.* New York: Manchester University Press, 1997. 1–28.

Zinn, Howard. *A People's History of the United States: 1492–Present.* New York: Perennial Classics, 1999.

Index

Adams, John, 33, 102
"Age of Democracy," 4–7
Alexie, Sherman, 90
American exceptionalism, 31, 99, 107, 108, 109, 127
American Fur Company, 16, 50, 61, 65, 66, 114. *See also* fur trade
American Philosophical Society, 23
Anderson, Marilyn, 106, 163n4, 163n5
"anti-conquest," 64–65, 68, 72, 80, 89
Apter, Emily, 167n5
assimilation, Indian, 30
 Catlin's hope for, 85–86, 117–118, 139, 141, 144–146, 155
 ideology of, 114, 147
 Jefferson's view of, 95, 97
 versus extermination, 103, 105, 106, 107–108, 109, 112
Audubon, John James, 74–76, 78, 98, 118, 146, 151

Bacon, Francis, 24, 26, 27
Bank, Rosemarie, 104
Bannock tribe, 155
Barnum, P. T., 3, 138, 153, 164n8
"Bartleby, the Scrivener," 1–2, 11
Bartram, John, 72–73, 75
Bartram, William, 34, 72–74, 75, 151
Baudelaire, Charles, 3, 144
Berkhofer, Robert, 94
Blackfoot Indians, 50, 154
Black Hawk, 12, 46, 123, 125
 and Catlin's lament, 156
 Catlin's portraits of, 115 (image), 116–119, 117 (image), 148, 164n10
 Catlin's staging of, 119–121, 126
 imprisonment of, 114, 115–116, 117, 119, 121
 See also Black Hawk War
Black Hawk and Five Other Saukie Prisoners, 116–118, 117 (image)
Black Hawk War, 12, 114, 118

Bruchey, Stuart, 40
buffalo, 14, 72, 80, 105, 142
 Catlin's depiction of, 51–54, 89 (image), 120, 155–156
 and Catlin's national park concept, 84–85, 148–149
 and commodity fetishes, 155–156, 157–158
 extinction, 8, 55, 86, 93
 and fur trade, 66
 and preservation of Nature, 88–89, 111

Calhoun, John, 5–6
Cass, Lewis, 5–6, 128–129
Catlin, Clara, 126, 127, 130, 137
Catlin, Francis, 123, 125
Catlin, George
 and Black Hawk, 115 (image), 116–121, 126, 148, 156, 164n10
 death of, 92, 150
 and environmentalism, 131, 151–152, 155, 166n1
 epiphany of, 21–23, 43, 47–48, 62, 104, 156
 as ethnographer, 3–4, 11, 13, 16–18, 20, 37, 51–52, 55–56, 61, 69–71, 77, 111, 123–125, 151
 in Europe, 127, 130, 131, 132–134, 137–139, 141–143, 147, 164n1, 165n5
 financial struggles of, 131, 136–137, 165n3, 165n4
 and his gaze, 61–67, 68, 69–71, 72, 82, 87, 88, 90, 93, 108, 110, 131, 156
 and his lament, 91–94, 112, 127–129, 148, 156, 159–160, 163n1
 in London, 3, 132, 133–138, 142, 147–148
 as national park advocate, 20, 53, 84–85, 87, 110, 148–149, 150–151, 166n1
 Peale's influence on, 19, 23–24, 36–37, 43, 84, 85, 90, 131, 134, 152
 as portraitist, 19, 23–24, 41–47, 56, 57, 59–61, 114, 118, 124, 137

Catlin, George (*continued*)
 and preserving "Nature," 4, 14, 19, 20,
 21, 22, 43, 47–48, 67, 72, 150–151
 Sioux and, 52, 53, 68–72, 119–120
 and travels west, 22, 50, 51–52, 56–57,
 58, 60, 61–62, 92, 146–147
 See also colonialism, global; expan-
 sion, Euro-American; Gallery
 Unique; Mandan Indians; "Wild
 West" shows; Yellowstone Na-
 tional Park
Catlin, Putnam, 46, 121–122, 125
Central Pacific Railroad, 153
Cherokee, 5, 9–10, 29, 122. *See also* Trail
 of Tears
Chickasaws, 29, 122
Chippewa, 29
Choctaws, 29
Chouteau, Pierre, 61
Clark, William
 Catlin's portrait of, 59–61, 62
 (image), 114, 118, 124
 Catlin's relationship with, 46, 50, 58, 61
 and Lewis and Clark expedition, 27,
 104
Clay, Henry, 9
Clinton, DeWitt, 23, 42 (image), 43–46,
 57, 60, 61, 118, 124
colonialism, global, 132–134, 137, 138, 140,
 144, 146, 154
Comanche Indians, 50
commodification, 5, 6, 20, 41, 152, 156–
 157, 159. *See also* commodity, con-
 cept of; fetishes
commodity, concept of, 157
Conn, Steven, 12
conquest, 65, 69, 85
 critiqued in art, 80–81
 fueled by "anti-conquest," 72
 ideology of, 80
 See also "anti-conquest"
Cooper, James Fenimore, 100, 104, 106,
 151
 lament of, 97–99
 Leatherstocking Tales of, 77, 98–99
 and Nature, 76
Cree Indians, 50
Creeks, 29, 122

Crockett, Davy, 9
Cronon, William, 83
Crow Indians, 50, 126, 154

Davis, Jefferson, 13
Delaware Indians, 29, 50, 96
Deloria, Philip, 9, 112–113
Dickens, Charles, 3
Dippie, Brian
 on Catlin in Europe, 132, 164n1, 165n5
 on Catlin's critics, 46
 on Catlin's ideological agenda, 15–16,
 17
 on the vanishing Indian, 110, 163n1
Douglass, Frederick, 17
Drake, Benjamin, 116

Emerson, Ralph Waldo, 76, 77–79, 87,
 162n2
Emmonds, Richard, 105
Enlightenment era, 75, 76
 and Catlin, 24, 48, 56, 71, 74
 and influence on Peale, 27–28, 29, 31,
 33
 and intersection of art and science, 37
 See also "Nature"; Peale's Museum
environmental ethics, 85, 159–160
environmental exploitation, x, xii, 2, 5,
 40, 54, 157, 158
environmental monumentalism, 153–154,
 166n2
Erie Canal, 40, 45, 60
ethics
 and "anti-conquest," 64, 72, 80, 89
 Catlin and, 11, 20, 47–48, 52, 53, 56,
 159–160
 of nature, 19, 56, 85
expansion, Euro-American, 33, 40, 96
 Audubon's perspective on, 76
 in Catlin's art, 57, 60–61, 66, 82
 and Catlin's ethnography, 111–112,
 119, 123
 and Catlin's idealism, 130–131
 Catlin's resistance to, 11–12, 13–14, 16,
 21–22
 commodity relationships in, 159
 and Indian conflicts, 29, 30
 and Indian removal, 65, 100, 101, 102

legitimating of, 108–109, 147, 148, 158, 159
and railroads, 6, 12, 152–153
romanticists' views on, 78–79

factories, 5, 6–8, 40, 157–158
Fairchild, Sharon, 165n1
fetishes
 Catlin's, 146
 commodities as, 157–158, 166nn3, 4
 of Nature, 147, 155
 See also commodification; Yellow-stone National Park
fetish theorists, 167nn4, 5
Forrest, Edwin, 106, 107, 108, 121, 163n7
Fort Leavenworth, 50, 61, 66, 88
Fort Union, 50, 65
Foucault, Michel, 162n1
Fox Indians, 50, 61, 114, 119
Franklin, Benjamin, 23, 33, 34, 75
Freccero, Carla, 8–9
frontier, the, 50, 60, 67, 71, 72, 85, 86, 134
 conditions of, 14–15, 80, 83
 life on, 51, 52, 91, 93, 116, 144, 148
 policy for, 12, 15
fur trade, 14, 16, 52, 53, 69, 91

Gaard, Greta, 8
Gallery Unique, Catlin's, 10, 27, 123, 137, 153
 efforts to sell, 13, 16, 50–51, 127–128, 133, 136
 multimedia shows of, 3, 18, 92, 110
 reviews of, 111
Gast, John, 13, 80, 105
"gaze," the, 162n1. *See also* "imperial eyes"
gender. *See* hierarchy, racial and gender; patriarchy; women
Glacier National Park, 153
Grant, Ulysses S., 150, 154
Great Northern Railroad, 152–153
Gruen, Lori, 8

Haberly, Lloyd, 11, 164n1, 165n5
Hamilton, Alexander, 32
Hart-Davis, Duff, 76
hierarchy, racial and gender, 7–8
Hight, Kathryn, 164n11

ideology
 of "Aristocracy of Virtue," 38
 Catlin's problematic, 70, 137–138, 147–148
 of conquest, 80
 defined, 8–9
 of environmental disconnection, 78
 and environmental ethics, 159
 of "naturalness," 9
 of Nature, 19, 20, 21, 47, 55, 71, 157
 power of, 5–6
 See also Indian removal; "Nature"
"imperial eyes," 64, 67, 68, 70–71, 89
Indian removal, x, 2, 7, 8, 99
 Catlin's challenge to, 13–17, 65
 and Catlin's lament, 90–91, 94, 110–112, 126–128
 and Catlin's portraits, 60–61
 and commodity fetishes, 157–159
 and dominant ideology, 5–6, 9–11, 13–14, 55, 109–110, 125
 and Goddess of Liberty, 80, 105
 Jefferson's vision of, 95–97, 112
 in literature, 98–103
 Monroe's proposal for, 97–98
 and nineteenth-century theater, 103–109
 and the Seminole, 122–123
 slavery in wake of, 6–7, 13
 See also Black Hawk War; Indian Removal Act; Jackson, Andrew; Seminole
Indian Removal Act, 9, 30, 104, 112
 ideology fueling, 5–6, 13, 98
 Jackson's defense of, 113–114
 See also Indian removal
Inuit, ix–x, xi, 159–160
Iowa Indians, 50, 61, 119, 138, 139, 140, 147, 148
Ioways. *See* Iowa Indians
Irving, Washington, 77, 99–103, 104, 106, 115

Jackson, Andrew, xii, 4, 13, 104
 and Black Hawk, 117, 119
 and Indian removal ideology, 5–6, 9–10, 126–127

Jackson, Andrew (*continued*)
 and push for Indian removal, 112,
 113–114
 See also Indian removal; Jacksonian
 Era
Jacksonian Era, 163n7
 American exceptionalism of, 107
 ideologies of, 4, 19, 146
 and Indian removal, 91, 128
 injustices of, xii, 18
 politics of, 127
 See also Jackson, Andrew
Jefferson, Thomas, 33, 34, 39, 75, 119
 and concept of Nature, 25, 26–27, 31,
 32, 78, 102
 as Enlightenment thinker, 24
 and Indian removal, 94–95, 98, 104,
 112
 and "Logan's Lament," 95–97, 98, 99–
 100
 and "natural equality," 95, 163n2
Jefferson Barracks, 115–116, 120, 121. *See
 also* Black Hawk
Jesup, Thomas, 123

Keenan, Thomas, 166n3
KeeoKuk, 114. *See also* Sauk
Kickapoo, 29, 50, 61
King Philip's War, 99, 100, 106, 108
Kiowa, 50
Kline, Benjamin, 12, 40, 166n1
Krech III, Shepard, 83

Last of the Mohicans, 98, 106. *See also*
 Cooper, James Fenimore
Latour, Bruno, 21
Leatherstocking Tales, 77, 98. *See also*
 Cooper, James Fenimore
Lewis, Jan, 7, 161–162n1
Lewis and Clark Expedition, 27, 104
Limerick, Patricia Nelson, 66, 86
"Logan's Lament," 95–97, 98, 99–100
Louisiana Purchase, 30, 97
Louis-Philippe, King, 3, 144

Macomb, Alexander, 106
Madison, James, 32
Mandan Indians
 Audubon's perception of, 74–75

Catlin's relations with, 67–68, 84, 92
 in Catlin's show, 120, 121–122, 125, 126
 Catlin's study of, 50, 51, 69, 76–77
Manifest Destiny, 4, 66, 105, 143, 153
Marx, Karl, 1, 166n3
Mason, Jeffrey, 99, 102
Mazel, David, 83–84
McCracken, Harold, 11
Melville, Herman, 1, 2
Merchant, Carolyn, ix, 26
Metacomet, 99, 163n3
Metamora: The Last of the Wampanoags,
 106–107, 108–109, 112, 121, 126
Miller, Lillian, 25
Missouri River, 50, 51, 61, 74, 82
Monroe, James, 97–98, 100, 103–104, 112,
 119. *See also* Indian removal
monumentalism. *See* environmental
 monumentalism
Muir, John, 151, 166n2
*Múk-a-tah-mish-o-káh-kaik, Black Hawk,
 Prominent Sac Chief*, 115 (image).
 See also Black Hawk
Mulvey, Christopher, 164–165n1, 165n4

Nash, Roderick, 11–12, 79–80, 151, 152,
 153, 166nn1, 3
"Nature"
 Catlin's ideologies of, 19, 21, 72
 Catlin's intent to preserve, 4, 20, 22,
 43, 47–48, 67, 88, 150–151
 dominant nineteenth-century ideol-
 ogy and, 9, 14
 Enlightenment construction of, 24–
 28, 30, 36, 47, 79
 problematic constructions of, 19–20,
 30, 109–110, 146–147
 romantic ideologies of, 76, 78, 155
 See also Emerson, Ralph Waldo;
 Peale's Museum; Thoreau, Henry
 David
Neopope, 116–117
Norris, Philetus, 153, 154
Northern Pacific Railroad, 152
Notes on the State of Virginia, 31, 95. *See
 also* Jefferson, Thomas

Ojibwa Indians, 50, 137–138, 143, 144
Opie, John, 166n1

Osceola, 12, 122–126, 124 (image), 148, 156
*Os-ce-o-lá, The Black Drink, a Warrior of
 Great Distinction*, 123–125, 124
 (image)
Ottawa, 29, 95

Palmer, Frances, 13, 80
patriarchy, 2, 7, 8, 9, 161–162n1
Peale, Charles Willson, 75, 92
 as agent of a successful republic, 36
 Enlightenment view of, 27–28, 33, 47,
 48, 71, 74, 87
 and *The Exhumation of the Mastodon*,
 34, 36 (image), 58
 as expansion supporter, 27–30
 historians on, 25, 27, 41
 and influence on Catlin, 43, 85
 and Nature, 25, 27, 78, 79, 155
 as portraitist, 34, 39
 self-portrait of, 33–34, 35 (image), 36,
 37, 44, 161n1
 See also Peale's Museum
Peale, Raphaelle, 39
Peale, Rembrandt, 33, 39, 43
Peale's Museum, 26, 63, 108
 and access to Nature, 27, 37, 38, 47, 146
 as anticolonial temple, 31–32
 elite membership of, 32
 and Enlightenment view, 74
 and impact on Catlin, 19, 23–24, 36–
 37, 84, 90, 131, 134, 152
 as orderly "Book of Nature," 28–30,
 33–34
 See also Peale, Charles Willson
Pennsylvania Academy of Fine Arts, 23,
 37, 43. *See also* Peale, Charles Will-
 son
Philadelphia Academy of Natural Sci-
 ences, 23, 75
Philadelphia Evening Post, 111
Philadelphia Gazette, 29–30, 111
Philadelphia Herald and Sentinel, 111
"Philip of Pokanoket," 100–103, 106. *See
 also* Irving, Washington; King
 Philip's War
Pontiac, 106
Porter, Peter B., 57, 60
portraiture, nineteenth-century, 37–38,
 48–49, 87

Catlin and, 19, 23, 41, 43–46, 57
Catlin's rejection of east-coast, 59
miniature painting and, 39
status in, 40–41
Pratt, Mary Louise, 63–65, 72, 130. *See
 also* "imperial eyes"
"Proclamation Line," 95, 96, 97

race. *See* hierarchy, racial and gender;
 slavery
railroads
 expansion of, 157
 as national park promoters, 152–153,
 154, 156
 and western expansion, 6, 12
 See also Yellowstone National Park
Rainier National Park, 152
Reddin, Paul, 12, 111–112, 164n1, 165nn3,
 4, 5
Red Pipestone Quarry, 50, 68–69, 70
 (image), 71, 133
Rice, T. D. "Jim Crow," 116
River Bluffs, 1320 Miles above St. Louis, 80–
 81, 81 (image)
Roehm, Marjorie Catlin, 59–60, 150,
 165n5
Rosebud Sioux, xii
Runte, Alfred, 153–154

Sauk, 5, 50, 61, 114, 118, 119. *See also* Black
 Hawk; Black Hawk War
Schoolcraft, Henry, 16
Sellers, Charles Coleman, 27
Seminole, 5, 122–123. *See also* Osceola
Seminole wars, 12, 122–123
Shawnee, 29, 50, 61
Sheepeater tribe, 155
Shoshone, xii, 154–155
Sioux, 50, 70 (image), 84, 114
 and Catlin's "gaze," 52, 53
 on Catlin's stage, 119–120
 and contradictions in Catlin's "anti-
 conquest," 68–72
Slaughter, Thomas, 72–73
slavery, 2, 10, 64, 79, 140, 162n2
 Jefferson's view of, 95
 and Seminole society, 122
 and the ideology of Nature, 8–9
 and the market revolution, 40, 158

slavery (*continued*)
in wake of Indian removal, 6–7, 13
smallpox, 121–122, 130, 139, 144, 147, 154
Souder, William, 75
Southern Pacific Railroad, 153
St. Louis, 45, 50, 59–60, 61, 63, 114, 115
Stanton, Elizabeth Cady, 17
Steinberg, Theodore, 157, 158
Stone, John Augustus, 106, 108. See also
*Metamora: The Last of the
Wampanoags*
Stuart, Gilbert, 39
Sulley, Thomas, 39, 43, 46

Tammany Societies, 112–113, 126
theater, nineteenth-century, 107, 119
Indian melodramas in, 103–105
"vanishing race" rhetoric in, 94, 104–
106, 163n5
See also "Wild West" shows
Thoreau, Henry David, 17, 76, 78–80, 87,
151, 162n2
Thumb, Tom, 130, 153
Trail of Tears, 5, 122. *See also* Cherokee
Truettner, William, 12, 116
Trumbull, John, 39, 58

Union Pacific Railroad, 153
United States Gazette, 111, 127

Van Buren, Martin, 127
"vanishing race" rhetoric
Catlin's paintings and, 118–119, 123–
125
as discourse, 94
and the intersection of lament and
removal, 109–110, 129, 141, 163n1
Victoria, Queen, 3, 134
Virginia Constitutional Convention, 58–59,
59 (image)
Virginia Museum of Fine Arts, 51

Ward, David, 41
Washington, George, 29, 32, 34, 39, 96,
97, 99

Webster, Daniel, 3, 9, 10, 127–128, 165–
166n5
West, W. Richard, 12
West Point, 46, 57, 58, 60
West Point Parade, 57–58, 58 (image), 60,
61
White, Richard, 83
Wichita Indians, 50
"Wild West" shows
Catlin as pioneer of, 3, 20, 151, 164–
165n1, 165n5
in Europe, 92, 104, 130, 138–139,
164n8
Indian delegations in, 119–120, 121,
137–138
reviews of, 164n9
sensationalism of, 126, 136–137, 141–
143, 149, 165n4
women
in "Age of Democracy," 5
and Jefferson on "natural equality,"
95, 163n2
labor exploitation of, 40, 158
and patriarchal ideologies, 7–8, 108,
161–162n1
See also patriarchy
Woodall, Joanna, 37–38
*Wounded Buffalo, Strewing His Blood over
the Prairies*, 89 (image)

Yellow Stone (steamboat), 50, 61, 63, 65,
66, 80, 89, 134
Yellowstone National Park
Catlin and, 20, 150–152, 166n1
and commodification of Nature, 20,
152, 155
and environmental monumentalism,
153–154, 166n2
as fetish of nature, 155, 156, 166n3
Indians of, 154–155
and railroad-driven tourism, 152–153,
154
Yellowstone River, 51, 56, 61, 65, 74, 131,
148, 150
Yosemite National Park, 153, 166n2